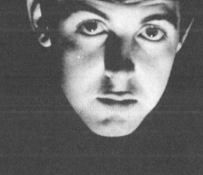

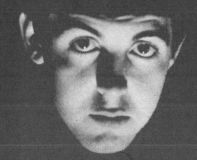
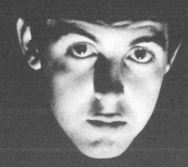

CW00515479

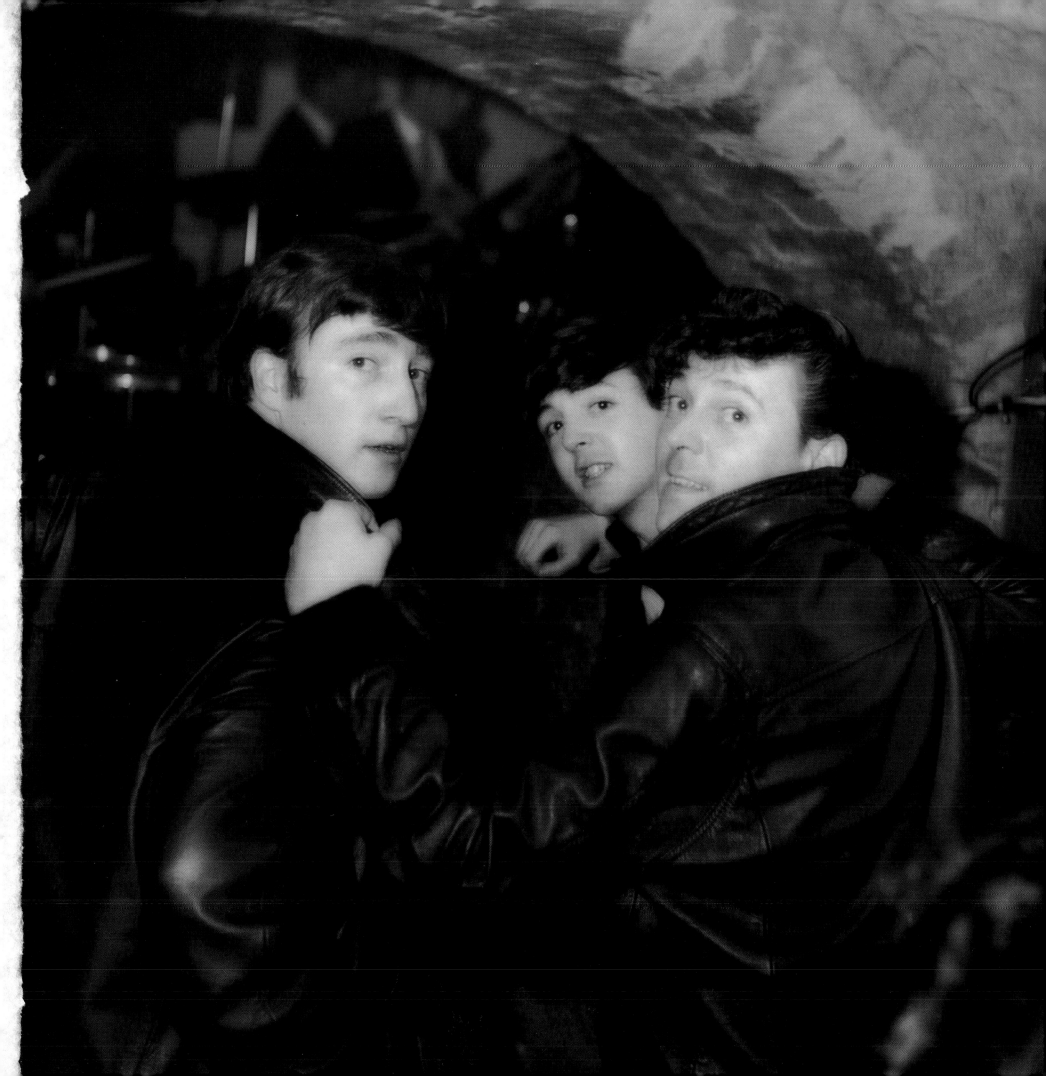

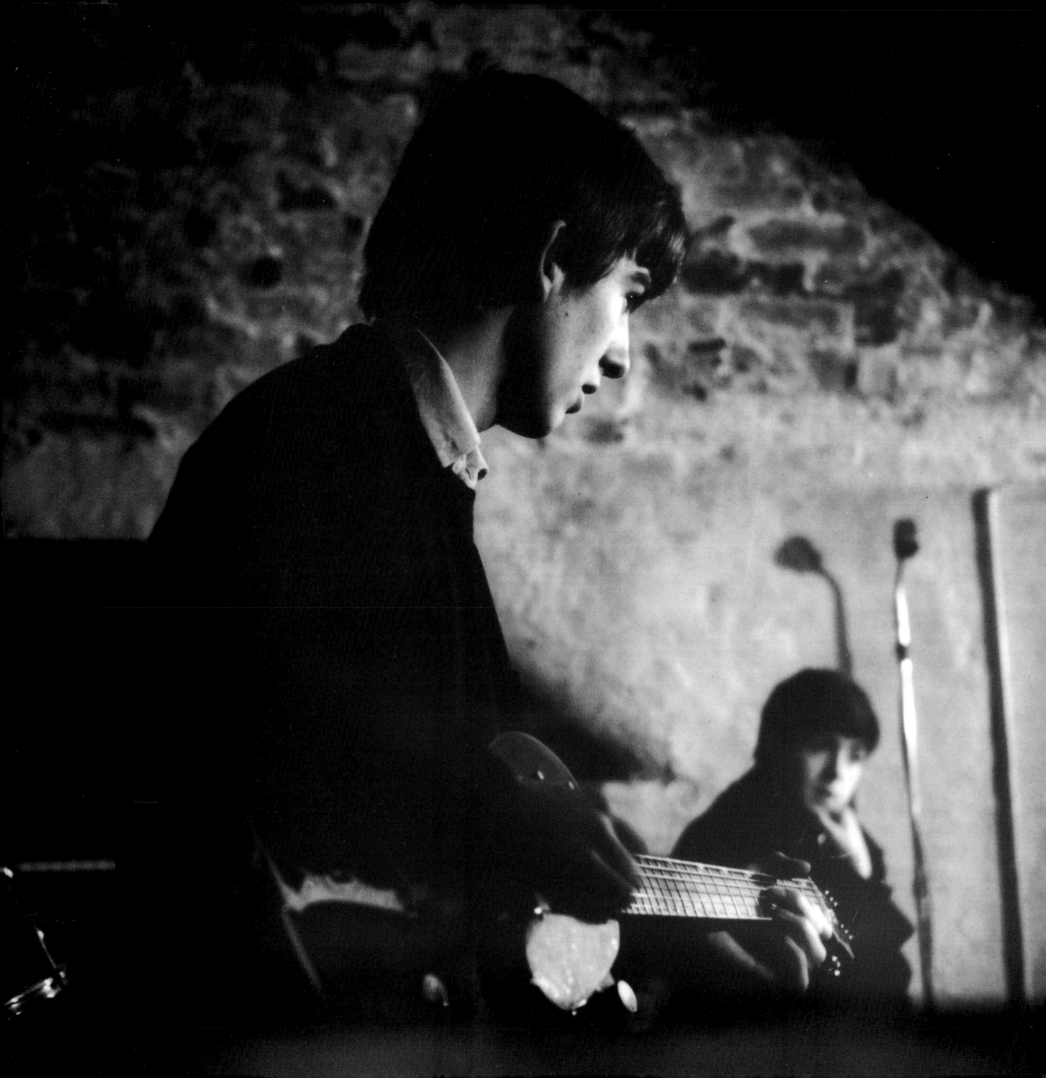

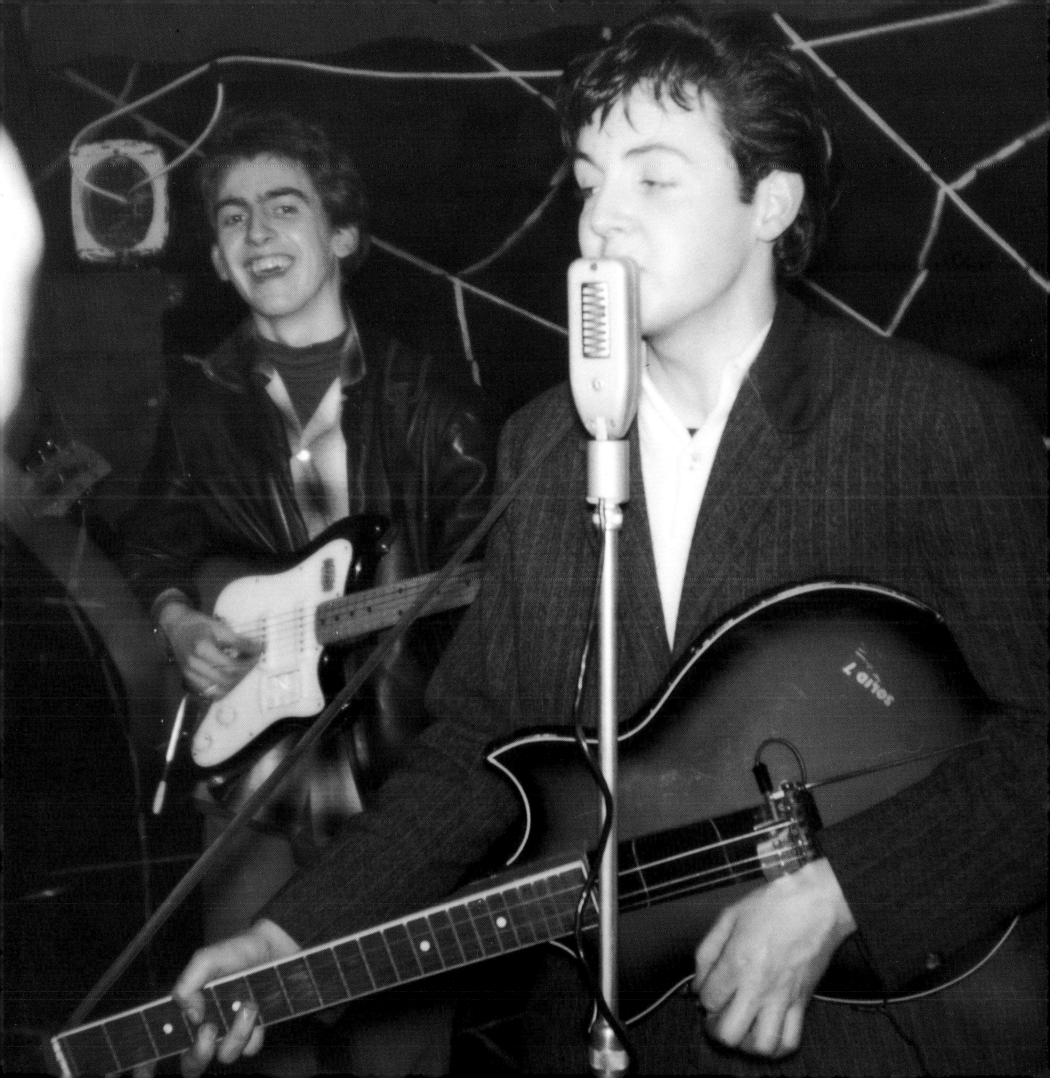

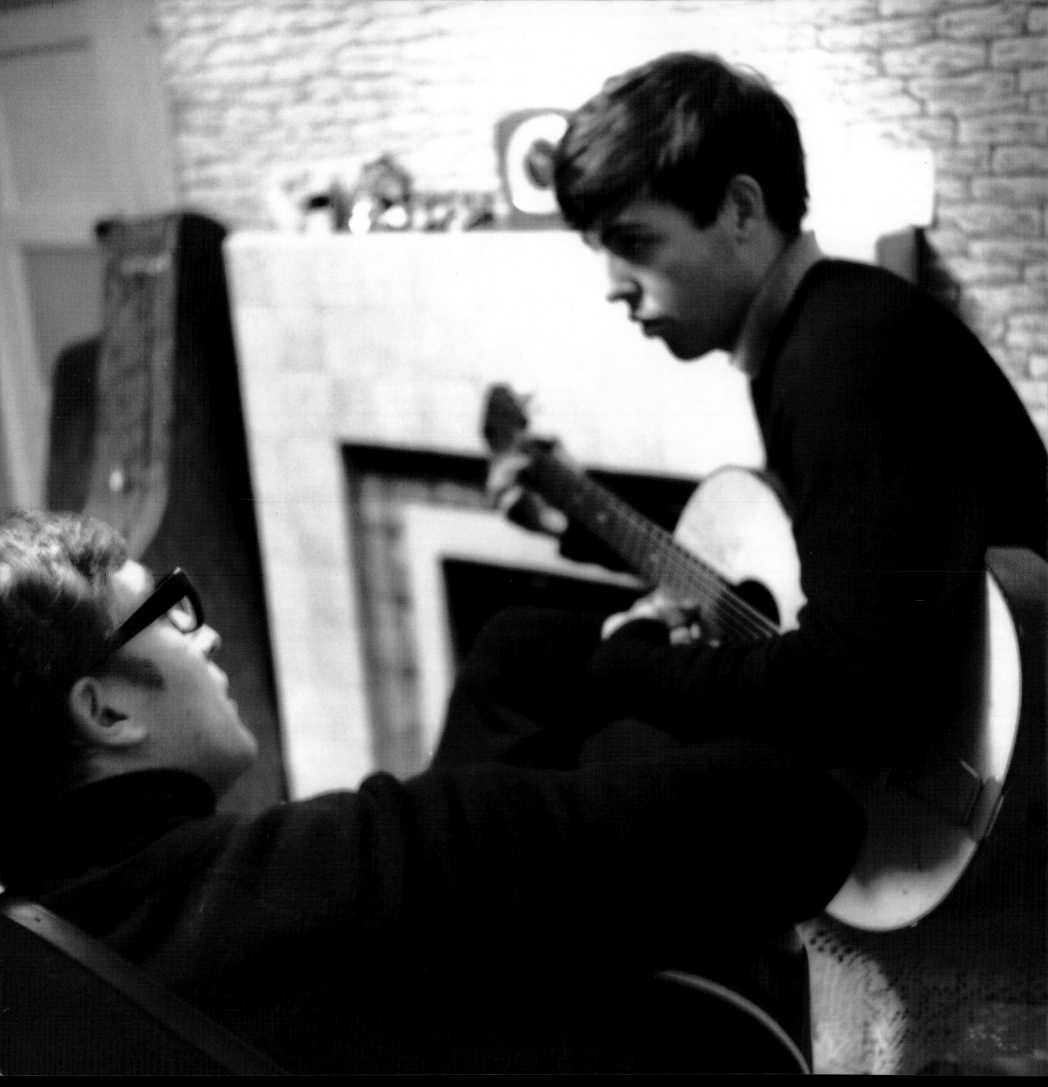

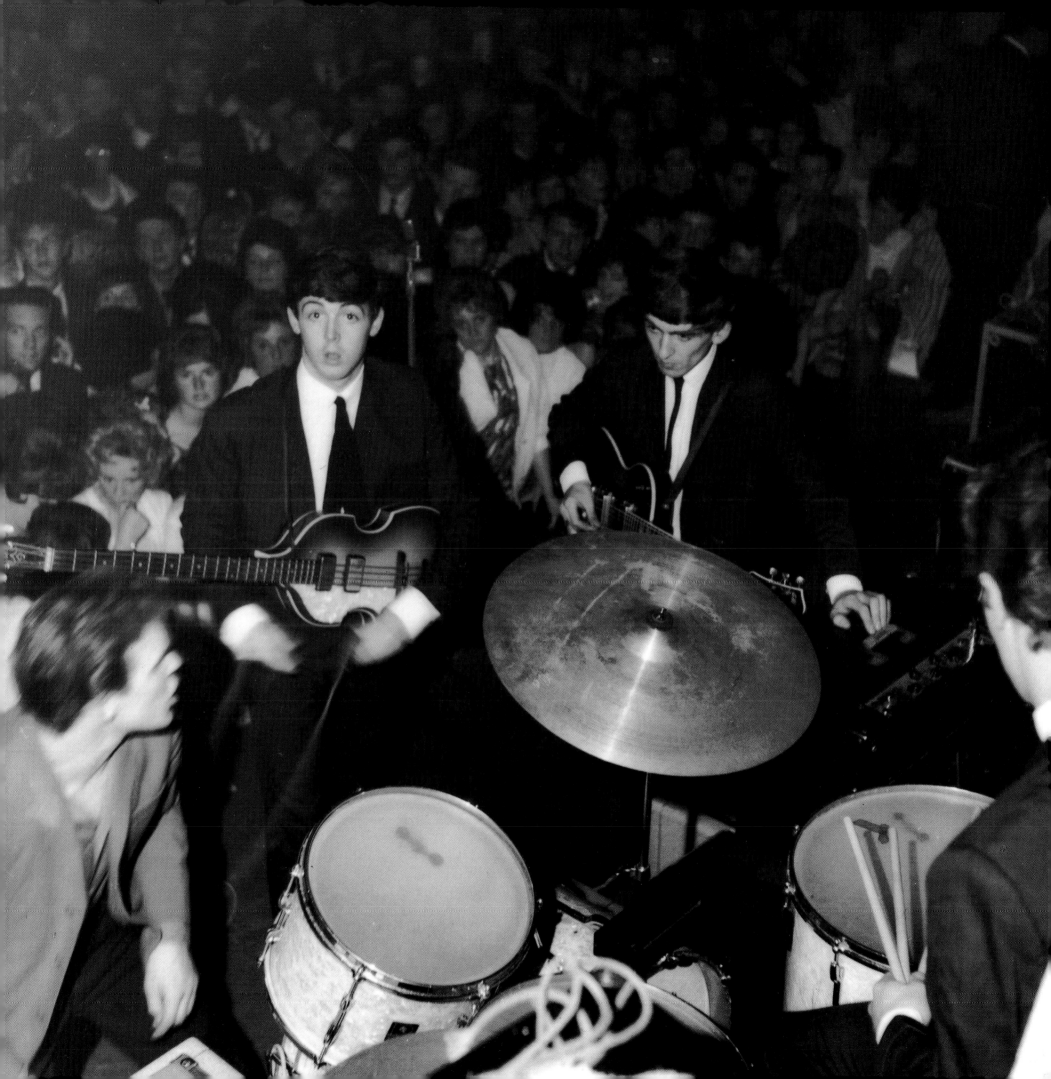

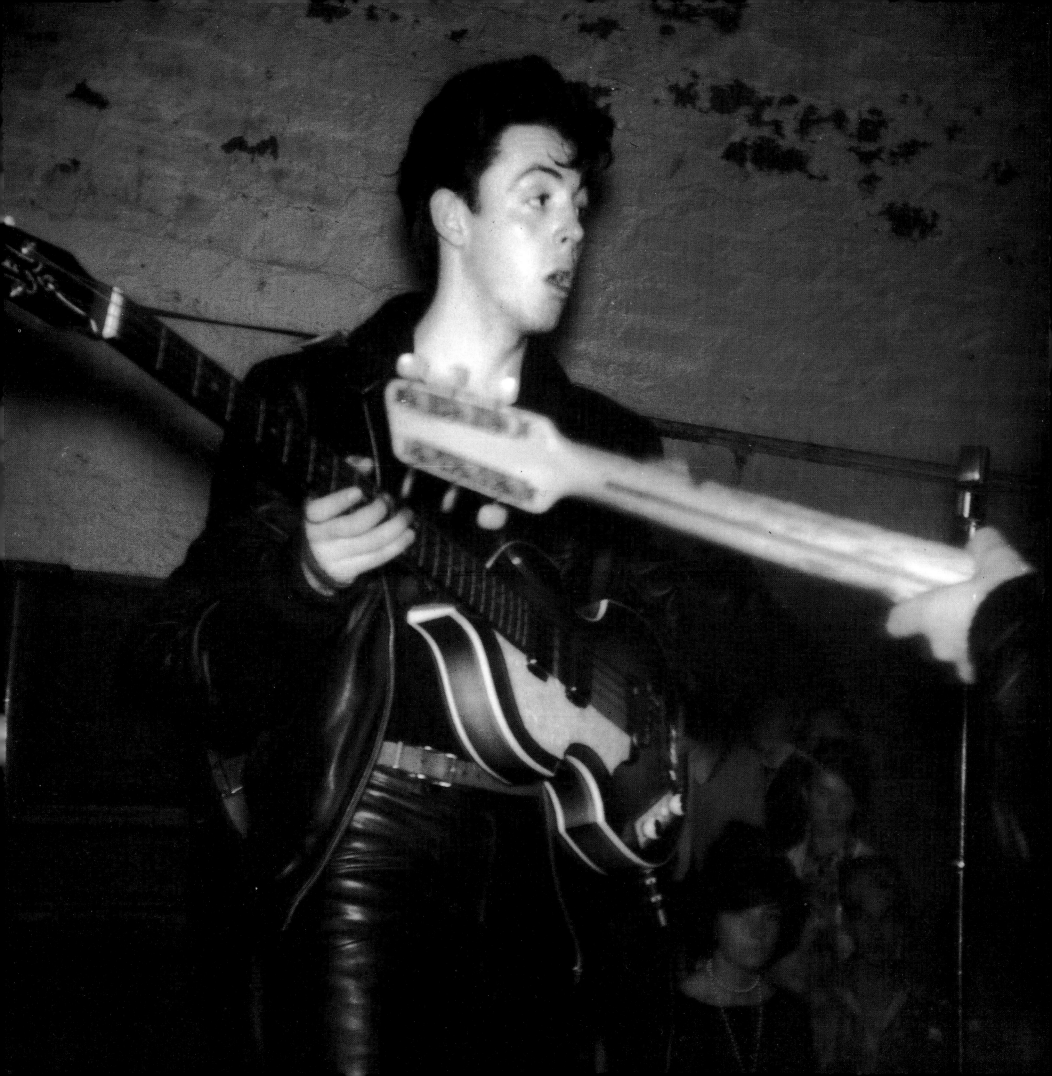

REMEMBER

THE RECOLLECTIONS AND PHOTOGRAPHS OF MICHAEL McCARTNEY

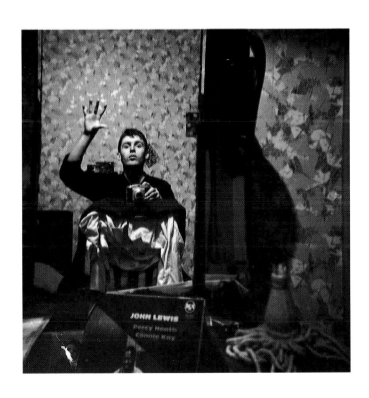

MEREHURST

LONDON

A FRIEDMAN GROUP BOOK

Published 1992 by Merehurst Limited
Ferry House, 51/57 Lacy Road
Putney, London, SW15 1PR

By arrangement with Michael Friedman Publishing Group, Inc.

Copyright © 1992 by Michael McCartney

ISBN 1 85391 321 9

A catalogue record for this book is available from the British Library.

REMEMBER
The Recollections and Photographs of Michael McCartney
was prepared and produced by
Michael Friedman Publishing Group, Inc.
15 West 26th Street
New York, New York 10010

Editor: Karla Olson
Designer: Stan Stanski
Art Director: Jeff Batzli
Photography Editor: Christopher C. Bain

Typeset by Classic Type, Inc.
Colour separations by United South Sea Graphic Art Co.
Printed and bound in Hong Kong by Leefung-Asco Printers Ltd.

Many of the photographs and silk screens included in this book are available as fine art prints.

PAGE 1: John, Paul, and Gene Vincent in the Cavern (Sounds Incorporated on stage). Gene was one of our big heroes. The Beatles were playing as a warm-up band for him and as soon as I appeared, Paul said, "Get a picture of us with Gene." At the time, the Beatles were big in Liverpool and Hamburg but nowhere else. (Three years later Gene would have begged for a picture of himself with the Beatles.)

PAGE 2: George and Paul at the Cavern rehearsing after they'd played their lunchtime set.

PAGE 3: This was taken slightly earlier than the previous photograph. This is the Casbah Club in West Derby, run by Pete Best's mother, Mona. Paul is playing the guitar upside down because he's left-handed, so he had to reverse it. There's only three strings on it, and I think they are piano wires. I designed the first Beatles' poster here, which Pete Best still has, an outline of John doing his Elvis impersonation.

PAGE 4: Paul and John rehearsing in the front room of our house in Forthlin Road, Allerton. You can tell this is an "exclusive" shot because John is wearing his glasses, which he never did onstage or for the media. They're in front of the fireplace that Paul and I cleaned out every morning and laid and lit each evening. After Mum died, Dad expected the boys to do their fair whack of the housework.

Behind them you can see just one of the three different wallpapers we had in that room.

PAGE 5: The Tower Ballroom in New Brighton, an enormous place with a sometimes rough crowd. It had very high balconies, and if anyone was giving trouble the bouncers hustled them up to the balcony and threw them off. You can see Eppie's [Brian Epstein] influence on the boys because they are wearing suits. They couldn't stand them, but Epstein told them, "All you have to do is wear mohair suits and smile and you'll become millionaires."

On the left is Neil Aspinall, who was then a roadie and is now the boss of Apple Records. On [white] drums is Pete Best playing one of his last gigs with the Beatles. The next week I took another photograph here [pages 82 and 83] with Ringo behind the [black] drums in a matching suit. The suit must have been made up as Pete was playing. That's how quick the change was. None of the boys actually wanted Pete to go, but if that was the way they were going to become stars....

FRONTISPIECE: Paul in the Cavern between trips to Hamburg. The girls were the true fans who used to come religiously every time the Fabs played. Paul and John once borrowed my Rollei Magic camera to take certain "experimental" photographs featuring young ladies. I've still got some of them, but nobody can pay me enough to publish them.

TITLE PAGE: A very young Michael McCartney in my bedroom-cum-darkroom with my Modern Jazz Quartet album, which Paul couldn't stand at first, but later conceded was the inspiration for one of his biggest hits. Mind you, he also hated my Bob Dylan album! Whenever I played them he would stomp off to his bedroom.

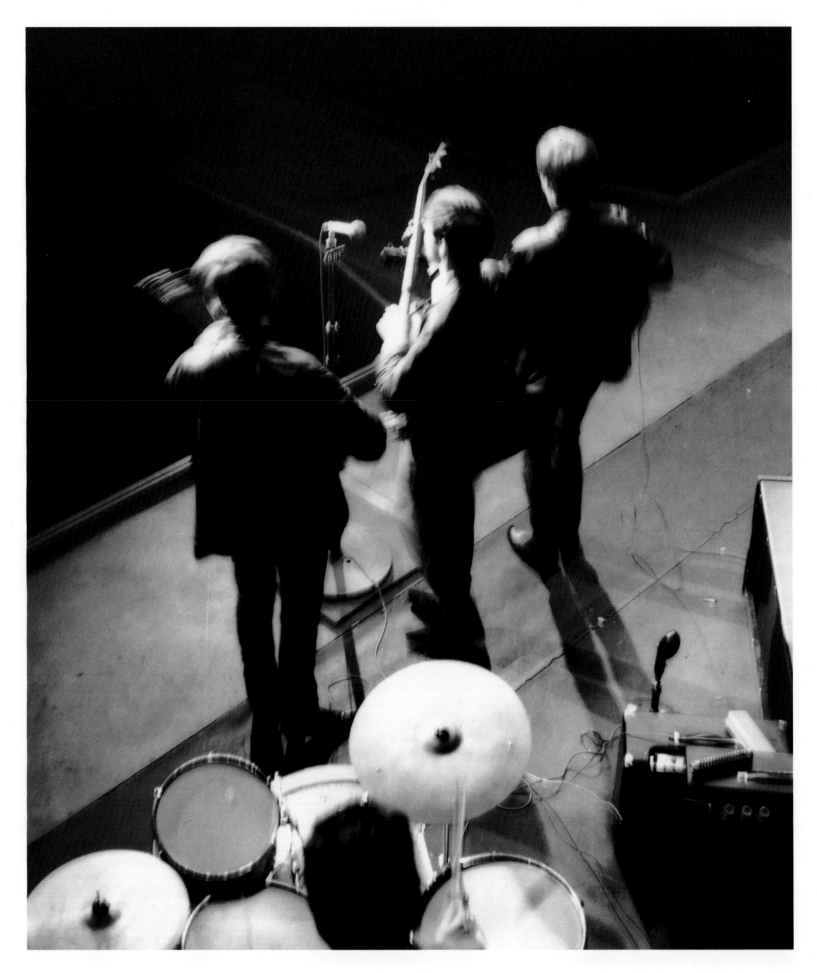

DEDICATION

This book is dedicated to Mum and Dad, Rowena and the kids (Benna, Theran, Abbi, Josh, Max, and Sonny), plus all the people who were part of or actually lived through this magic era, and all those who are still fascinated by it.

ACKNOWLEDGMENTS

"Thank U Very Much" to my printer Terry Cryer (Leeds 6, England) for his patience and expertise with my old negs; to Jeremy Pascall for ploughing through all those tapes to condense my insane dribble (or profound statements); to the National Museums and Galleries on Merseyside for allowing the use of the photographs on pages 46 and 74, taken from "MMM—Mike McCartney's Merseyside" book of Liverpool Now Images; to Ian and Jackie for all those Sunday Dinners; to Jerry Stanley and Howard Greenberg for introducing me to silk screening; to Roger (and Sue) Burrows for having faith in the whole project; and finally to Jamie Robertson for starting the whole process, by introducing me to Roger.

LEFT: **The Beatles rehearsed all day in their "scruff," then after a word from new manager Brian, they changed from jeans and leather jackets into "posh" mohair suits (see page 99) and performed live for…radio!**

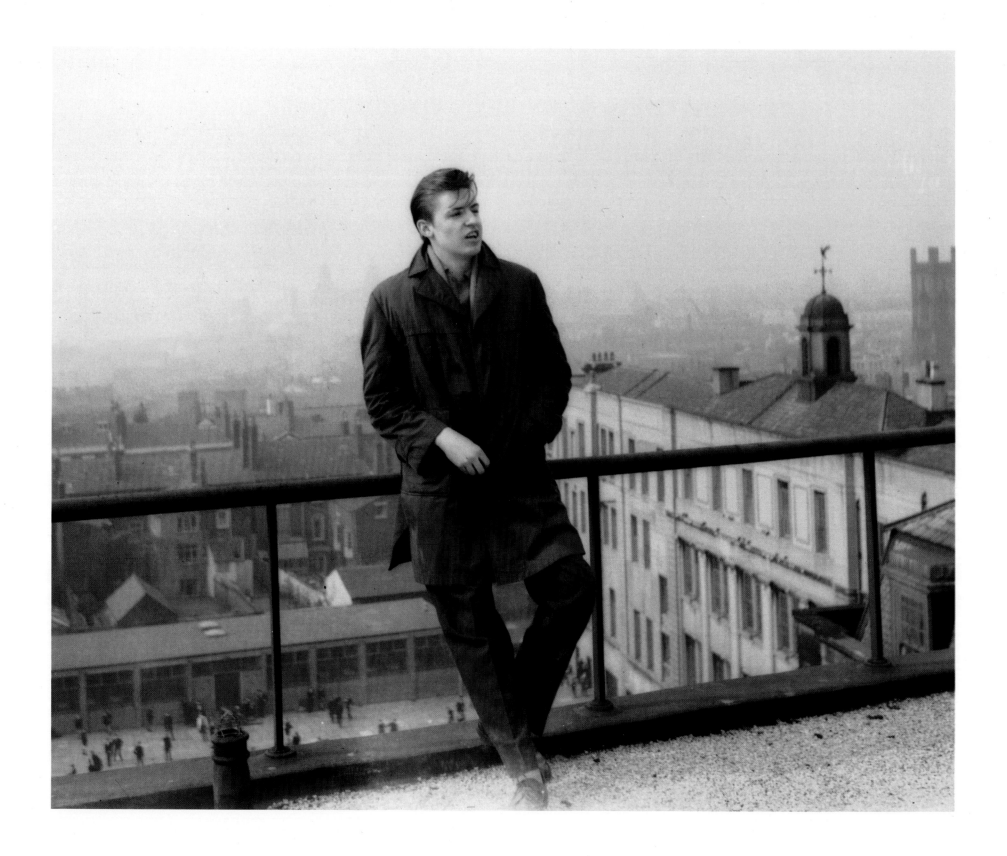

INTRODUCTION

Remember. Do you remember? After all, it *was* over thirty years ago that most of these photographs were taken. At the time, photography was more an intense passion to me than a hobby. Luckily, instead of the cat or Granny in her rocking chair, I had the raw, working-class, down-to-earth reality of Liverpool and my family, plus my elder brother and his fab chums to practice on. There was also the odd passing rocker (and some were very odd!).

Images of all those yesterdays ago, captured by an intense young man and now encapsulated for *historic* purposes. Remember? How could any of us who were part of that unique period in time ever forget?

Looking at these photographs, Dave Putnam (fast-speaking, brutally honest megastar film producer) felt the "shock recognition of not just haircuts, clothes, and instruments, but more importantly, the well-remembered sofas, curtains, and even wallpapers of the late fifties and early sixties."

Looking at my own photographs again after all this time, some of which I've not seen for thirty years, the memories flow back: the miracle appearance of my first *successful* 2¼″ print (The first one went black! So, back to the drawing board, or in my case, back to the Allerton Library books to learn my trade); Brylcreeming my hair back, then pulling it forward to look like Elvis; struggling to pull on my "permitted" skintight jeans; practicing Everly Brothers' close harmonies with my brother. (Years later, at "Buddy Holly Week" in London, with the actual Everly Brothers' assistance, we figured out that in harmonies, he was Don and I was Phil.) Memories of Dad's family sayings repeated over and over again,

LEFT: Overlooking a foggy Liverpool, Mike 'Elvis' McCartney posing on the Art School roof. At the school, twenty-five years later, I started the silk-screen printing process with Rex Edwards. The building in the background is the Liverpool Institute High School for Boys (the 'Inny'), which was closed down by militant politicians, but with Paul's intervention is due to reopen as "LIPA"—Liverpool Institute School of Performing Arts.

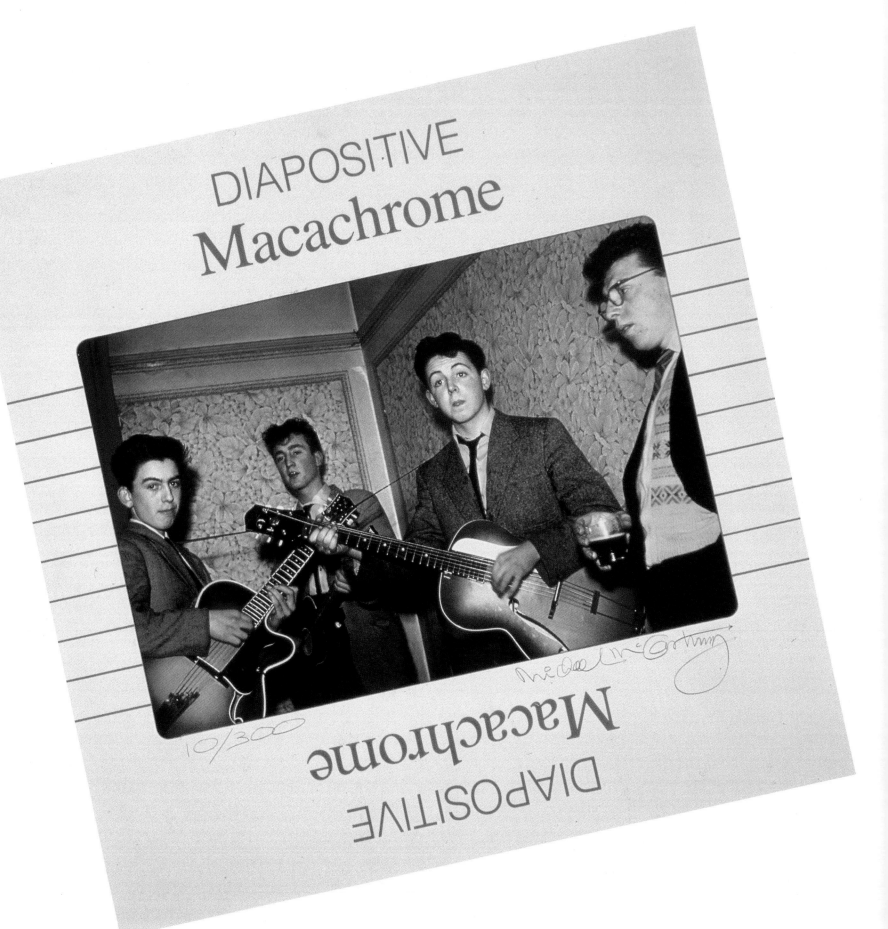

DIAPOSITIVE

Macachrome

10/300

Macachrome

DIAPOSITIVE

14

just as I repeat them now to my poor kids; hearing Little Richard's earth shattering voice for the first time; John (Lennon) betting I wouldn't dare ask Bruce Channel to autograph his hand-out picture "To *Bruce* McCartney, please." (And I've still got it!)

All a long time ago, but *I* remember.

A time when the roots your Liverpool parents and family gave you were firmly planted in the working-class standards and ethics of Right and Wrong, etched out of the poverty they were determined to escape. But this upbringing gave us the backbone of life and the rock (and roll) upon which we could build our future.

But times change, not always for the better. John's murder brought this home to all of us. As time is so short (ask Mum and Dad, Gin and Harry, Millie and Albert, Tara, Eppy—and John), please feel free to use this book to go back and remember the *good* times. Don't forget—remember. As Dad would say, "God bless your cotton socks."

—Peter Michael McCartney

LEFT: **With a slight twist on Kodachrome, I turned the first-ever color photograph of the Beatles [see page 34–35] into a "macachrome" and gave it to Paul as a Christmas present.**

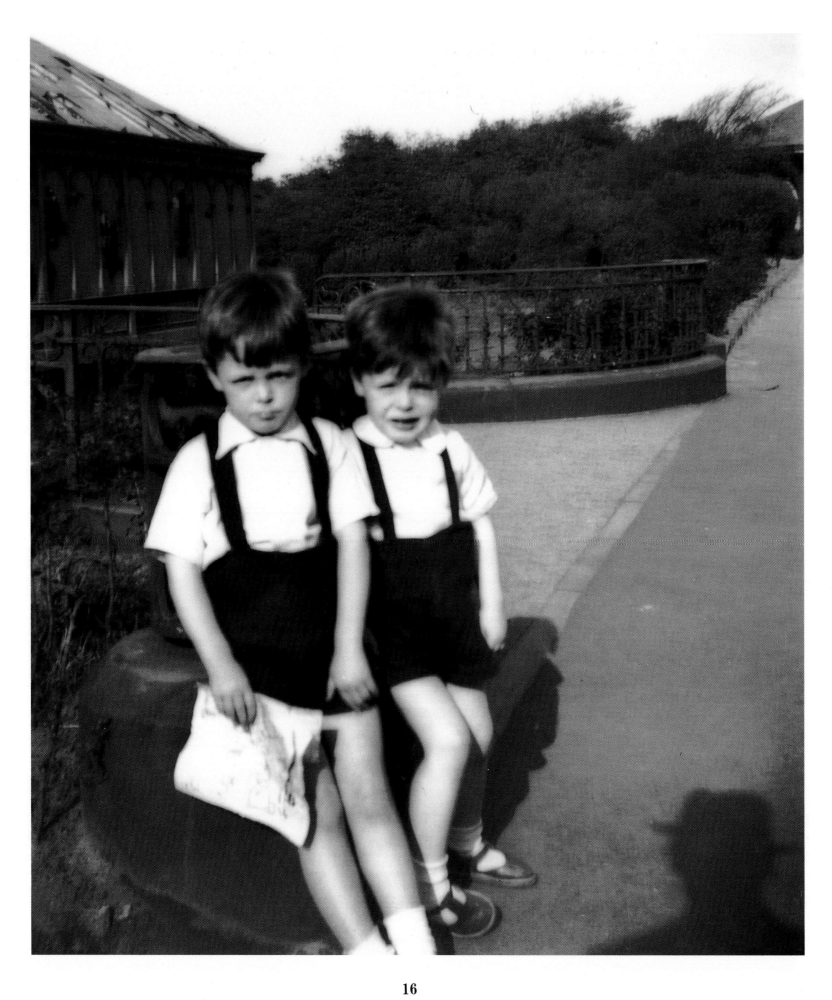

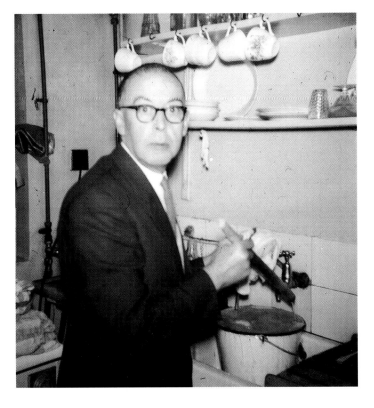

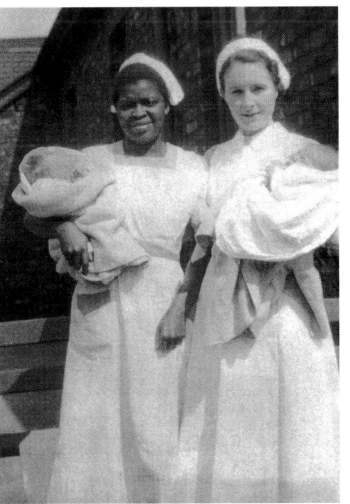

OPPOSITE PAGE: The two lads, dressed as twins. I love this photograph, taken by Dad, because you can see his shadow in the bottom right-hand corner. It transforms the photo into a Magritte painting.

TOP LEFT: Dad in the kitchen washing "the smalls"—undies—in a bucket. No washing machine in those days, just a bucket and a mangle.

This was after Mum's death and my aunties—Milly and Gin—told him how to do the housework.

Notice how dapper he looks. He's dressed in his business suit (he was a cotton salesman), so this was taken (with my new flash) either early in the morning before he went off to work in the Cotton Exchange or just after he'd returned home.

BOTTOM LEFT: A lovely photograph. My mum—the one on the right—outside Walton Hospital, where she was a nurse and where Paul and I were born. Being the first son, he got a private ward, but I didn't.

This was taken before the war and before Mum married Dad. After the war she became a community midwife. I remember her going off to bring babies into the world on her little bike with a box on the back and a wicker basket on the front.

My second daughter, Theran, is the only one of the family who has followed my mum; she's just become a staff nurse in Guys Hospital in London.

It's also interesting that there's a black nurse with Mum. Liverpool has always had strong black and Chinese communities. You probably wouldn't have seen a black nurse in London before the war. I'd love to know who this nurse is. If anybody recognizes her, please get in touch, because I'd like to know more about my mum.

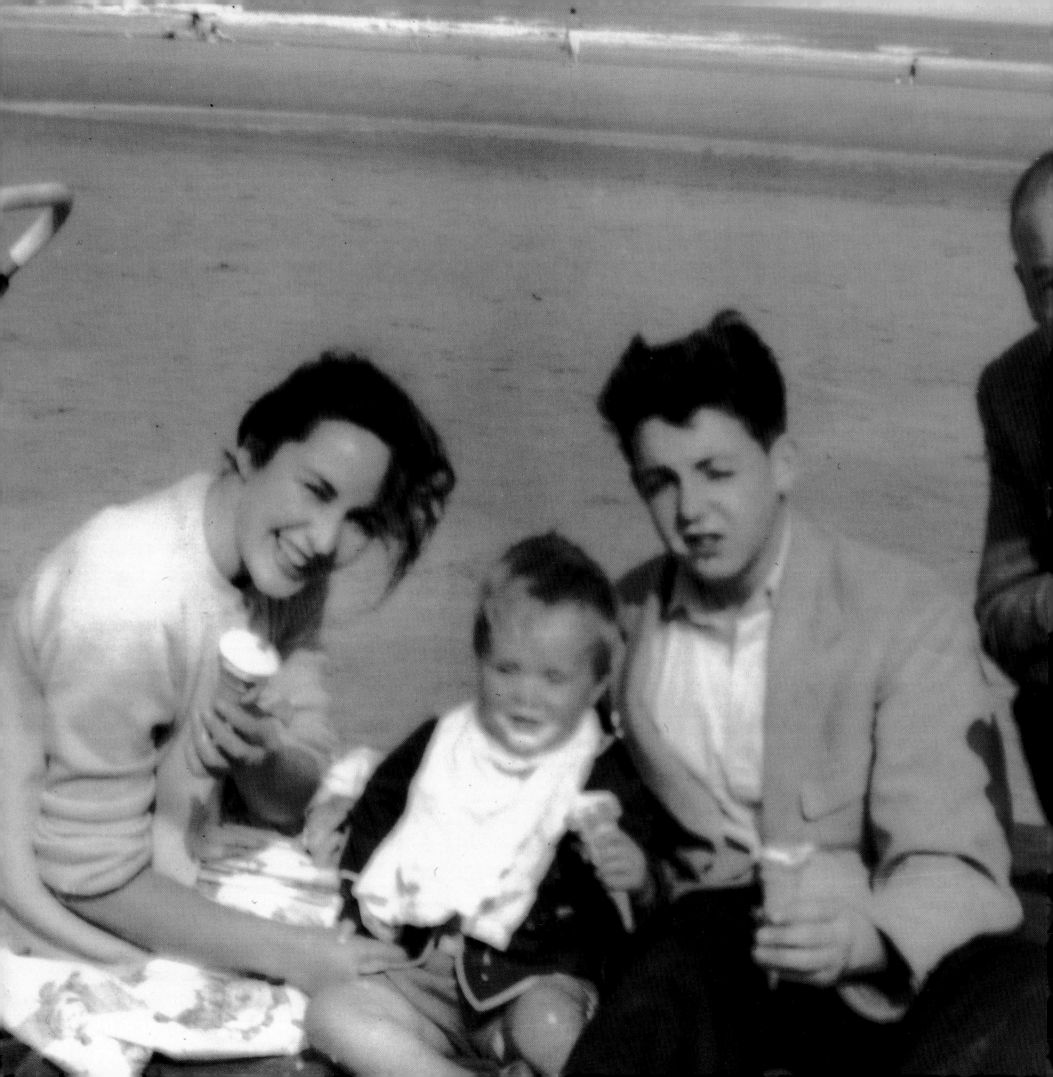

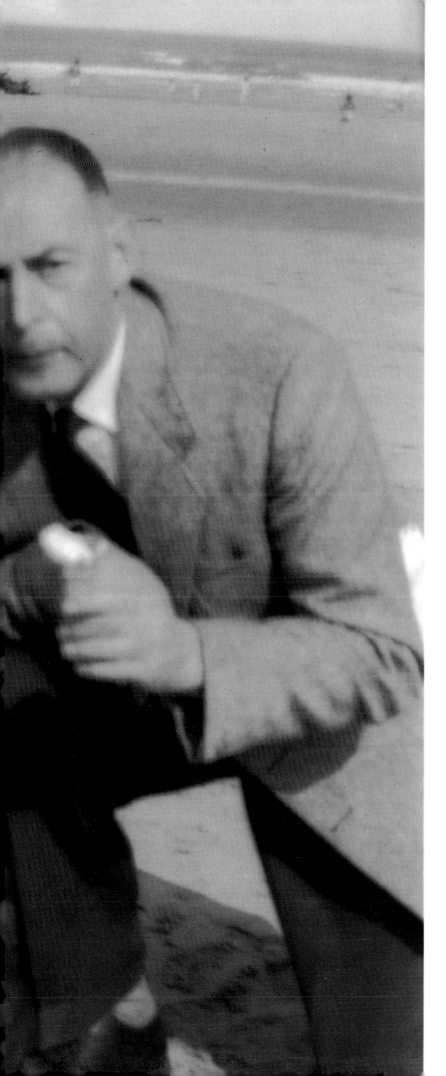

On the left is my Cousin Bett, the daughter of Dad's sister, Annie Mac. Bett and her husband Mike Robbins were Red Coats at Butlins' Holiday Camp. The baby is her son, Ted. Ted and his sister Kate both went into show business. Ted is a comedian and Kate had a big hit song in 1981 with "More Than In Love." She's a frighteningly accurate impressionist and supplies many of the voices for "Spitting Image."

Dad [on the right] was known to everyone as Uncle Jim or Jim Mac, and I told Martha Reeves when she visited Liverpool that when she sings her hit "Jimmy Mack", she is really singing about my dad.

19

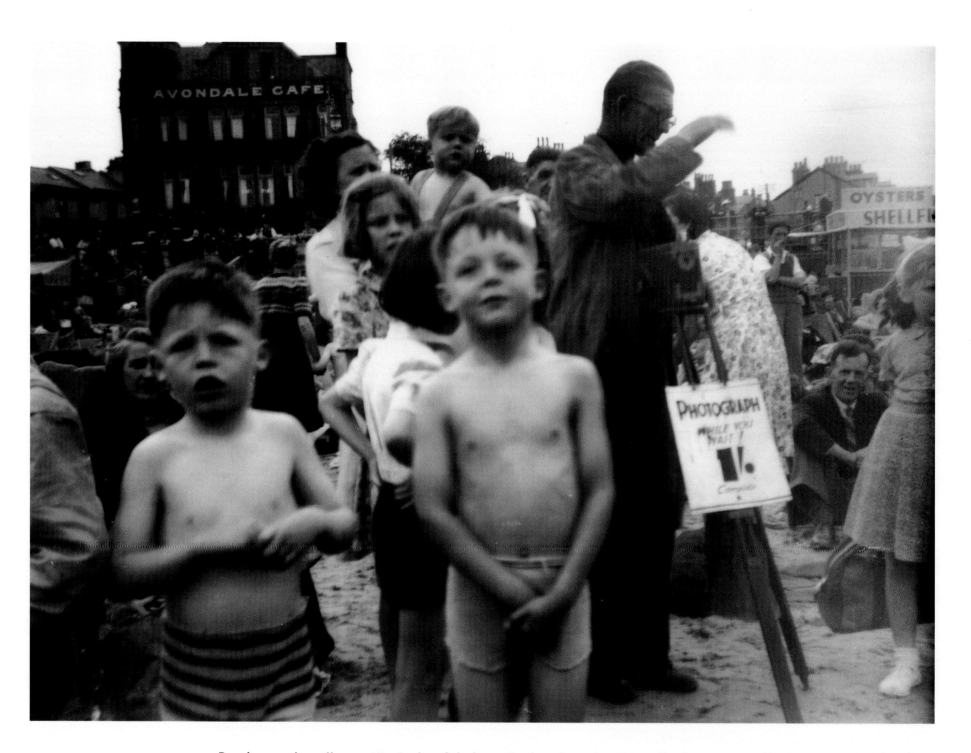

Beatle people will say, "Isn't that fabulous, Paul and Michael are so young." My photographic printer doesn't even notice us. He says the most important aspect of this photograph is the "Photograph While You Wait" photographer. "This is history," he says. "There aren't many photos of a Tin-Type photographer at work."

This was taken by Mum or Dad on our Kodak Box Brownie, which I was occasionally allowed to use, and that's what got me into photography. What I remember best of this time are the cozzies [bathing costumes]. They were made of wool, and as you went through the water they became heavier and heavier until they'd start slipping down and eventually the bloody things came off.

We were typical brothers, always fighting (and we still are). Paul was bigger and stronger than me at first, and when he started to put on some puppy fat, the only way I could get back at him was by calling him "Fattie."

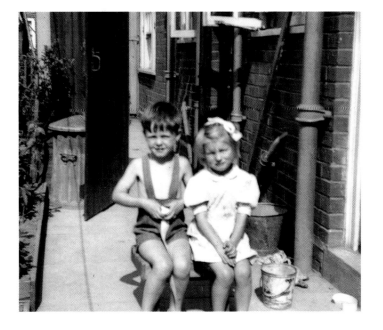

TOP LEFT: Paul with the little girl next door in Western Avenue, Speke, looking very innocent. This was probably taken by Dad, although he may have let me loose with the Box Brownie.

Paul looks angelic and we remember ourselves as being angels, but to this day Uncle Joe says we were ''two right little swine.'' In next-door's garden there was an apple tree and we would lob bricks at it to get the apples off. We were amazed when the man next door complained to Dad about our stealing his fruit. We protested our innocence, but the bricks on the other side gave us away!

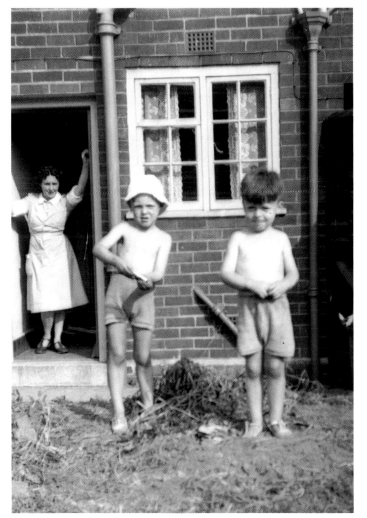

BOTTOM LEFT: Mum in her midwife's uniform in the garden of Western Avenue. There are not many pictures of Mum; I wish I could have taken loads of her.

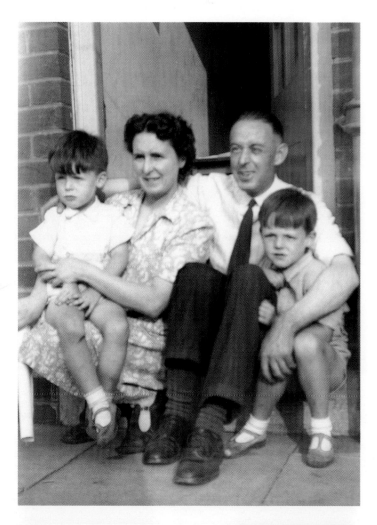

TOP RIGHT: This is one of my favorites; I've got a copy of it hanging in my lounge. Very typical of Jim and Mary. Dad with his arm around Paul and Mum with me on her knee. Despite having very little money we were always nicely turned out; that was very important to Mum.

According to Beatle history, the mop-top haircut was invented by Astrid Kirchherr and Klaus Voorman in Hamburg, but looking at this, I think we beat them to it by years!

BOTTOM RIGHT: Uncle Albert and Auntie Millie. Millie and Ginny were my dad's sisters, and when Mum died, Uncle Albert and Auntie Millie would come on the Monday of one week and Auntie Gin and Uncle Harry would come on the Monday of the following week. They would cook a proper roast for their own families on Sundays, and on Mondays, they'd do the same for us.

They came a long way by bus and ferry to look after us. After the meal they did the ironing, which you can see on the clothes horse behind the settee. No wonder they were exhausted.

Paul immortalized Uncle Albert in his hit "Uncle Albert/Admiral Halsey," which got to number one in the States. He also got Auntie Gin, Cousin Ian, and me in his hit "Let 'em In."

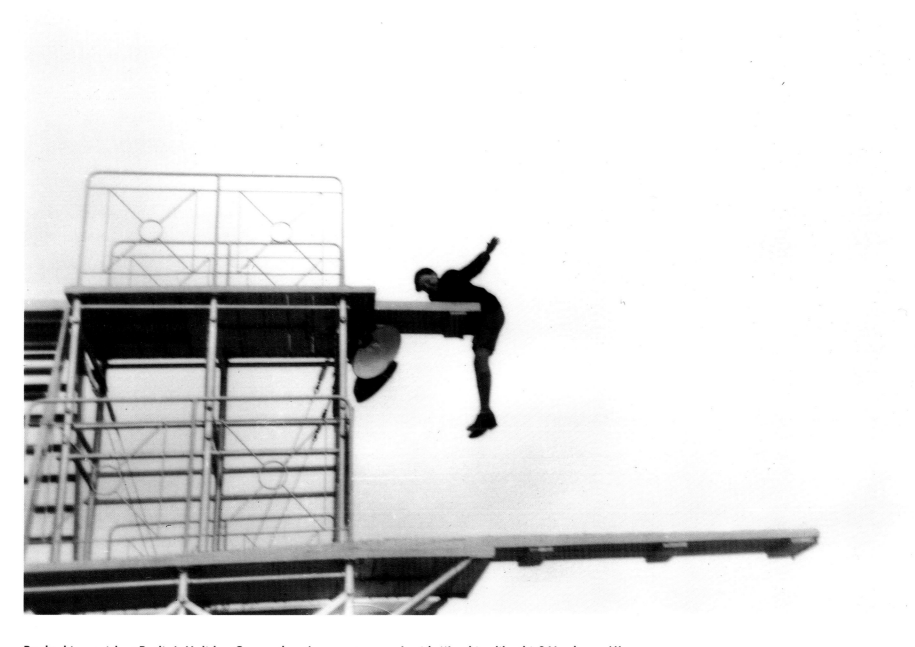

Paul taking a risk at Butlin's Holiday Camp; there's no water in the pool—it was a concrete grave below! After I'd broken my arm, we went to Butlin's, where Cousin Bett's Mike [Robbins] was a Red Coat. I was very pale after being in hospital for a month and had this dead fish on the end of my arm—my hand lying in a sling. Mike organized the concerts and asked Paul to do a turn. He didn't want to go up alone so he tried to persuade me to join him in an Everly Brothers song.

I said, "Looking like this? No chance!"

That afternoon Mike brought Paul onstage. Paul whispered to Mike, and the next thing I heard was Mike calling my name.

So I had to go up, and we sang "Bye Bye Love." As soon as we'd finished and Paul's confidence had returned, he shoved me off and went straight into his Little Richard routine.

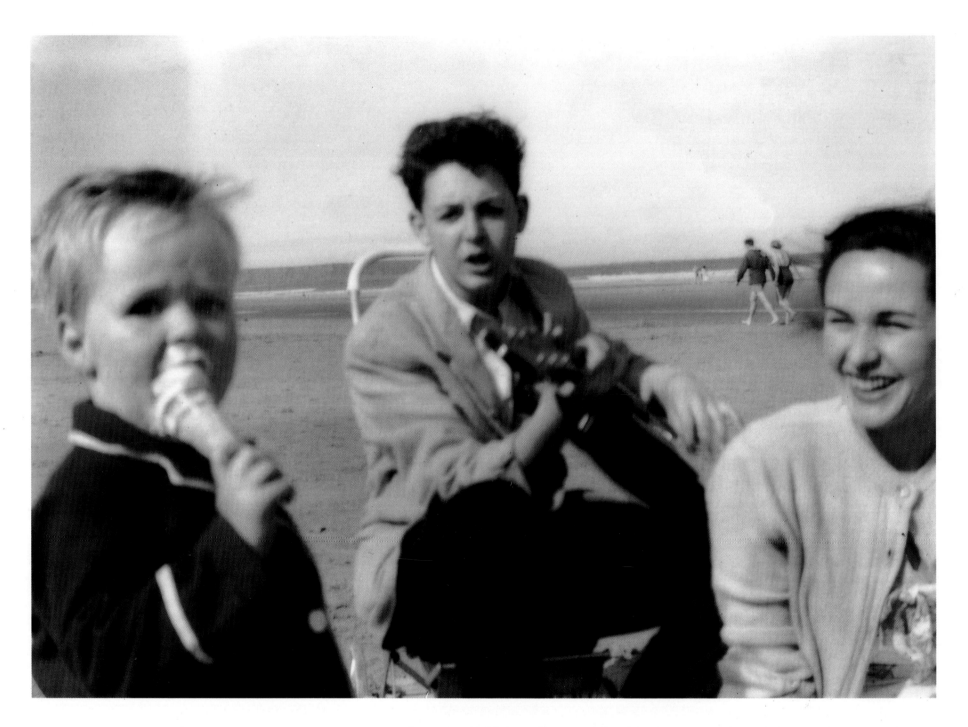

Cousin Bett Robbins and her son Ted with Paul sitting in Ted's pushchair. By this time Paul was so obsessed with the guitar that he took it everywhere—the bogs, the bus, and even the beach.

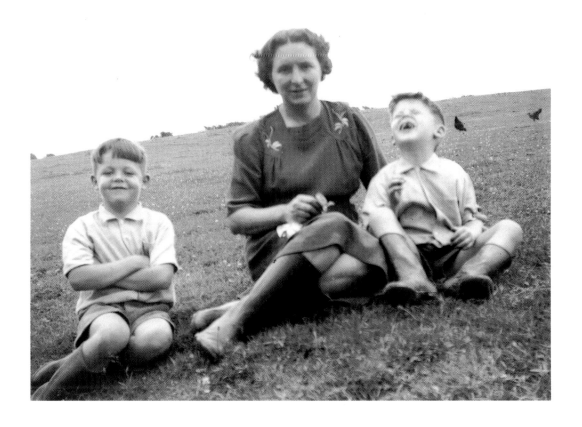

The family on a farm holiday in Wales (note the looney on the right). These photos were used in the television film of Paul's *Liverpool Oratorio*. Dad puffing the pipe, which Paul and I at a later date would fill with tea leaves and try to smoke! At Christmas, if we could afford it, Paul and I bought him a posh Havana cigar. He used to put lavender (which he grew in the garden) into the ashtray, and I remember the wonderful smell wafting through the house when he let the cigar burn away in the lavender.

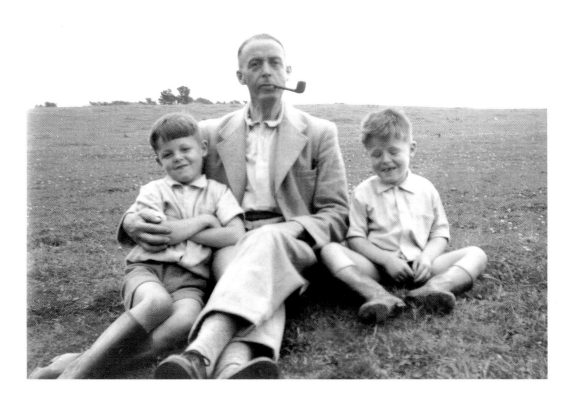

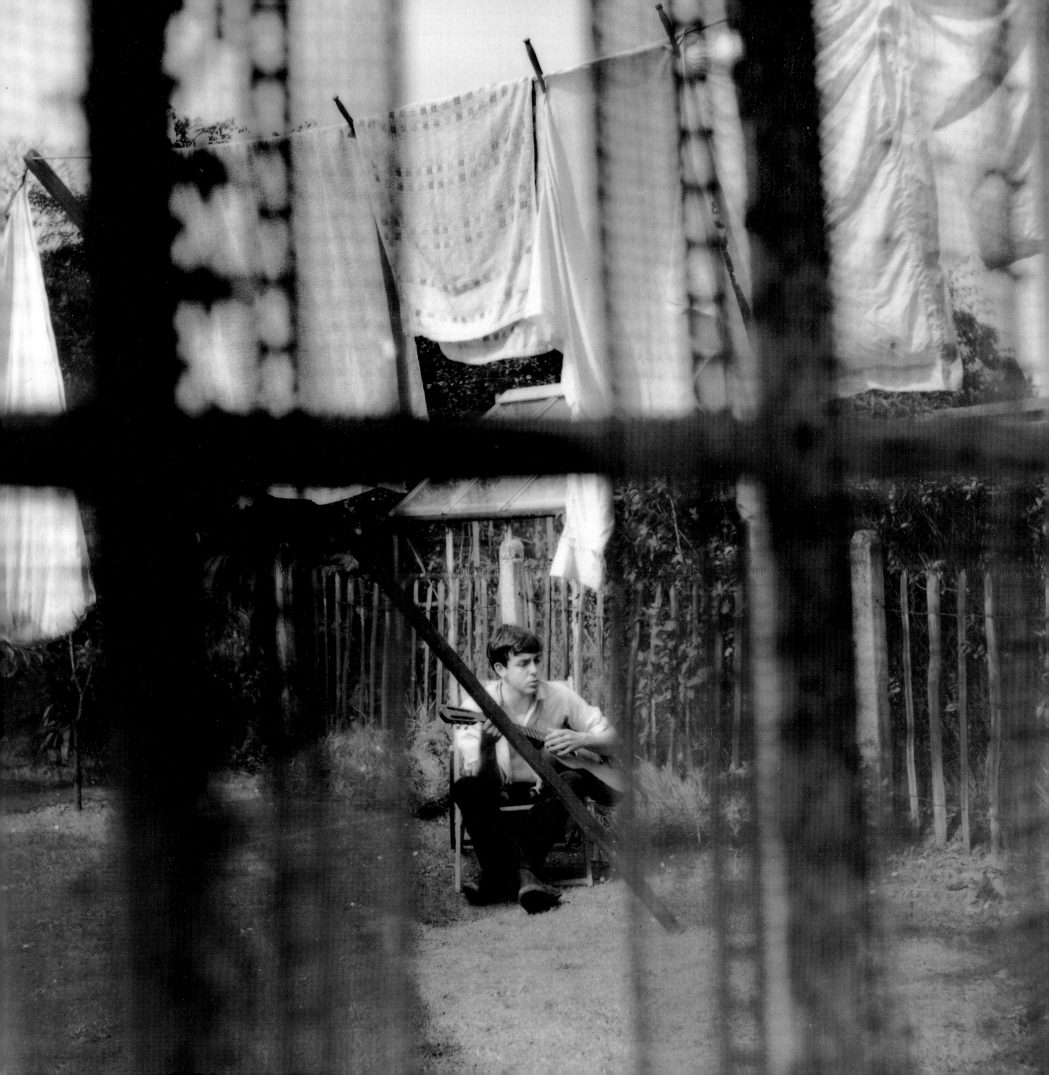

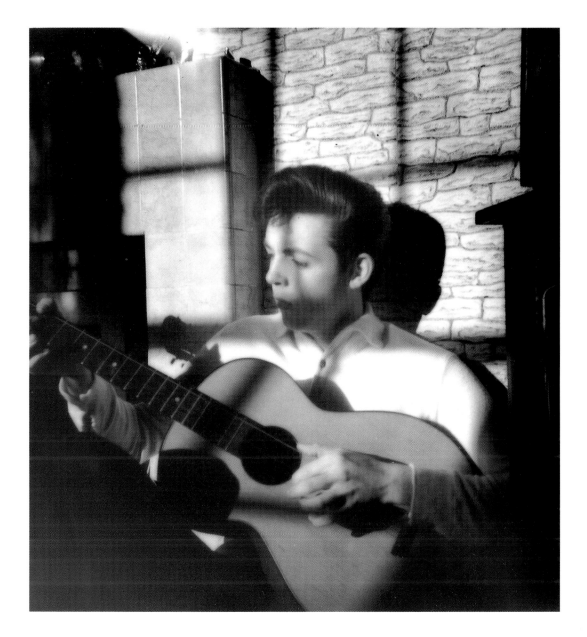

LEFT: While he was in Hamburg, Our Kid sent a letter saying, "I've bought you a Rollei Magic camera, the same as Astrid's. You can ENLARGE the photos and the subject looks Fab Gear." (So that's who started it all!) That's why he bought me the camera—so I could make *him* look great. But I wasn't complaining. I got a "professional" camera out of it. In the books, it said you should never take photographs into bright sunlight. Every now and again I break the rules. This is one of them. I thought, "Sod it! if it doesn't work, it doesn't matter." But it did work, and produced a very interesting image.

LEFT: The back garden of Forthlin Road taken through Mum's net curtains. Paul is playing his first guitar. Dad always wanted us to play instruments because he reckoned music was a passport out of poverty. Earlier he'd paid for piano lessons for us with Mr. Milne (who now teaches at my daughter's school), but we had better things to do with our time. As soon as Paul became interested in the guitar, Dad went out and bought him one. I got a banjo.

This was taken just after our Mum died. He was fourteen and I was twelve and it was impossible to rationalize that someone we'd had a very strong love for had been taken away. As soon as Paul picked up the guitar, he'd go into a world of his own. It was his way of getting on with life. With me, it was taking pictures.

My wife, Rowena, was looking at this photo and said, "Have you noticed the towel above Paul's head?" To me it was just a boring towel but she spotted that it featured in another photo at the Tower Ballroom [on page 52]. After she pointed it out to me, I used it as a motif in my silkscreen prints [pages 56 and 57].

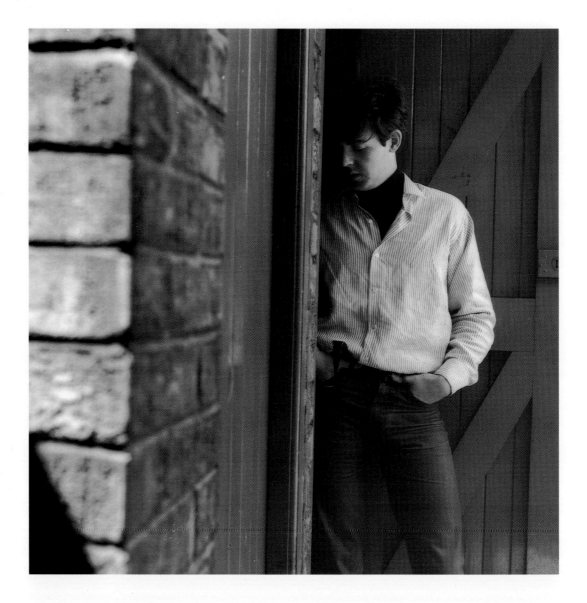

RIGHT: A moody, magnificent Paul McCartney pose. What he's actually doing is gazing into the outside toilet! He's wearing his David Frost "That Was the Week That Was" shirt, so this would be around 1962.

Before the Beatles really happened, Paul wanted me to take photos that would make him look fab or famous. The boys all practiced being famous. They'd come up to me and say, "Make us look like Elvis."

In those days, they were desperate for fame and I'd take their photos because I was desperate for willing models. By the time fame arrived they were ready for it (all helped, of course, by my fastidious preparation).

RIGHT: Paul with a drum kit that "fell off the back of a lorry," which means we didn't ask any questions about how he got it.

I think he acquired it for me so that I could be the drummer in the group. I didn't become a Beatle because at scout camp I imitated Tarzan by swinging through the trees. Unfortunately, I swung *into* a tree and spent a month in hospital with my broken arm in splints. When eventually they took the splints off, my left hand was paralyzed and it took years for me to regain full use of it.

In the meantime, Paul practiced on "my" drums and became very proficient. Then, of course, they found Pete Best and, eventually, Richie [Ringo].

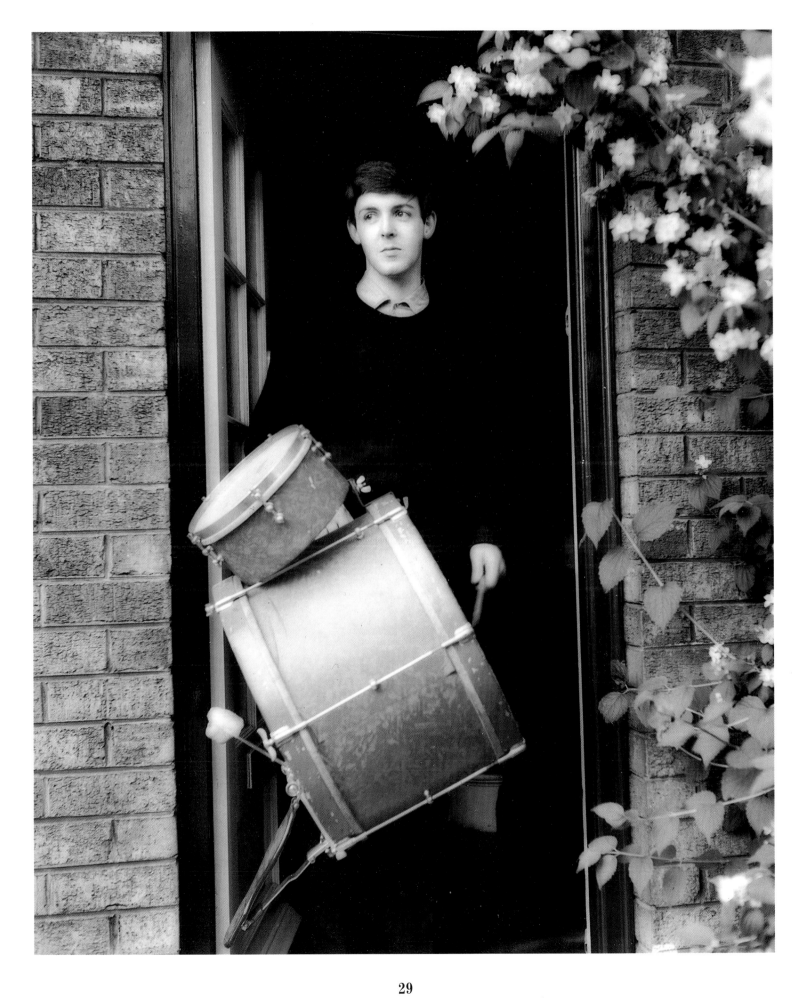

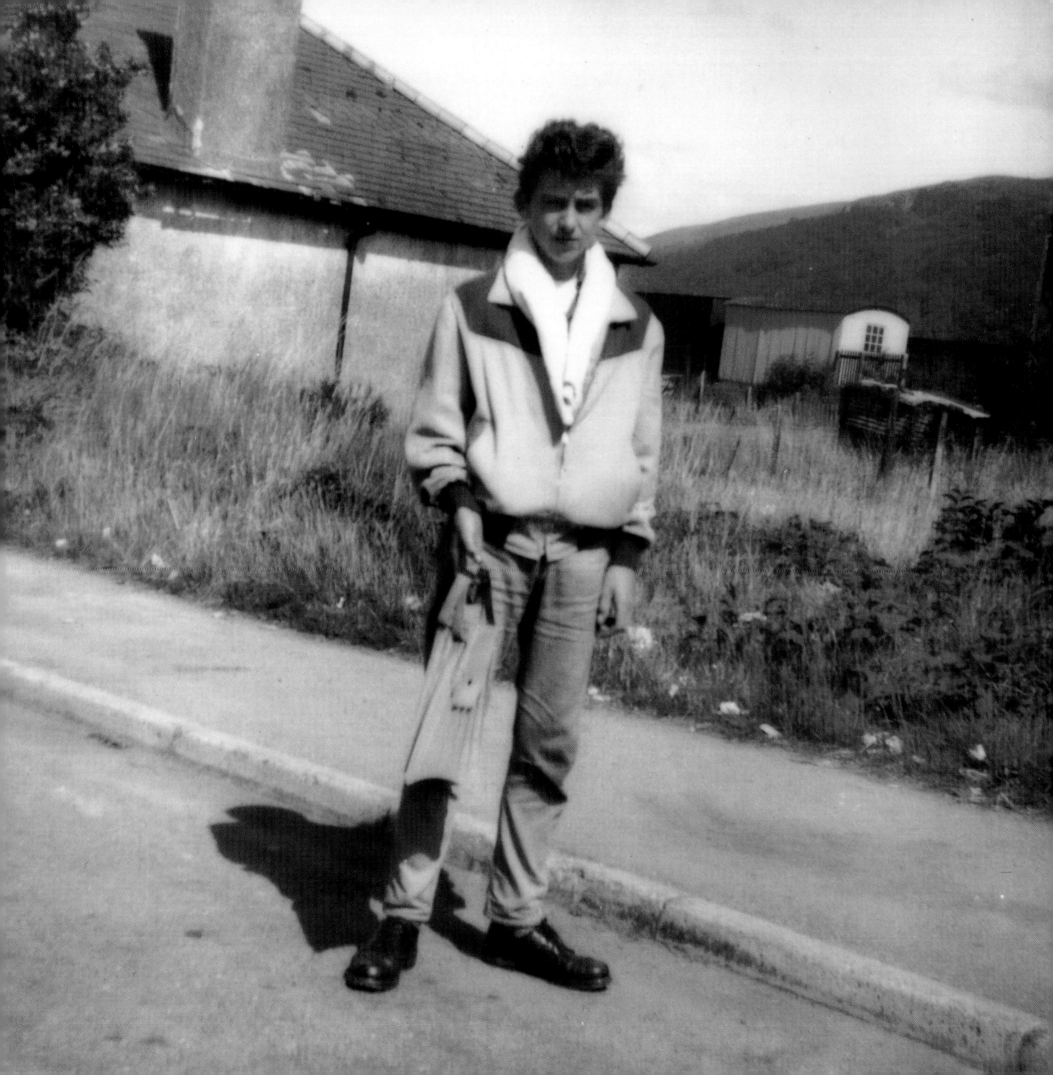

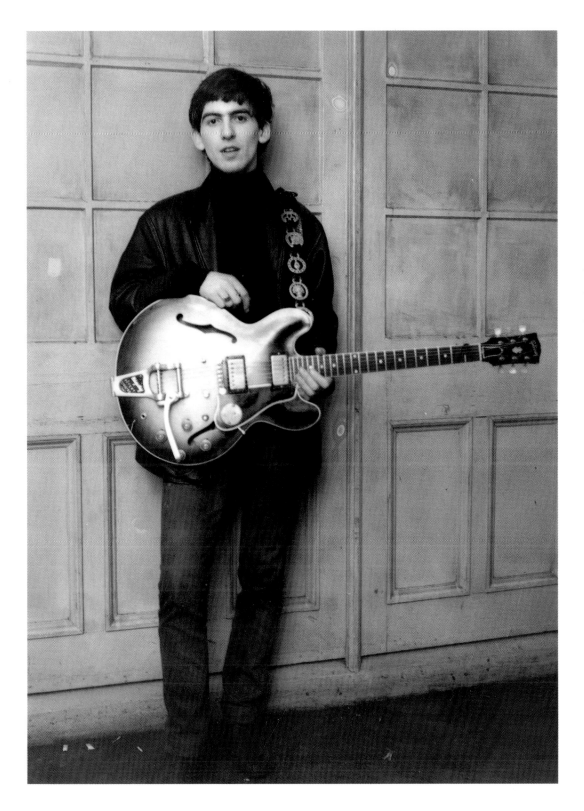

LEFT: George in the Tower Ballroom, New Brighton, when the group was warm-up band for Joe Brown and the Bruvvers. George was going past their dressing room and saw Joe's guitar. He shouted at me to take a quick photo of him with it, while Joe was in the toilet. Joe didn't know anything about this photo, but years later Paul told me it was one of George's favorites; by then George and Joe Brown were big mates.

Later I used this image in a silk-screen print [pages 62 and 63].

LEFT: A young George Harrison with his Tony Curtis haircut, bright fluorescent green waistcoat (under the towel), and skintight jeans. He's carrying flippers, so he must be off to the swimming pool or the sea. This would be around 1958 or '59, when George, Paul, and John were in the Quarrymen skiffle group. I thought I'd taken this photograph, but Paul rang up to complain, "Hey you bugger lugs! I took that one!"

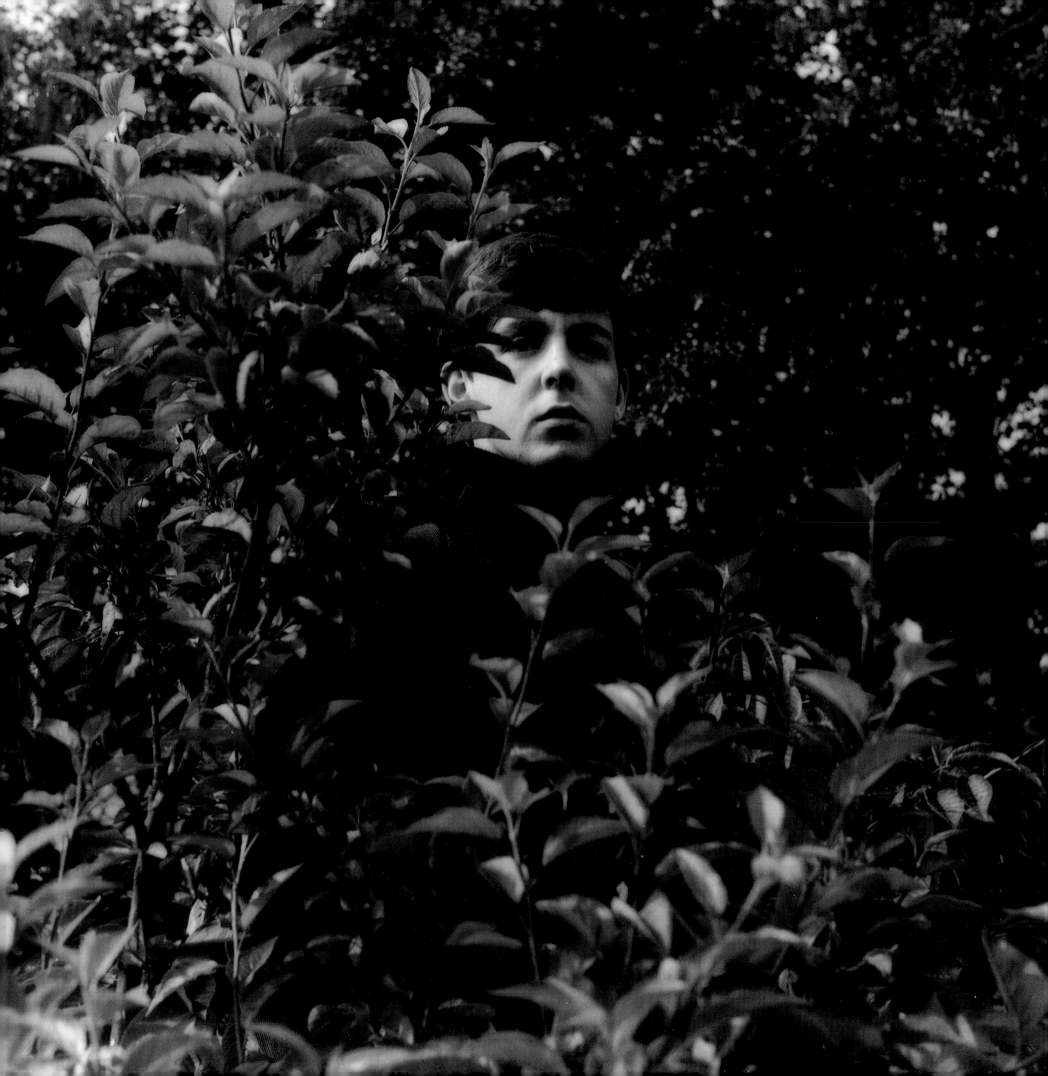

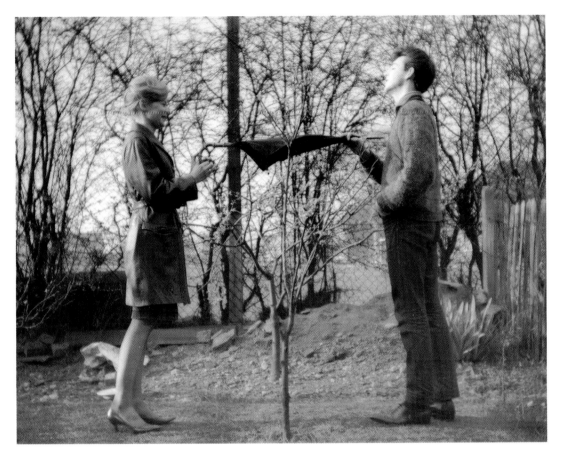

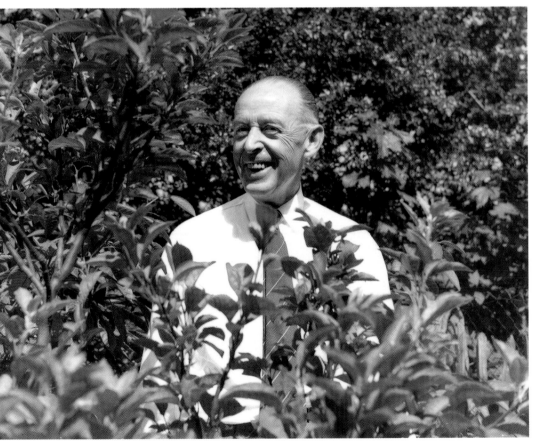

OPPOSITE PAGE: This is another of Paul's "make me look famous" poses, taken in our back garden. The two of us collaborated on his image building, and this is similar to the photographs other people took of the Beatles after they'd achieved stardom.

TOP LEFT: A winter shot in our Allerton back garden. The girl is Dot Rohne, who was Paul's girlfriend at the same time John started going out with Cynthia. Nobody knows about Dot. A very nice, simple, shy girl who didn't want any of the bullshit surrounding the Beatles' stardom. As soon as they got famous, she retired from the scene.

BOTTOM LEFT: The Ex-Secretary of the Speke Horticultural Society—my Dad, planted firmly and smiling broadly in the middle of his prized apple tree in the Forthlin Road back garden.

FOLLOWING PAGE: "John, Paul, George, and...Dennis." Dennis was Cousin Ian's best friend. Three very eager skifflers looking for stardom, and Dennis looking for anonymity —Dennis made it! Them with their guitars, him with his half-pint of Guinness and Fair Isle cardie.

I gave a "macachrome" version of "Dennis" [see page 14] to Paul as a Christmas present a couple of years ago and told him to note the beer stains on his collar and John's shaving rash. ("Shaving rash, my arm," came the reply. "He was bevied.") They're very, very young; George is about fourteen. We're at Auntie Gin's house for her son Ian's wedding.

This is the first-ever color photograph of the Beatles.

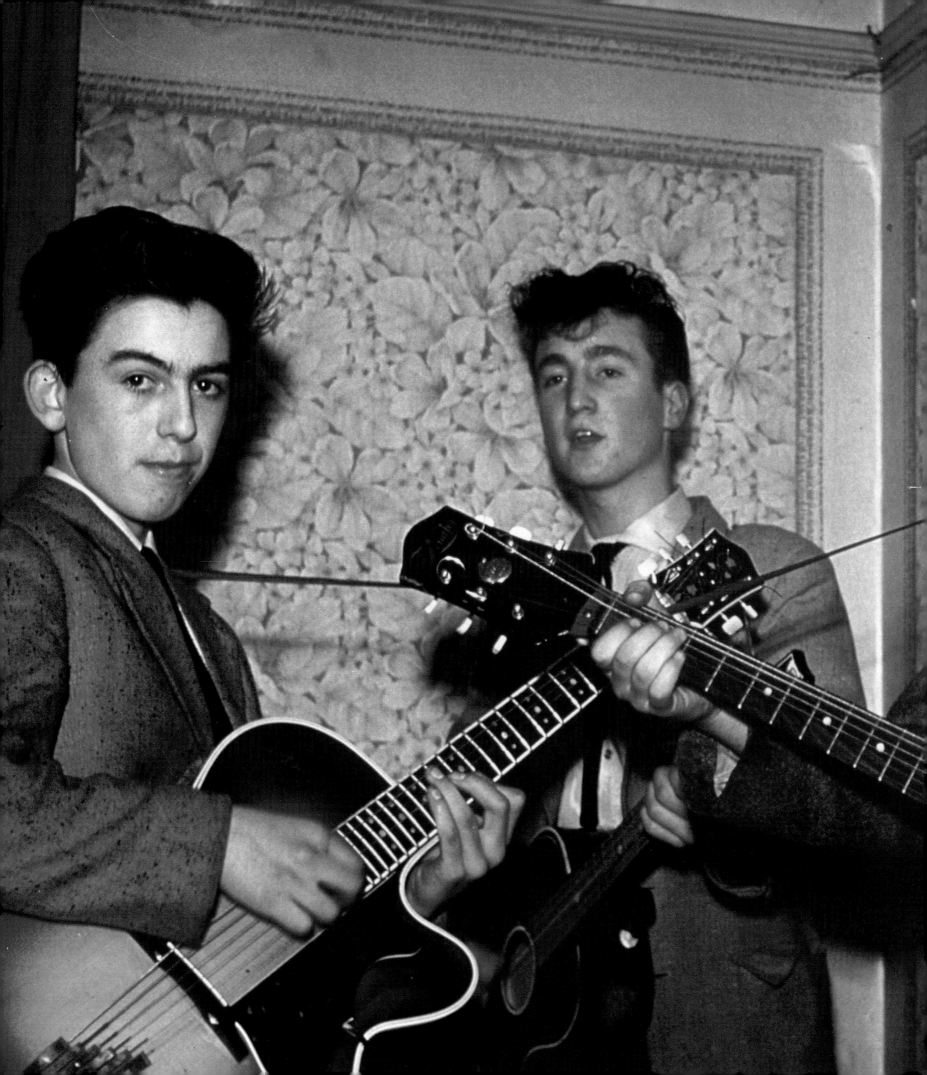

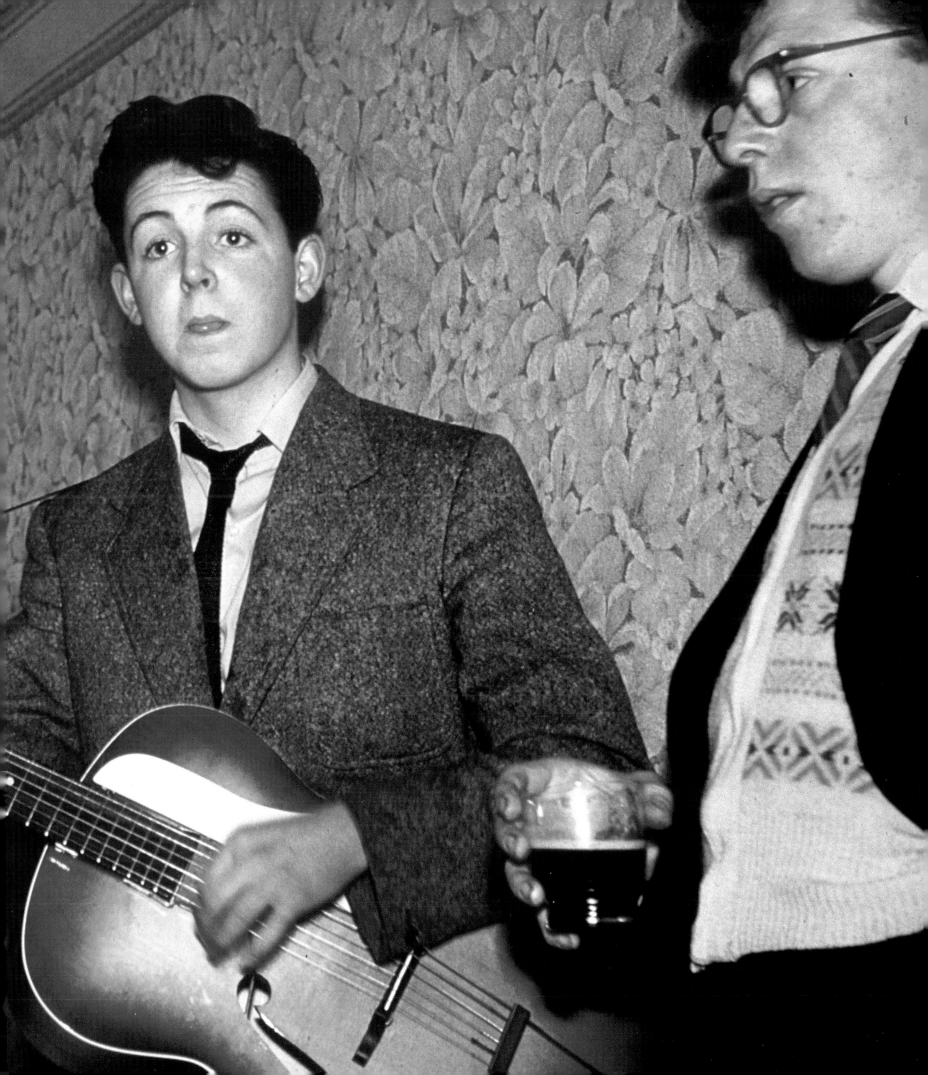

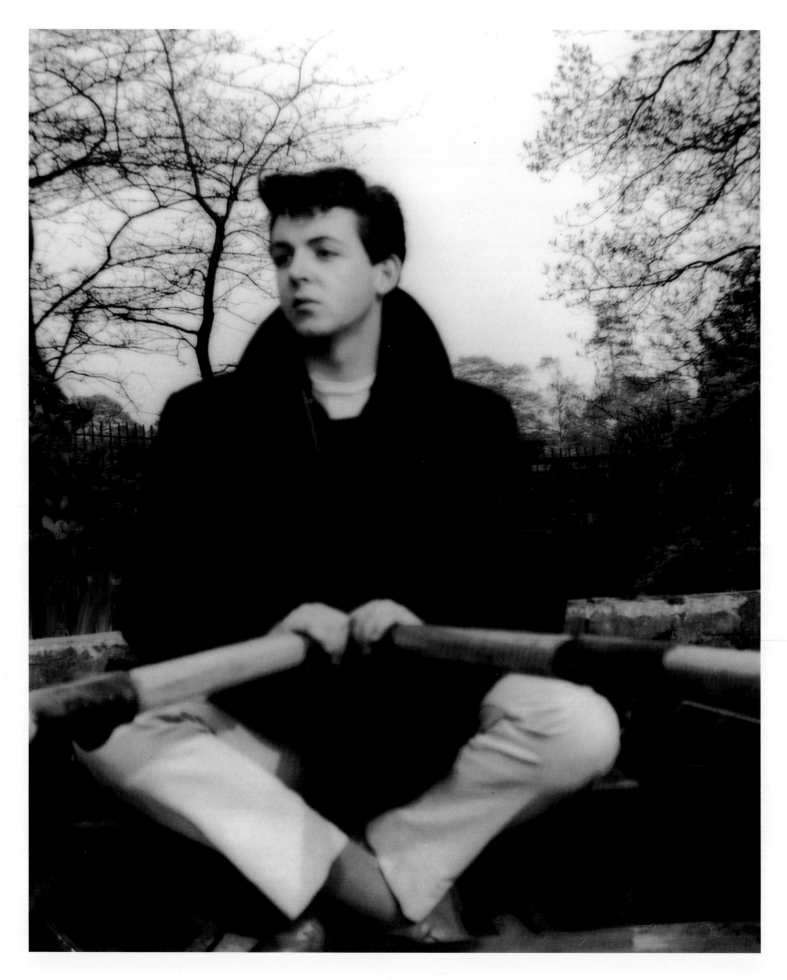

LEFT: Paul posing in a rowboat on the lake in Sefton Park. He's in his Elvis period, and I think I took this with the family box camera. Not a bad result, considering.

PAGE 38: Brother looking at winkle-picker shoes, which he couldn't afford. This was taken very early in the morning waiting to get the first bus home after an "all-nighter" at the Cavern. Paul had come out of the club, sweating from playing all night, and it was freezing cold with the wind from the Mersey whipping down Castle Street.

PAGE 39: Paul with "my" drum kit. He's nicked it by now and put a handwritten sign on the bass drum. Recently I saw an old picture of my dad's band, and he had a hand-painted sticker saying "Jim Mac's Band" on *his* drum.

Paul sitting on Dad's piano with my banjo in between his first guitar on the right and a more recent guitar on the left. But the oldest instrument here is the trumpet. It originally belonged to Cousin Ian but he wasn't getting on with it so he gave it to Paul, who managed to tootle a tune. It was Paul's first instrument, even before the guitar.

For those interested in wallpaper, you can see the second of the three patterns we had in this room.

PAGE 40: The Fabs with Pete Best in the dressing room of the Cavern, just before going onstage. Pete was the Jeff Chandler of Liverpool, a very good-looking lad. Nice man, quiet and shy. I feel sorry for him missing out on all the money. My joke theory is they threw him out because of the gray socks he's wearing in this picture.

There's a lesson about fame here. If you want to be famous, you must obey the photographer. I climbed on a chair and told them, "When I say 'go,' all look up at the light." *Two of them got it right.*

PAGE 41: Astrid Kirchherr, John, and Stu Sutcliffe outside the Cavern. The Beatles met Astrid in Hamburg, where she and Stu became engaged. They always looked magnificently cool—black polo-neck sweaters, narrow tailored jeans.

Stu was our James Dean, and Astrid was a waiflike figure who looked like Mia Farrow. She was a very good photographer and took great shots of the Beatles in Hamburg. Of the photos taken at that time, I rate hers first and mine second. Mind you, coming from a well-to-do family, she could afford a bit better equipment than I could. She and Stu were heavily into existentialism and everything they did was full of symbolism; when George was ill in Hamburg they took him *one* red rose.

Stu was wearing this strange German jacket that had no collar and the Beatles took the piss out of him for it. Of course, as soon as they became famous they "borrowed" the idea and wore jackets with no collars. Stu came back to see his family at Christmas, 1961. I remember he was looking terribly pale. The following April he died of a brain tumor.

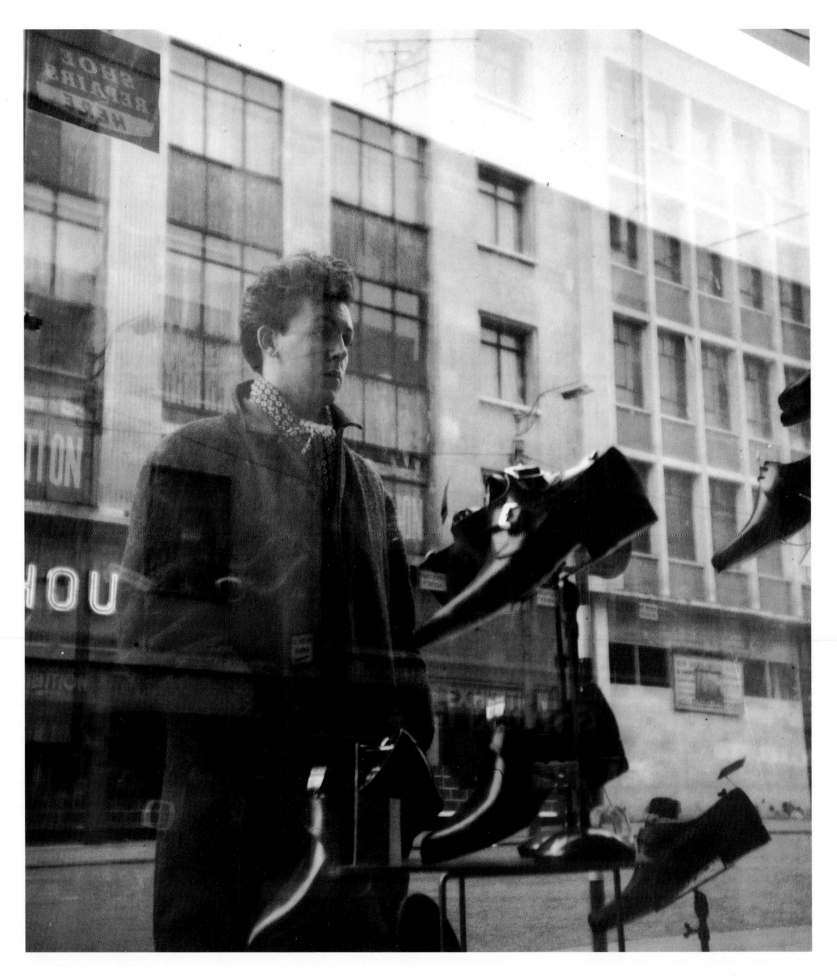

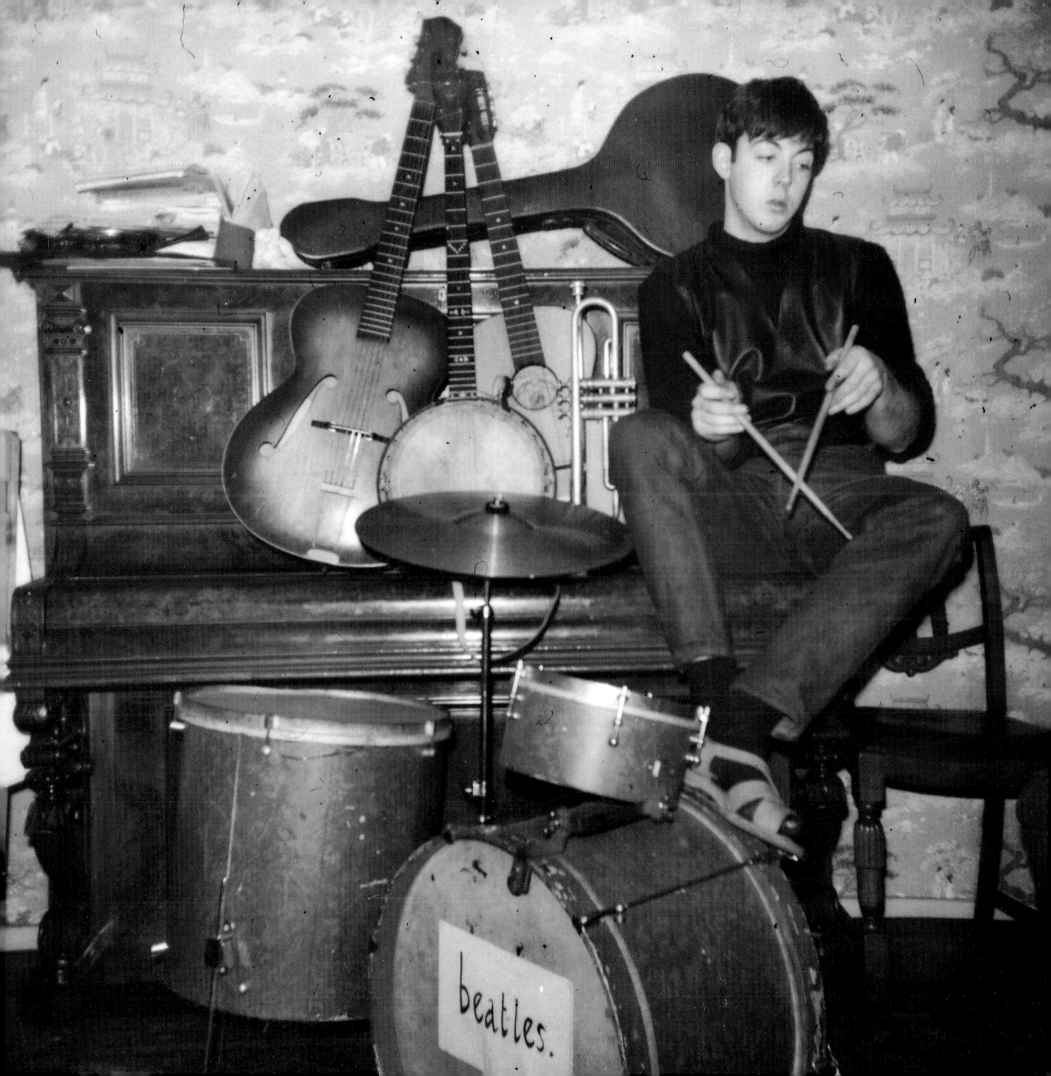

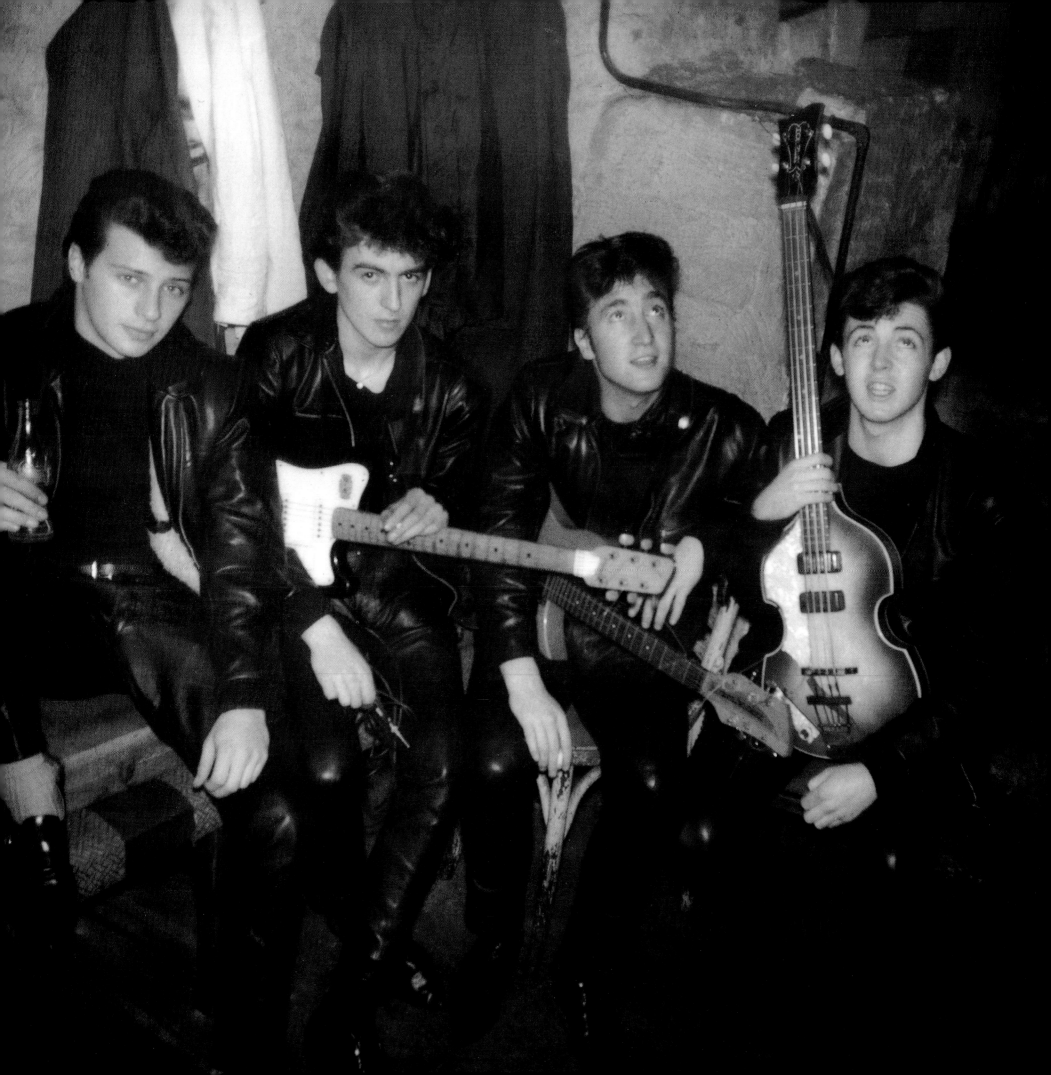

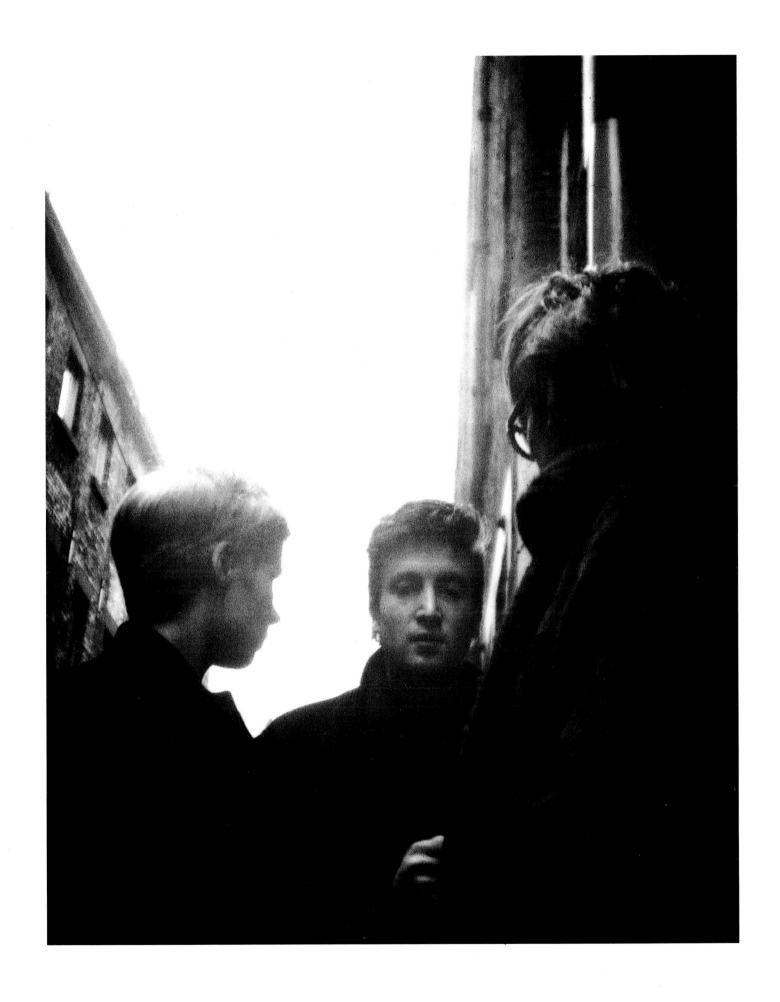

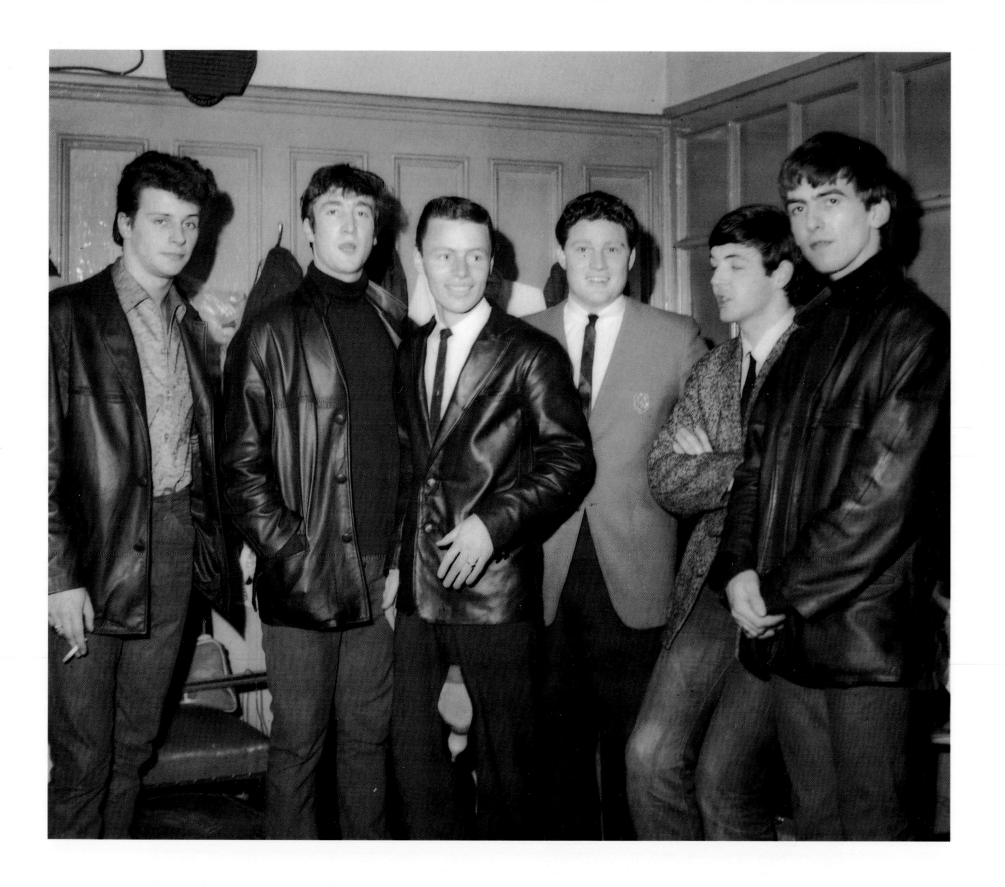

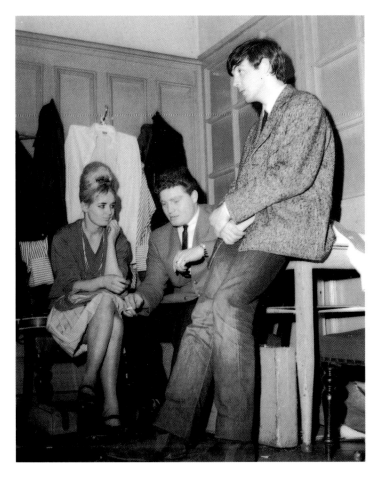

OPPOSITE PAGE: Backstage at the Tower Ballroom. The Beatles with American singer Bruce Channel (wearing the blazer). We thought he was going to be like Gene Vincent, moody and mean, but he looks like an all-American Ivy Leaguer.

The bloke in the middle is Delbert McClinton, who played the harmonica on Channel's hit, "Hey! Baby." John picked up a lot of tips from him and used them to good effect on their first record "Love Me Do." [For more, see page 70.]

TOP LEFT: At the Tower Ballroom, Paul, Bruce Channel, and young lady in a beehive hairdo. I used to be a ladies' barber and I know what hard work it is to back-comb your hair and what damage it does to it.

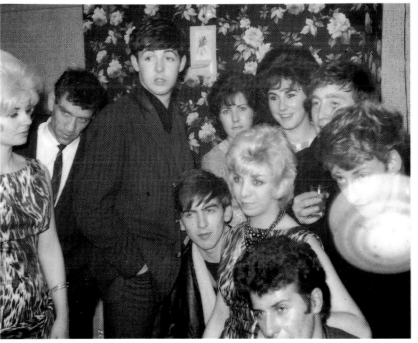

BOTTOM LEFT: The same evening. The man behind the "flying saucer" light is Rory Storm, who had a pronounced stutter. The funny thing was that he only stuttered offstage; as soon as he got on and started singing it completely disappeared.

PAGES 44 AND 45: John and Paul rehearsing at the Cavern. At the bottom of the shot on page 44, on the stage, was our Grundig tape recorder on which the boys taped all their early songs. Years later I accidentally used the tape to record my kids and wiped out half the songs! I dread to think what a tape of the Beatles' first recording would be worth now.

In the foreground of the shot on page 45 is a chair with the words Star Club; they must have nicked it from Hamburg.

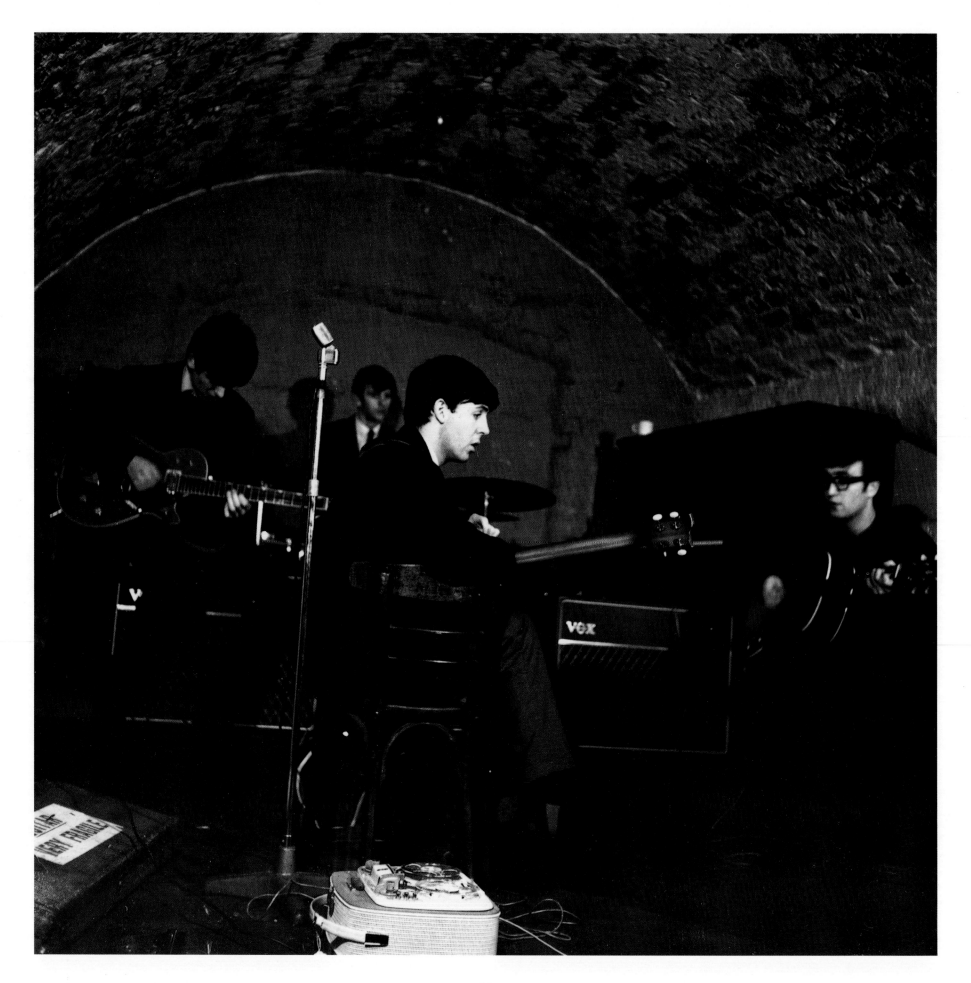

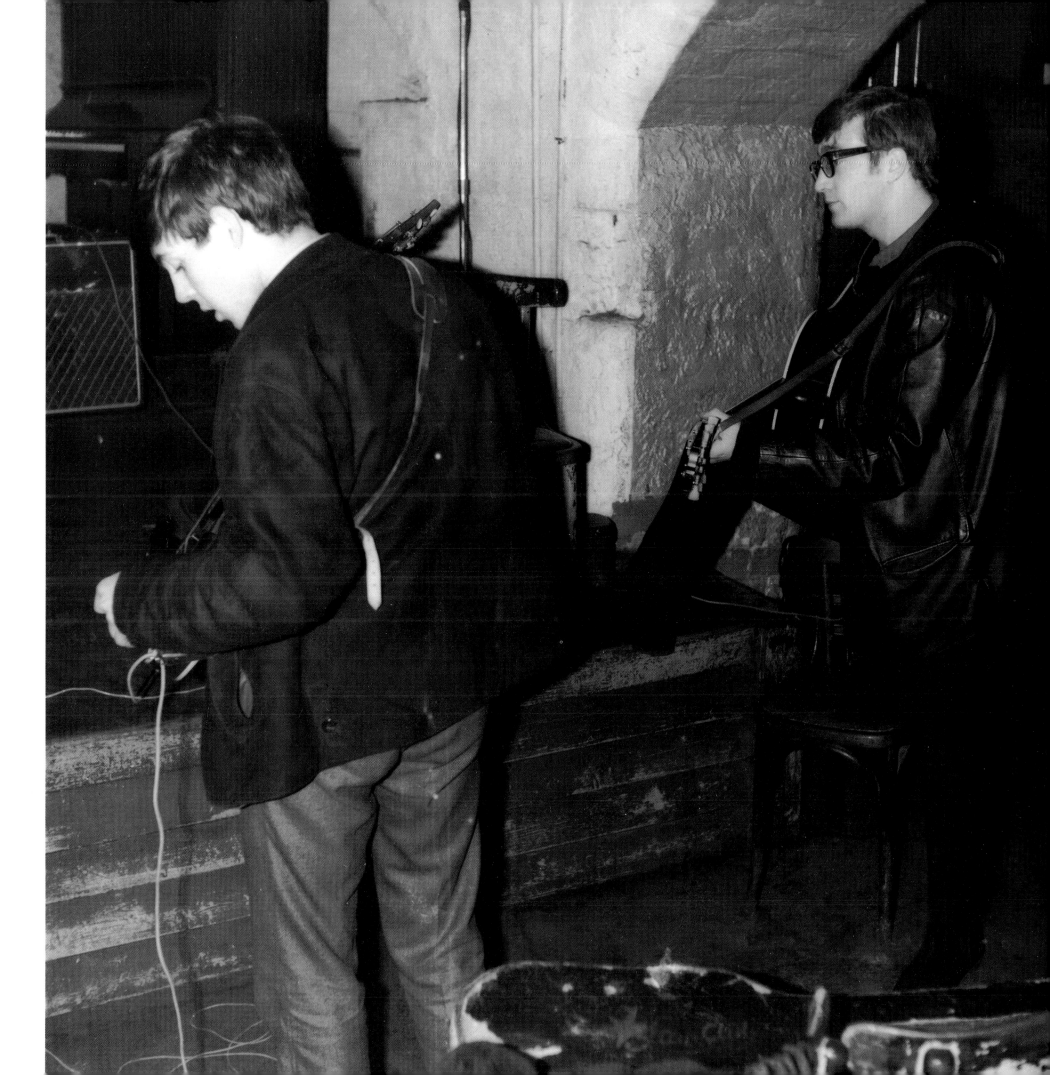

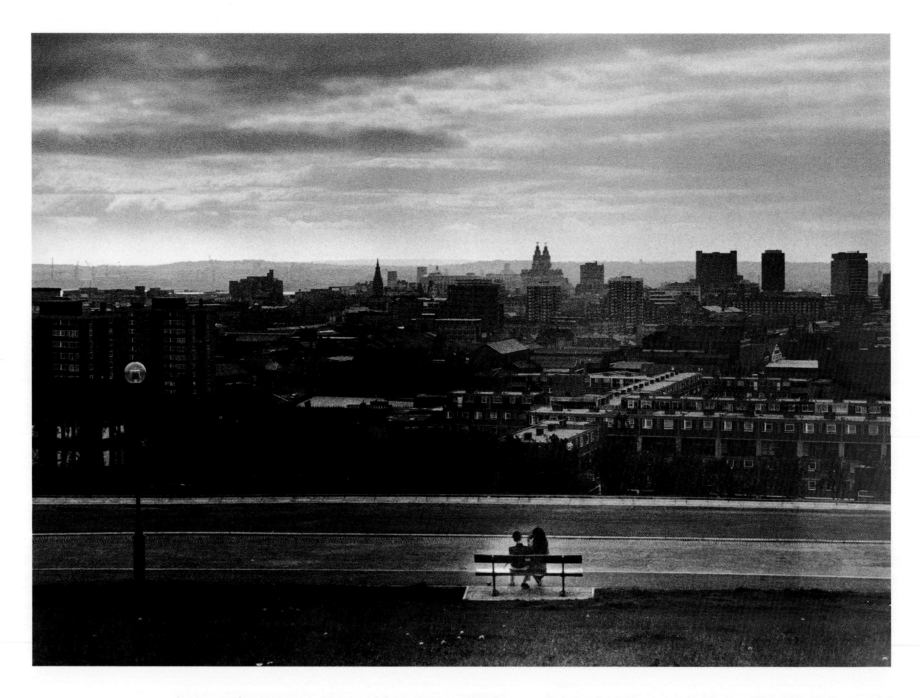

ABOVE: The view over Liverpool from Everton Heights, where my parents were brought up. Liverpool gets its name from a Norse word meaning "the pool of the slopes," and it shows in the way it slopes down toward the River Mersey. This was the view Mum and Dad had from between the terraced houses in the streets where they lived as children.

RIGHT: A view across the Mersey from Woodside, topped with some barbed wire from the old cattle sheds. When I started silk-screening I continued the barbed wire on and around the photograph until it was floating in space. If you look carefully at the wire, you'll see that I've painted in little insects—spiders, ants, and, what a surprise, the odd beetle.

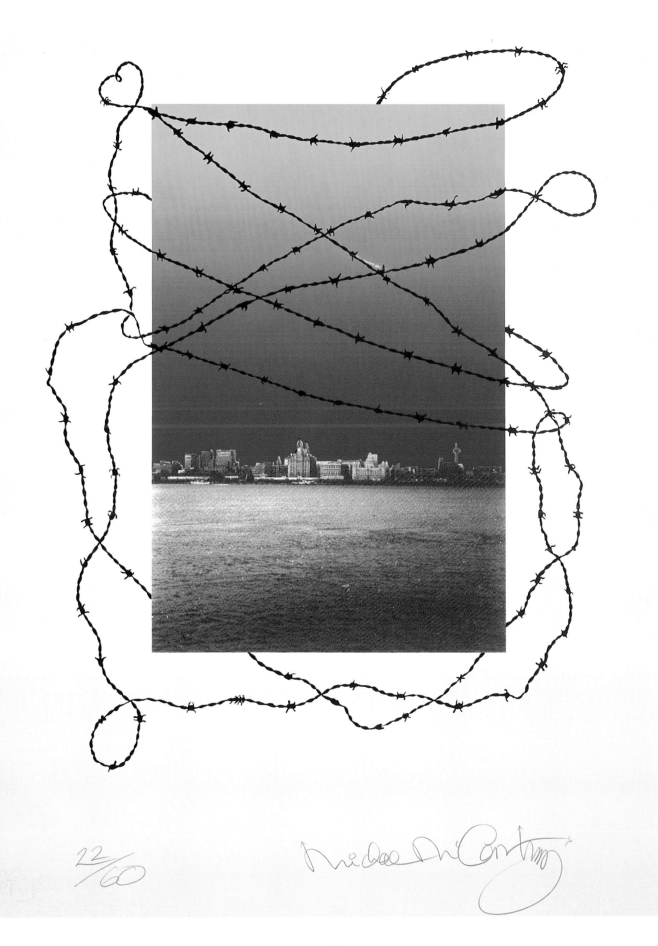

22/60

47

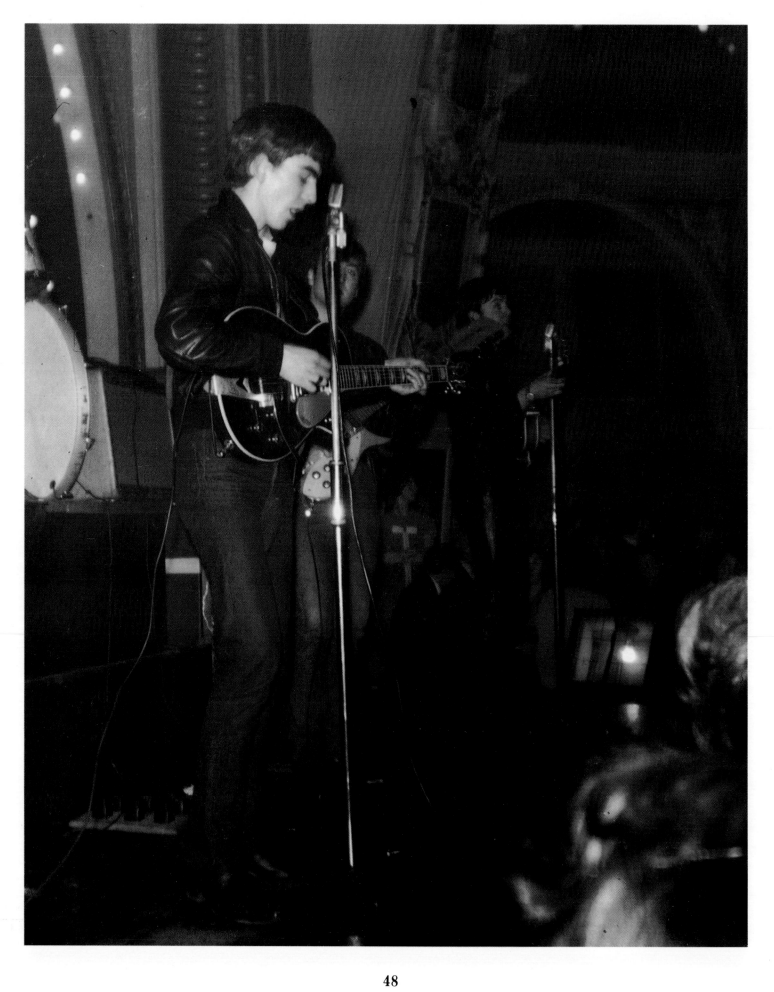

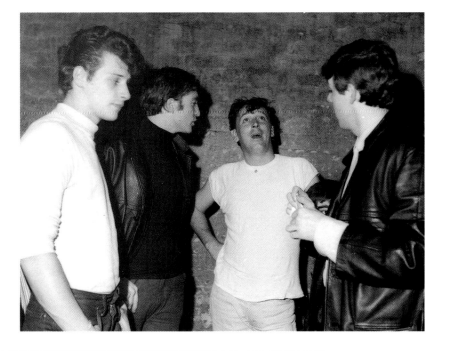

FAR LEFT: Onstage at the Tower Ballroom in New Brighton in the days when Pete Best was still the drummer.

TOP LEFT: Another shot of Gene Vincent with Pete, John, and Paul down the Cavern. You can just see George's eye peeking out between Gene and Paul. After this I got Paul to take one of me with Gene. I brushed my hair forward and put my comb under my nose. Gene must have wondered why he was having his picture taken with this strange young man pretending to be Adolf Hitler.

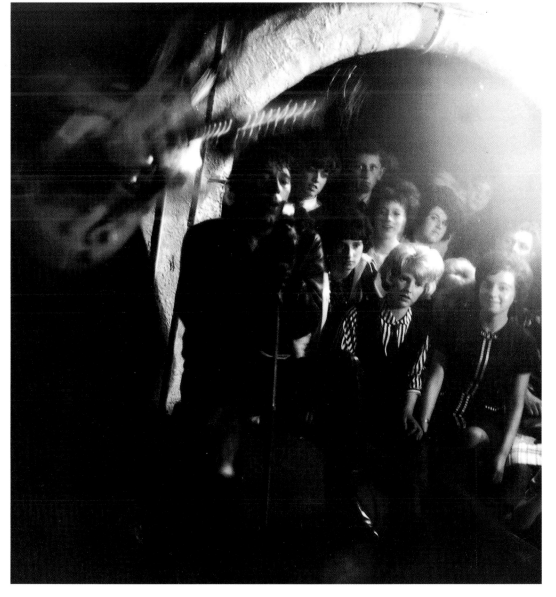

BOTTOM LEFT: Another sweaty night in the Cavern. The striped shirt the girl is wearing is almost identical to the one Paul is wearing on page 28. We imitated the style set by David Frost, and the fans imitated us. As soon as they saw what the Beatles were wearing, they rushed out and bought the nearest thing to it. The man they are ignoring (while they wait for the Beatles to come on) is our great hero Gene Vincent.

PAGE 50: An accidental triple exposure, but I love it. One exposure shows Paul, on the left. Another shows him, center, doing his Little Richard impression (with Stu Sutcliffe on his right). The third exposure shows me in the audience, between the two Pauls. I must have taken his two pictures and then passed the camera to him to take a photo of me dancing. Either we forgot to wind on the film or it jammed in the camera. Whatever the reason, the result is very atmospheric.

PAGE 51: A *double* exposure this time, taken backstage at New Brighton Tower Ballroom—John, left, Brian, center, and Pete, right, plus (onstage) Peter's drums, left, next to original tiny amp, and the lads facing their Ballroom audience.

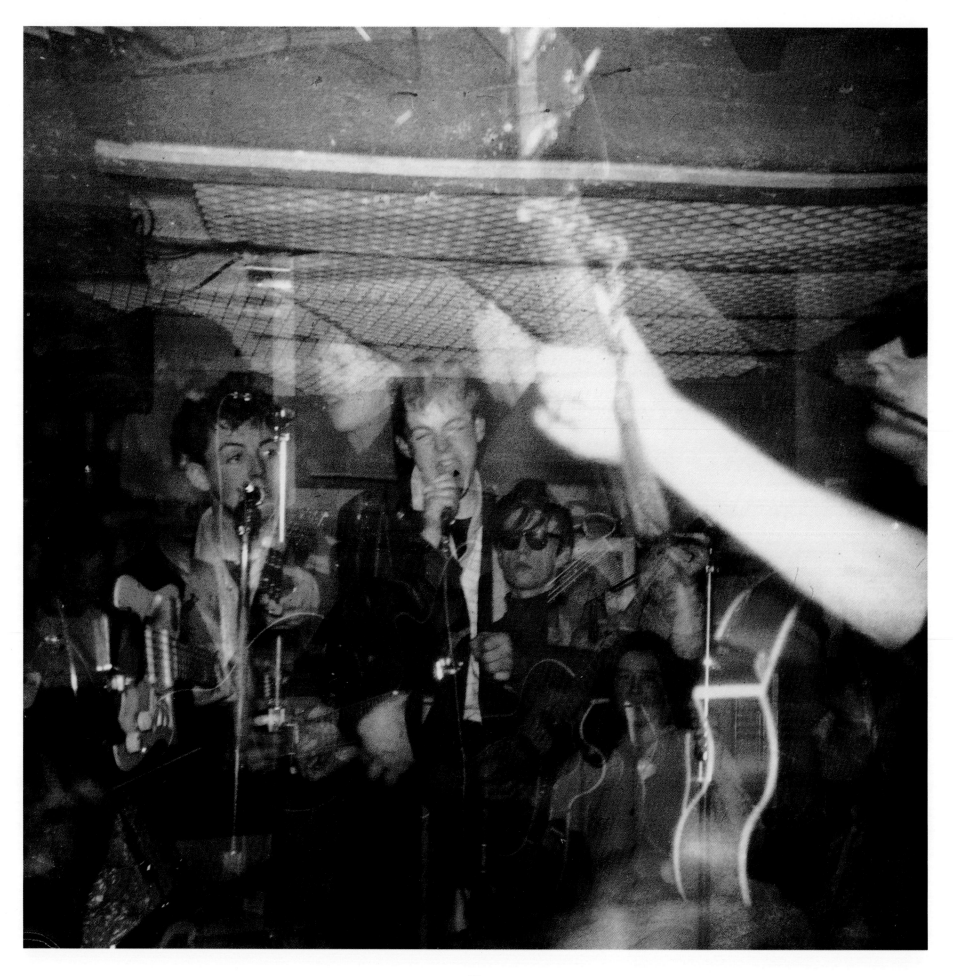

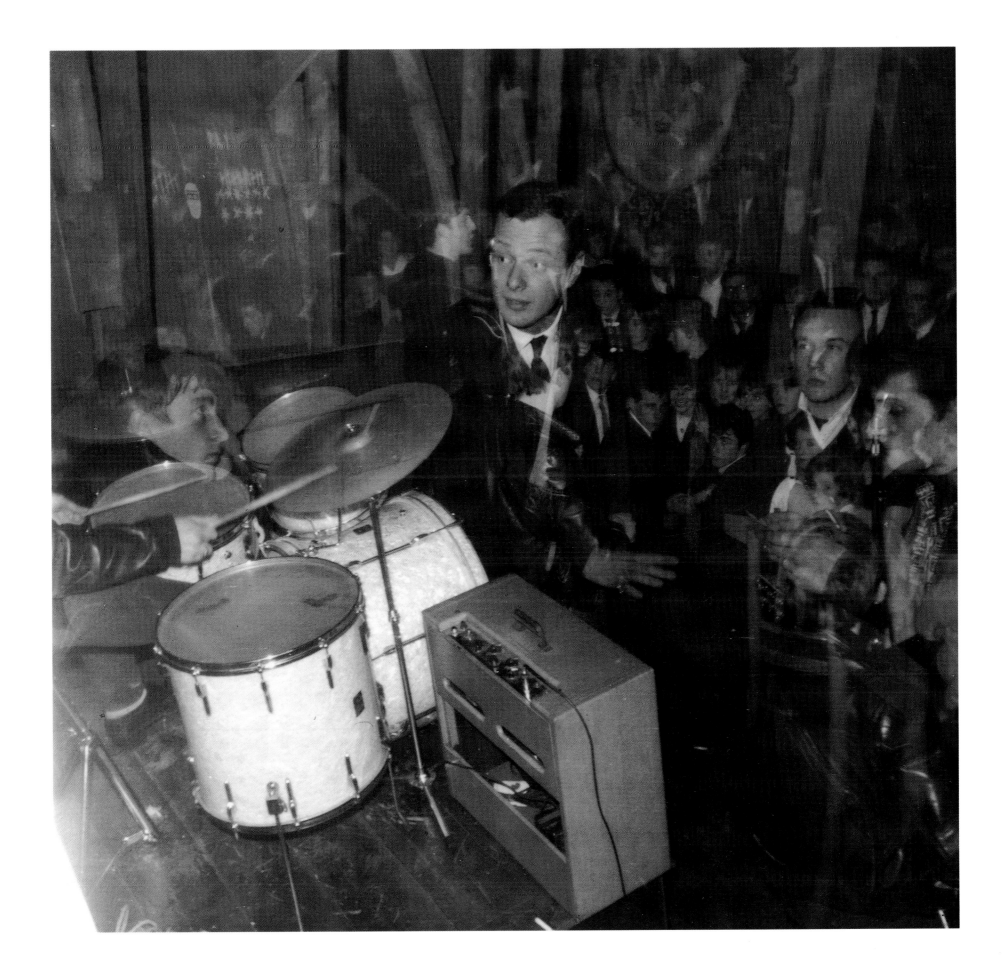

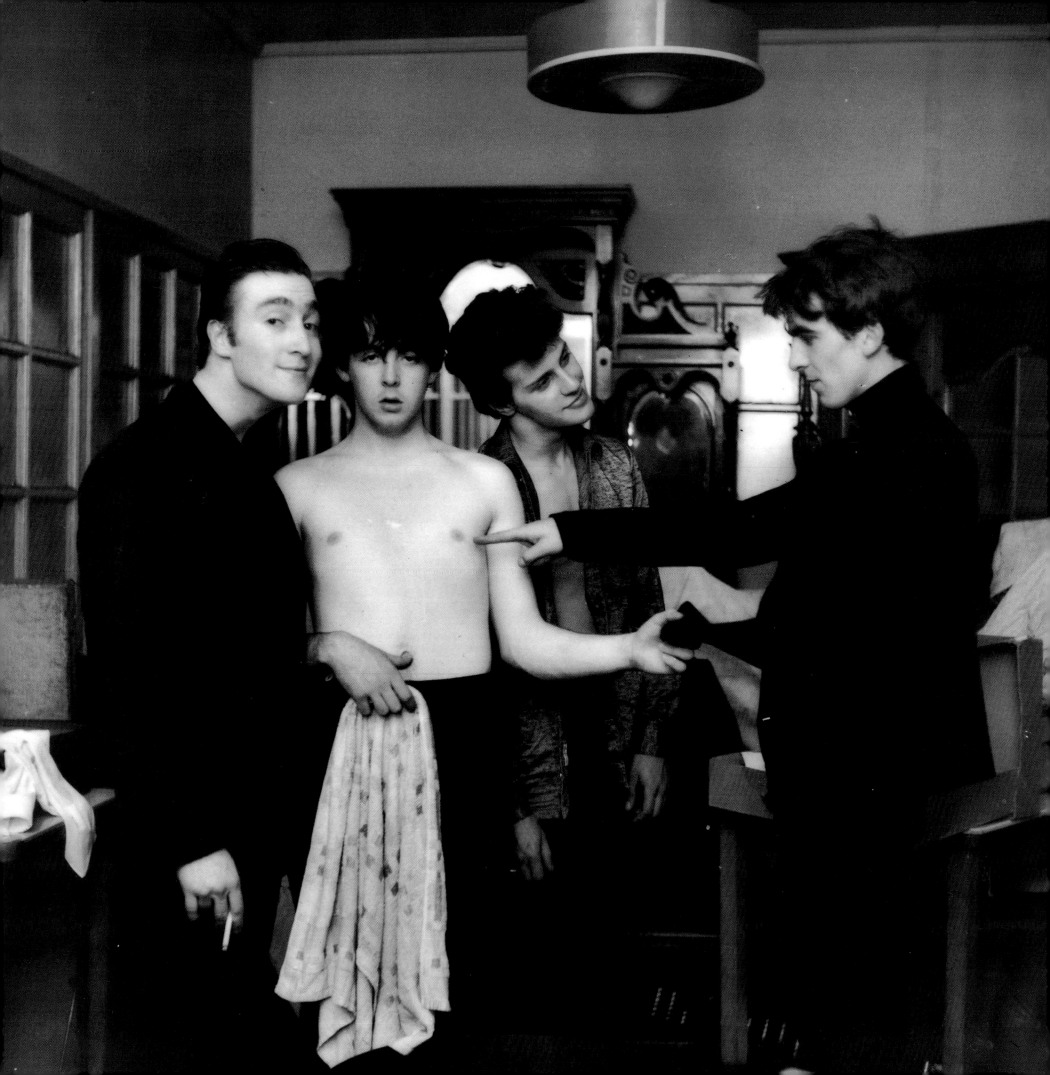

LEFT: One of my favorites because it absolutely personifies John. This is *exactly* what he was like (with Our Kid looking remarkably like Sylvester Stallone).

This is one of the first "wacky" Beatle pictures, very influenced by the Goons; Peter Sellers and Spike Milligan were an important part of our upbringing, which is one reason the boys were keen to work with George Martin, who had produced comedy records for the Goons. This photo is a forerunner of the sort of stuff they did in *A Hard Day's Night,* directed by Dick Lester, who made the classic *Running, Jumping and Standing Still Film* with Milligan. This is after a gig at the Tower Ballroom. "Rambo" Paul is rubbing down, and John's hair is plastered against his skull with sweat.

PAGES 54 AND 55: Giant black-and-white dot silk-screen prints I made from the previous photograph.

Starting the silk-screen process at John's old art college, next to the "Inny," I continued in Guadalajara, Mexico, but actually finished this limited edition in the heart of New York.

Wash Day Blues

PAGES 56 AND 57: Examples of how you can give new life to old photographs by turning them into silk-screen prints. The image connecting them is the towel. It first appeared in a photo called *The Lone (St)Ranger* [page 26], and when my wife pointed out that it reappears in the photo on page 52, she sowed the seeds of an idea....

On page 56, I've removed the background of the photograph and painted in my own, which includes an exploding light bulb inspired by Picasso's *Guernica* plus references to Dali and the surrealists.

The print on page 57 is my tribute to Andy Warhol, who I met a couple of times in New York. The imagery is windows; the photograph was taken through one, so the four versions of the photograph were given a blue tint, arranged as panes in a larger window and retitled *Wash Day Blues* (title care of Rowena).

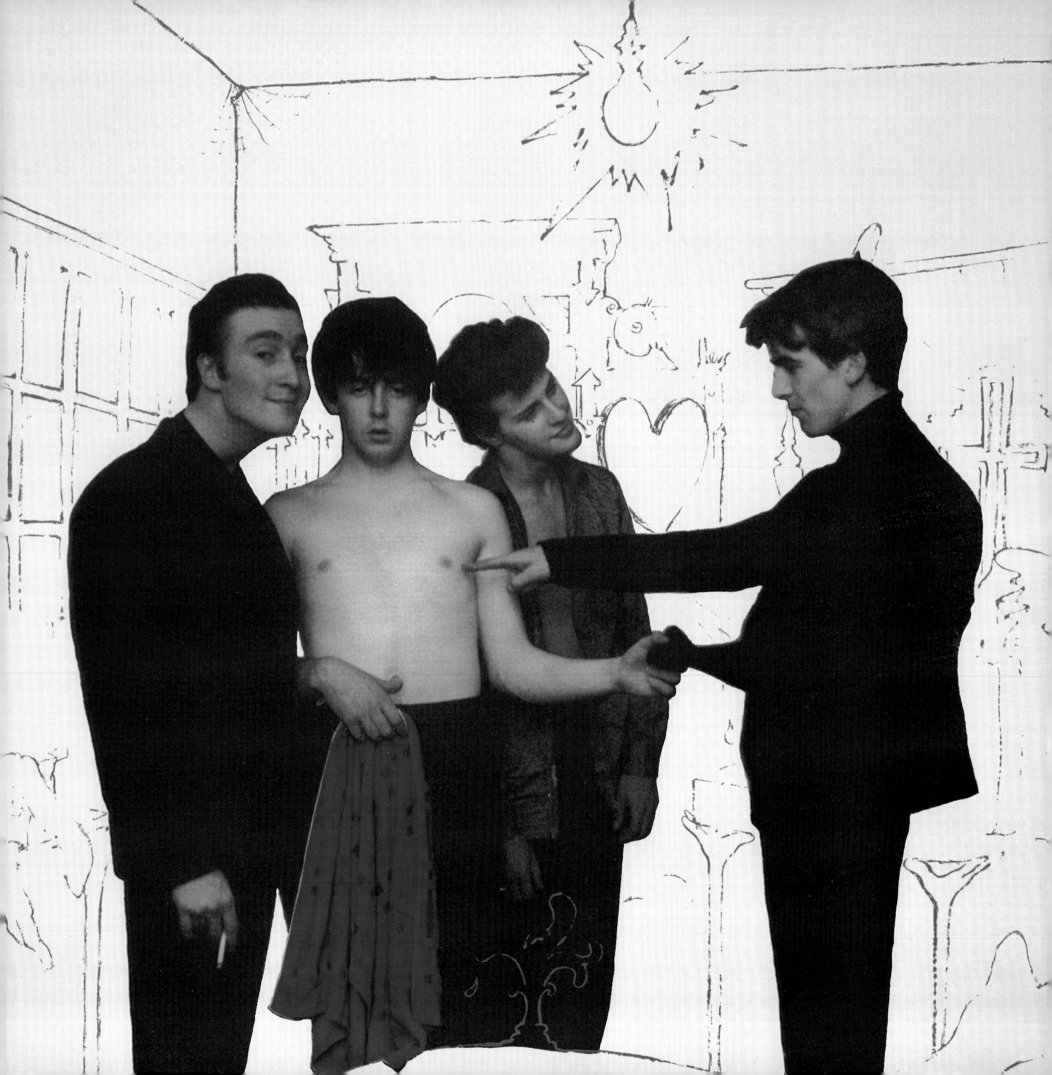

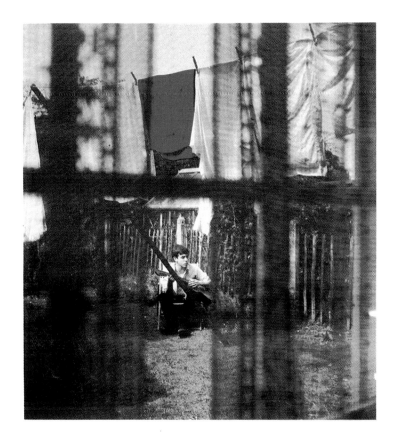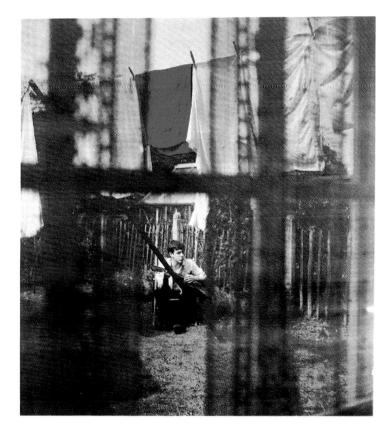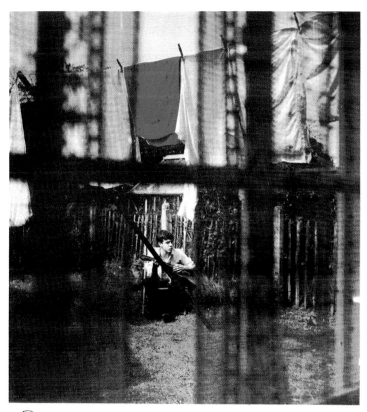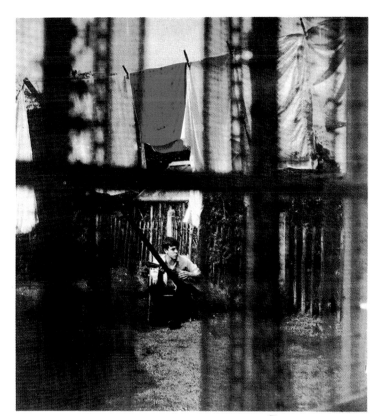

31/60

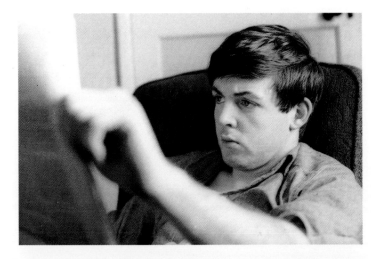

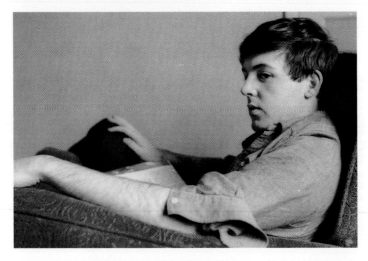

Speaking of Picasso, as I was on page 56, here's Our Kid reading about him in the *Observer*—we may have been poor but we wasn't thick. Notice how Paul is posing artfully with his hand on one arm of the chair and his leg over the other. His hand is hiding a hole in the cover and his leg is covering a spring that came right through the upholstery, and used to rip our clothes to shreds.

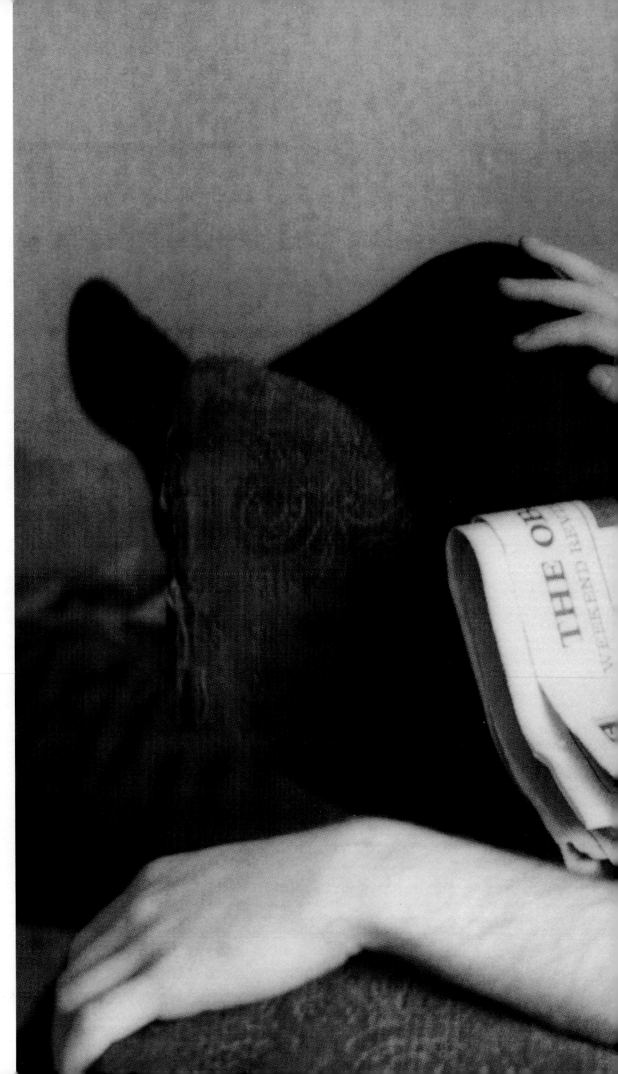

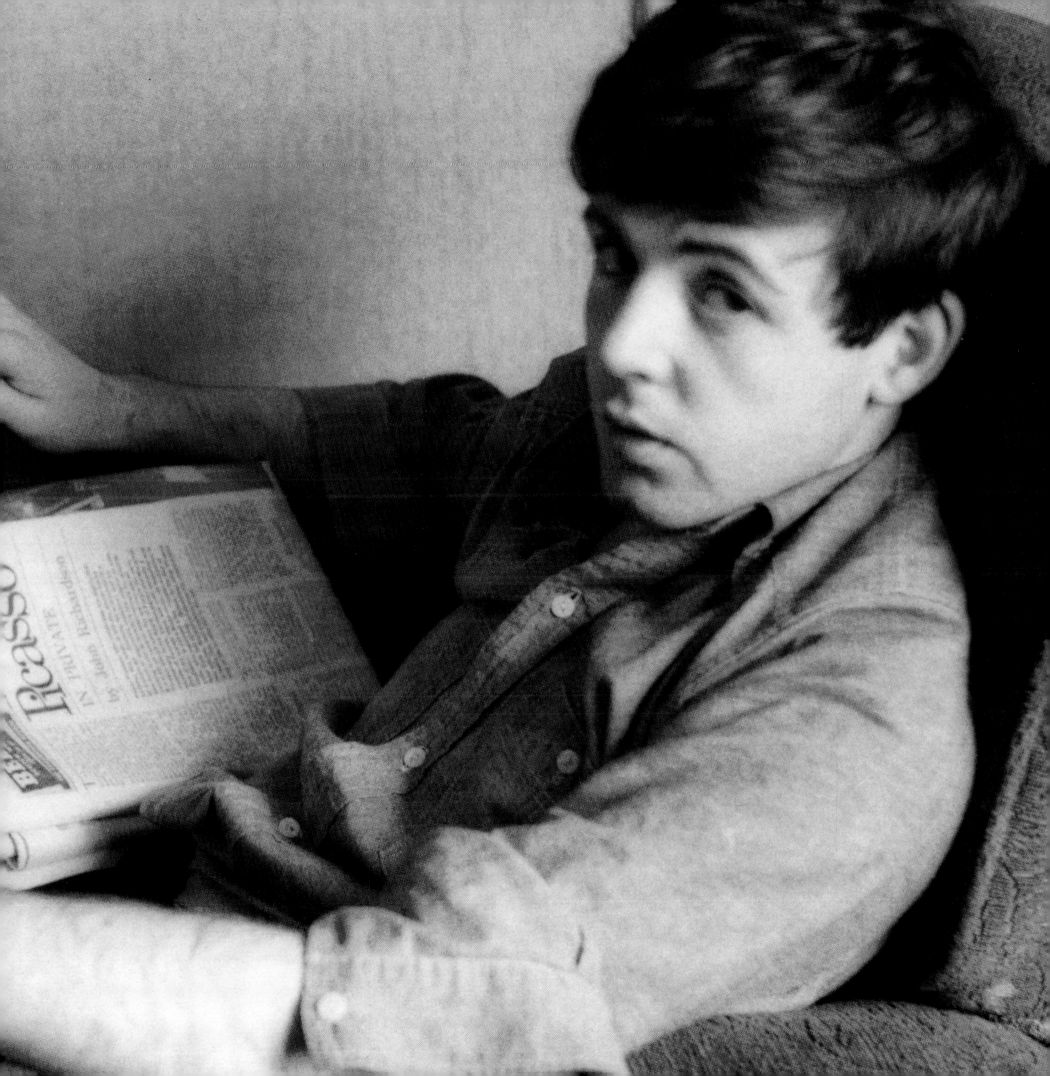

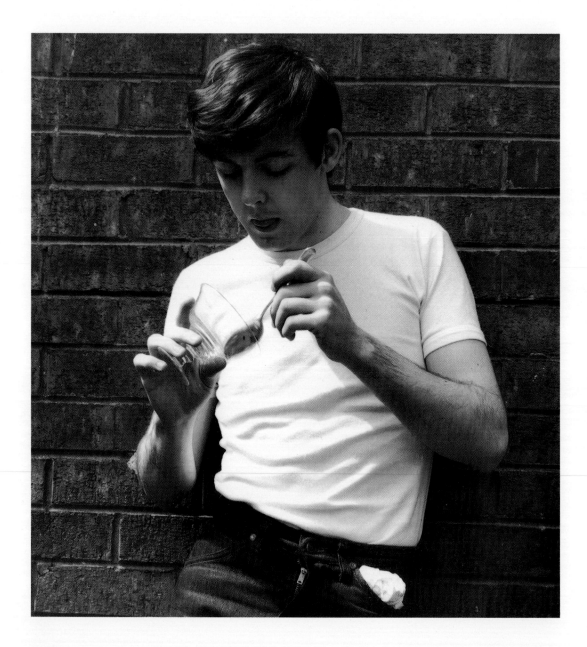

Paul in a yogurt commercial, although I don't think we had yogurt in those days. This is one of Paul's classic Marlon Brando T-shirt poses.

RIGHT: The back of our house in Forthlin Road. I'm leaning out of my bedroom window as Paul climbs up the drainpipe. This was the way we'd get in if we lost our keys. We'd shin up to a tiny window into the toilet and slither through headfirst, hoping the lid was closed on the toilet. Otherwise we'd end up with our heads down the pan. Paul's wearing tight jeans, which Dad hated because they made us look like "Teddy Boys." He'd come with us when we bought trousers to make sure they weren't too tight. He didn't know that Paul would then go to a tailor's shop to have them taken in. Every week they got a bit narrower, until Dad would eventually notice. "I told you not to buy those drainpipes," he'd say. And Paul would answer, "They're not 'drainies,' Dad. Look, they're the ones you bought." And he'd show Dad the label—the start of politician Paul.

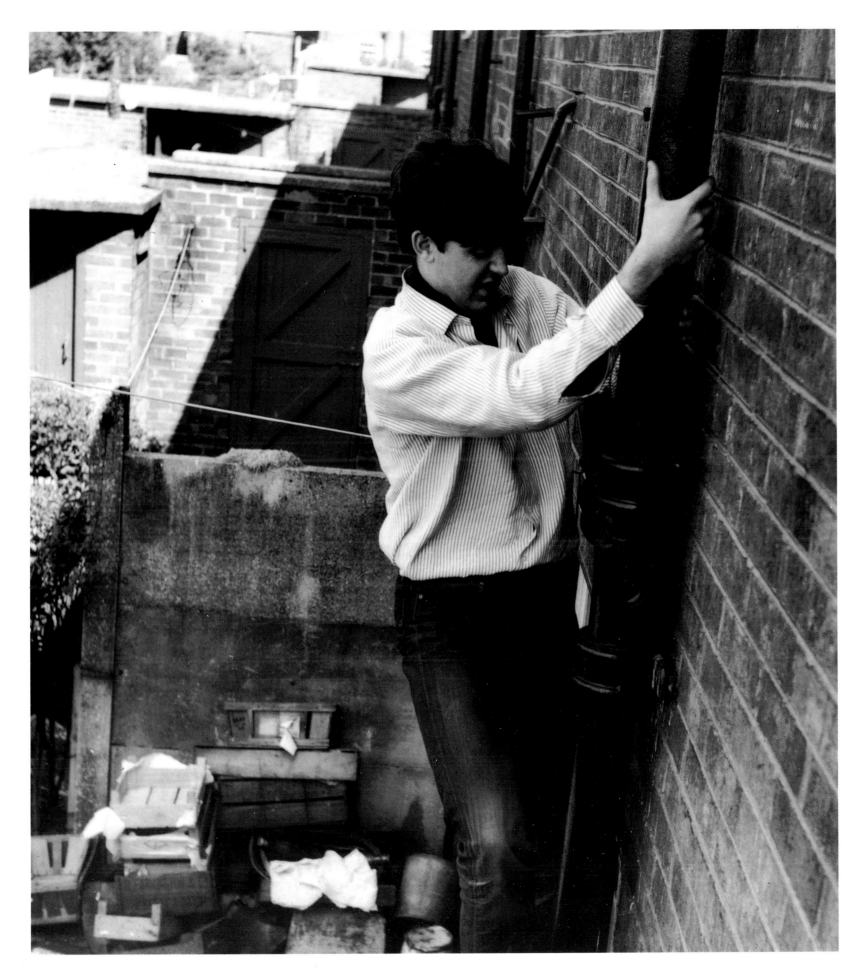

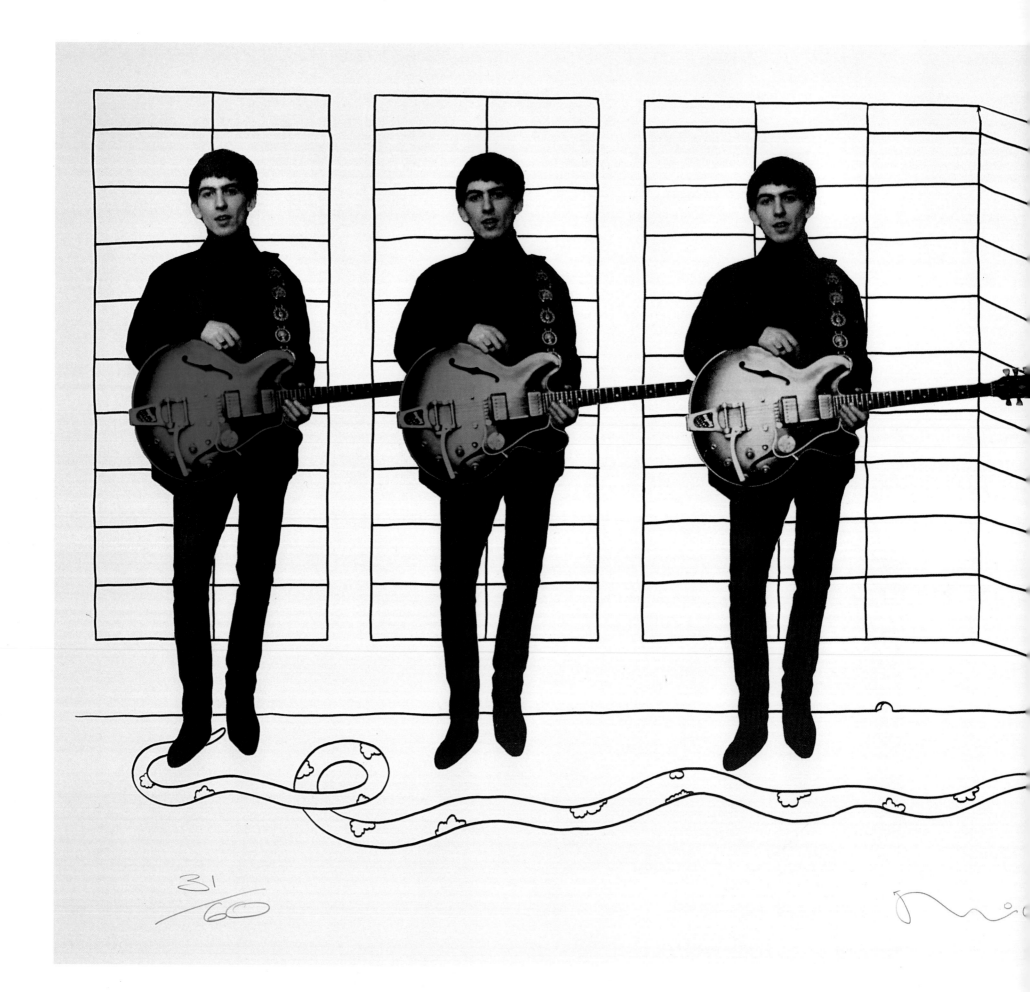

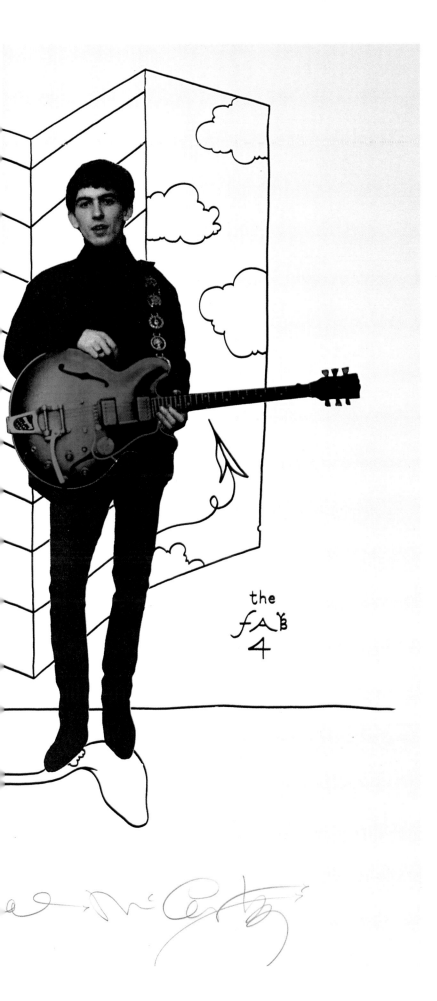

the fAB 4

LEFT: This is the "Fab Four" silk screen I made from the photograph of George with Joe Brown's guitar on page 31. I've transformed the background from the wood paneling at the Tower Ballroom into Japanese screens with the odd cloud. I like the mouse hole in the skirting board but I don't even want to think about the symbolism of the snake!

PAGE 64: A very typical shot of my dad with Paul, sitting in the garden on a sunny Sunday, reading the *Observer*, quite a posh paper for us "working-class" people. Mind you, on the grass is the *News Of The World*, which was *not* posh!

PAGE 65: Although John was the only Beatle who went to art college, this shows how good Paul was. He's sitting in front of a very strong, honest self-portrait. Next to him is a huge collage he painted. Indeed, he still paints today (on Magritte's old easel!).

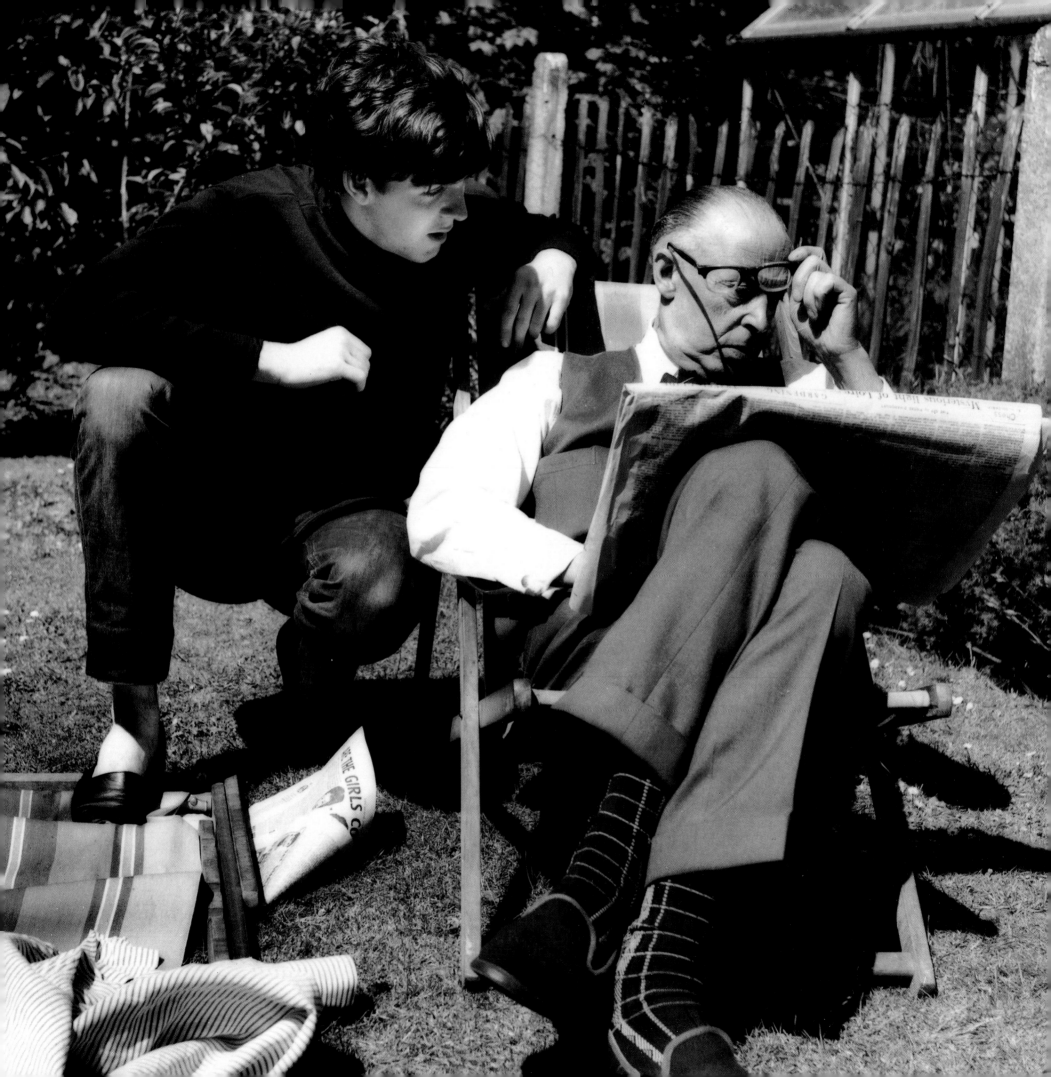

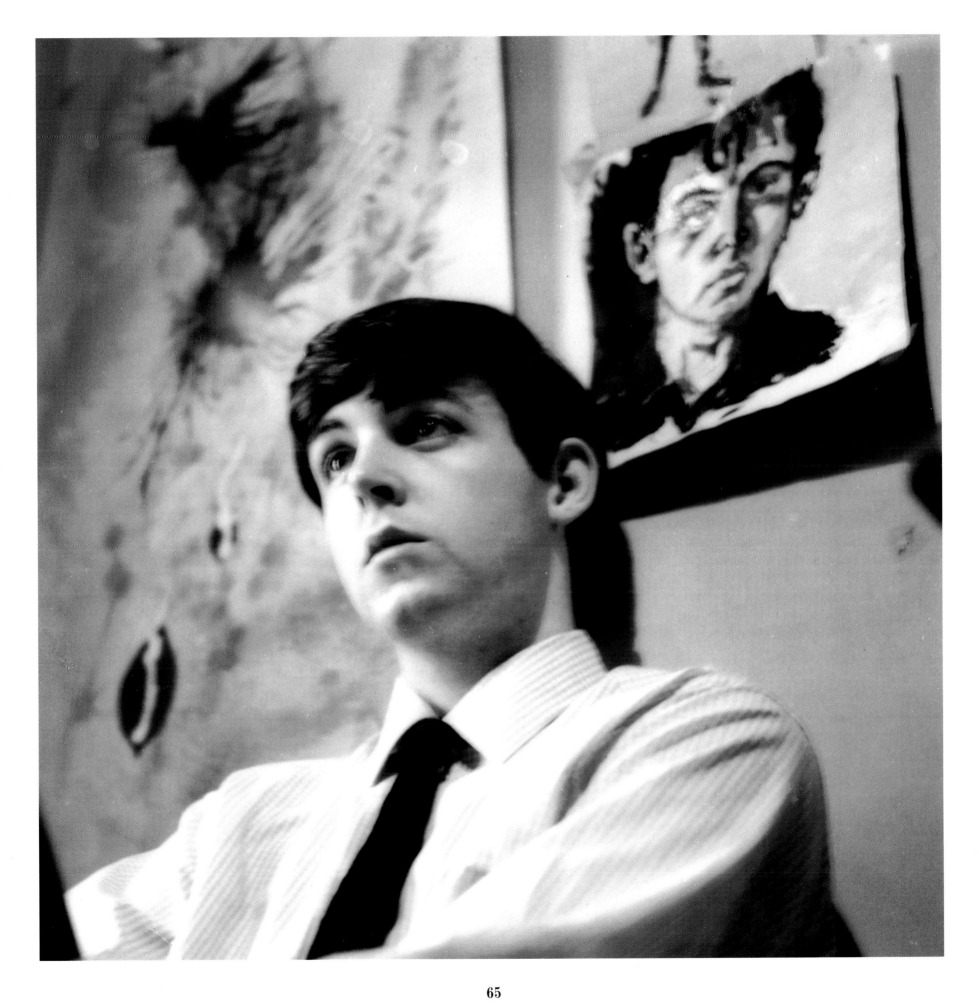

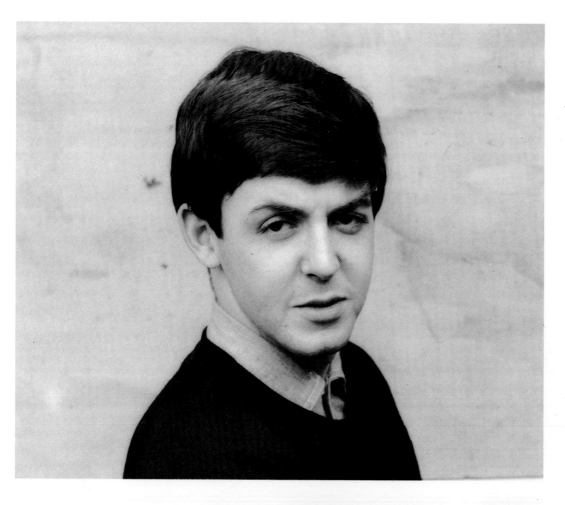

RIGHT: An arty pose. I would get Paul to sit for hours while I experimented with techniques. I must have taken hundreds of photographs in the first half of 1962, just before they made their first hit, "Love Me Do."

Paul was twenty and I was eighteen, I'd just left school and was starting my first job at Jacksons, the tailors, selling very straight suits.

The job didn't suit me, so I answered an advert in the *Liverpool Echo* for "an ambitious young man required." It turned out to be a job as a door-to-door salesman for a Catholic Bible firm. I wasn't very successful. The only Bible I sold was to Mr. and Mrs. Gall, our next-door neighbors, who took pity on me.

I quit after a few soul-destroying weeks. I had no idea what to do until Auntie Gin said "You're artistic, and hairdressing's an art." So I became an apprentice at André Bernard Coiffures for £1 10s and 9d a week. I worked alongside the comedian Jimmy Tarbuck and the respected actor, Lewis Collins.

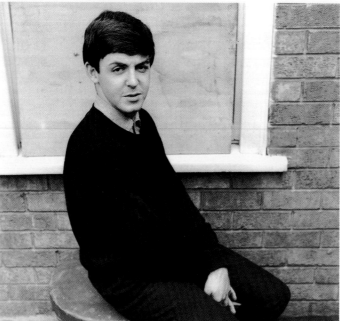

This was supposed to be a moody shot of Paul. The reality is that I've posed him in front of a backdrop made out of plywood while sitting him on a dustbin. I really had to improvise in those days, using *anything* that was at hand.

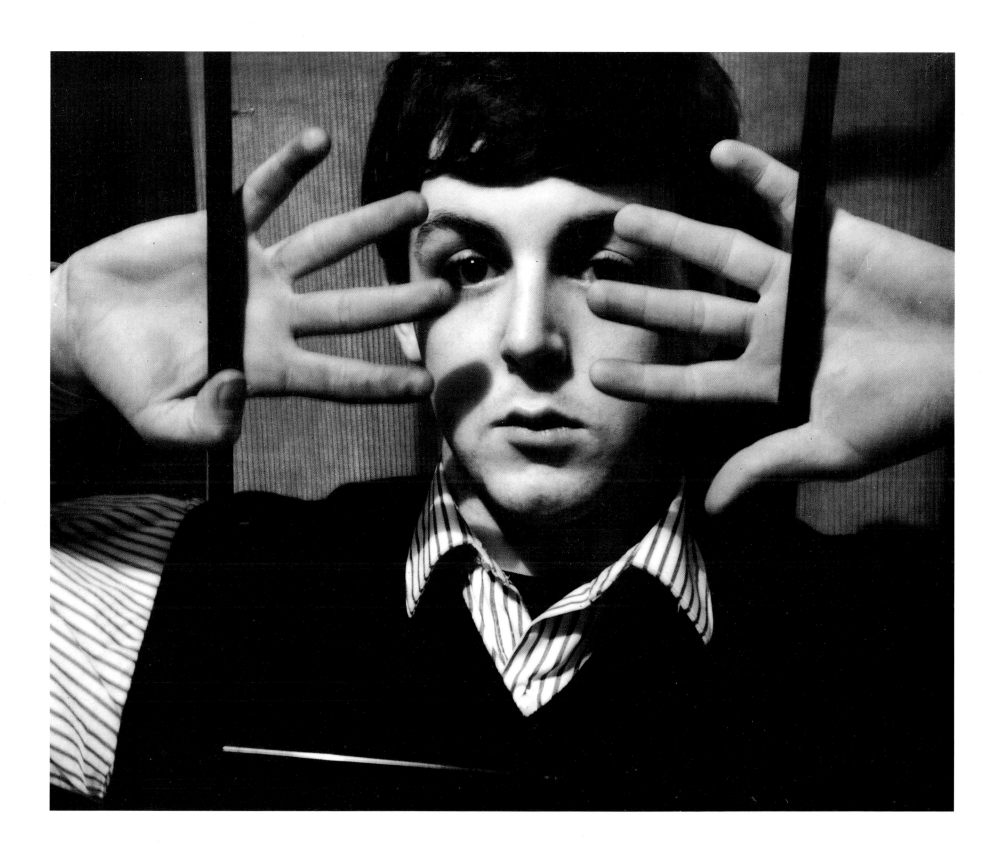

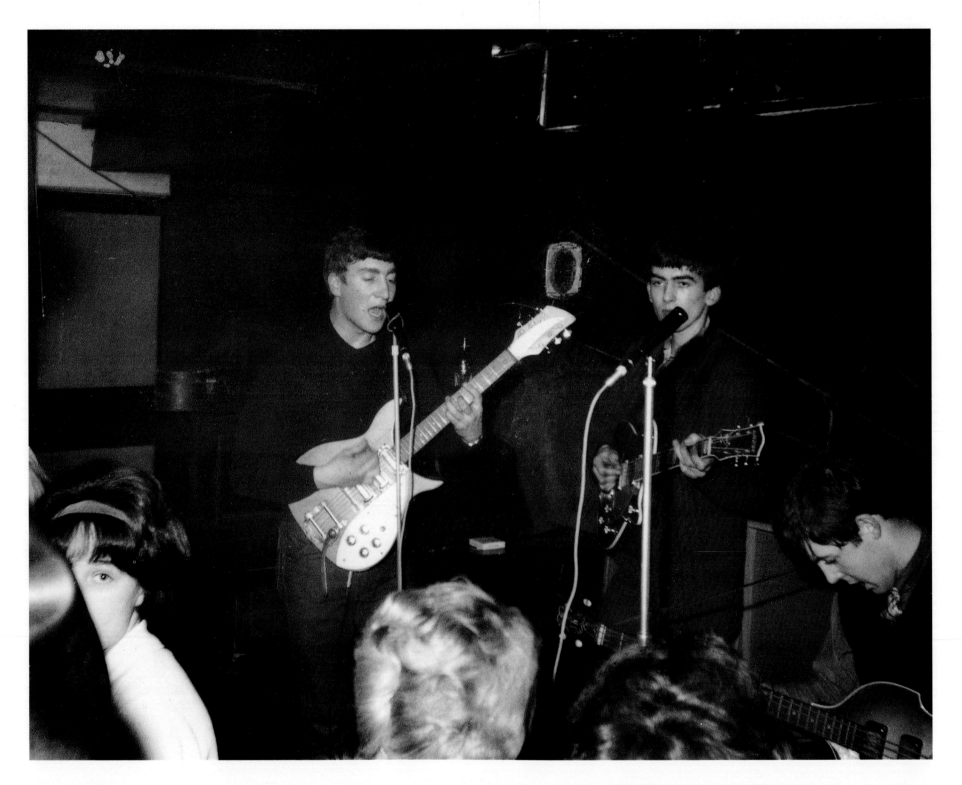

John, George, and Our Kid, getting down to it at the Casbah in Haymen's Green.

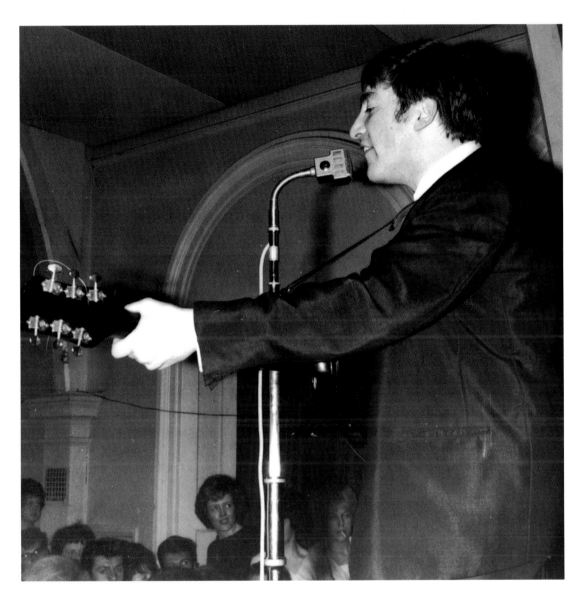

John in his typical stance; he's looking aloof and distant, but that's because he couldn't see a thing without his glasses.

PAGE 70: Paul playing piano down at the Cavern, with John practicing the harmonica for "Love Me Do." When the record came out some critics noticed its similarity to Bruce Channel's "Hey! Baby," which had been a hit earlier in 1962. John denied he had "borrowed" the lick, saying that they'd never heard the song because they were in Hamburg when it was in the charts. But the photograph on page 42 shows the Beatles had actually appeared with Channel at the Tower, and John had simply "got some tips" from his harmonica player. It seems John was being economical with the truth. There's a story that John had shoplifted the harmonica on the way to Hamburg. Rubbish! It must have fallen off the counter and John caught it in his pocket to stop it from smashing to pieces.

Those are my fingers walking along the piano. This was my surrealist stage, when I did very odd things, like walking around the streets of Liverpool with a handkerchief stuffed in my mouth. Paul told me I had to stop because Gerry Marsden (of the Pacemakers) had asked him if I was soft in the head. Strange Dada behavior didn't go down too well in Liverpool in the early sixties, it seems.

PAGE 71: The Beatles came back from Hamburg and the fan club organized a welcome home party at the Cavern. John and Paul dressed up as Santas (after all, it was the middle of summer!), and played a couple of songs with the Fourmost, whose first two hits, "Hello Little Girl" and "I'm In Love," were written by John and Paul.

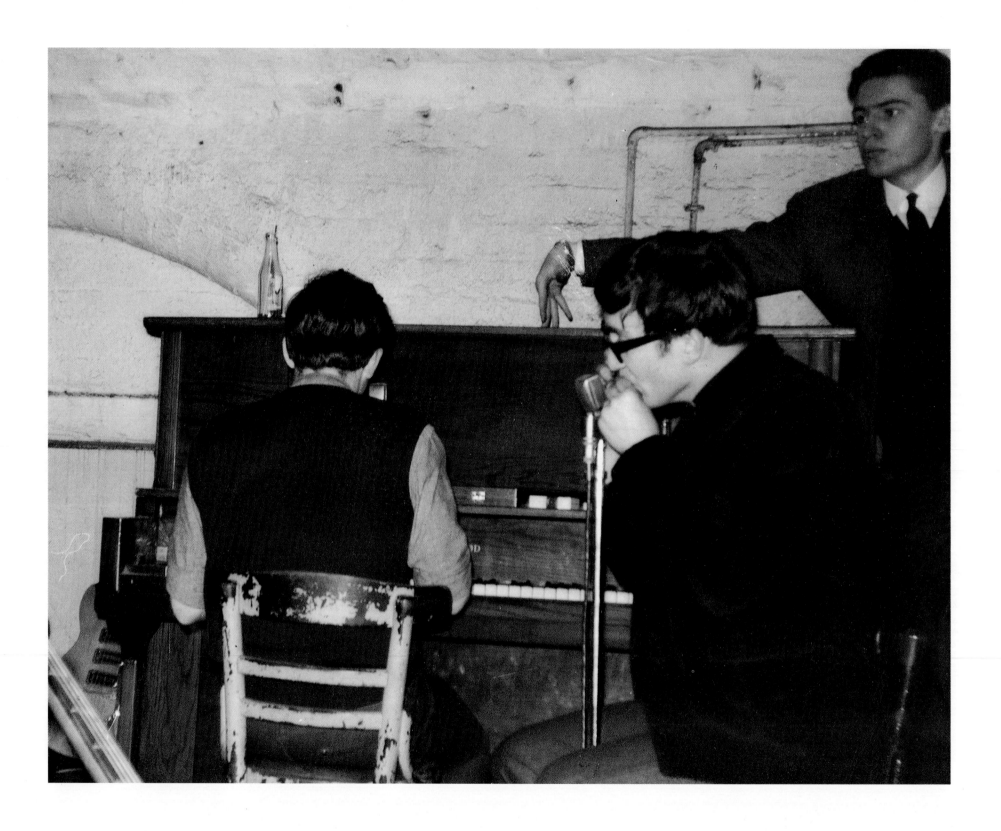

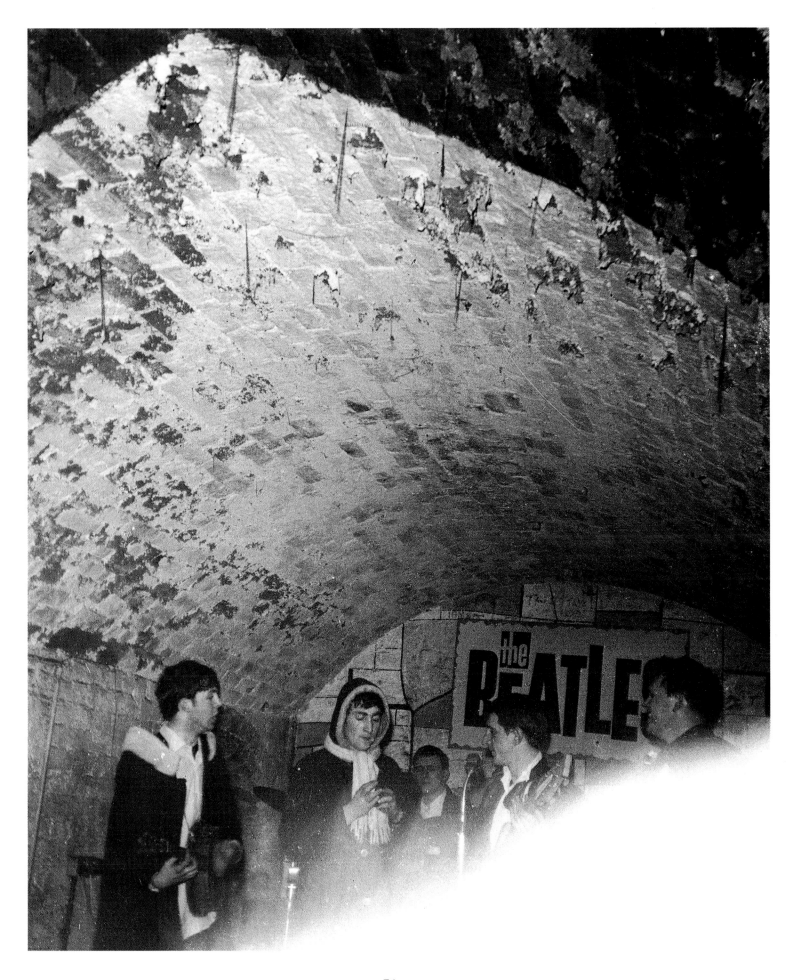

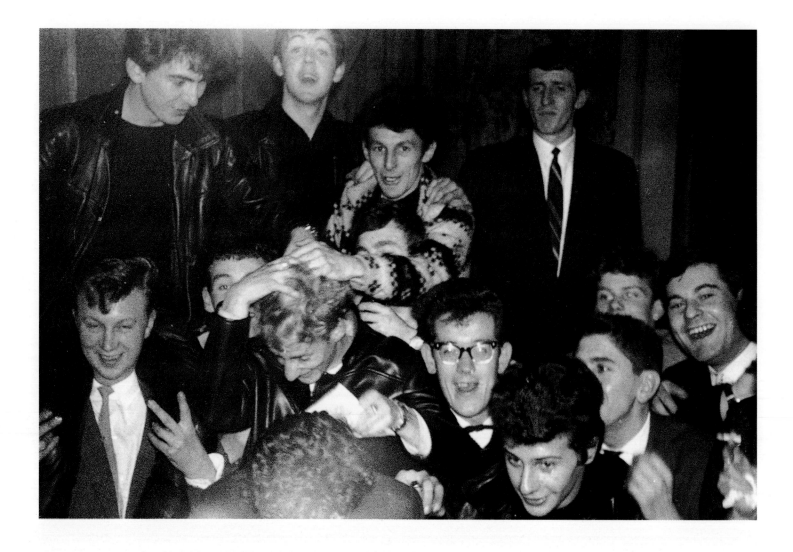

BOYS WILL BE BOYS

ABOVE: A bunch of Liverpool bands playing to the camera behind stage at the Tower Ballroom. The man in the center with his head down is either Bill Harry, editor of *Mersey Beat*, or Sam Leach, promoter. Here, Paul is on the shoulders of Bob Wooler, who was the MC/dj at the Cavern. Piggyback on John is Johnny Guitar, from Rory Storm and the Hurricanes, with his woolly sweater hand on Rory's blond head. Buddy Holly look-alike is Rory's bass player Lu Walters. Billy Hatton of the Four-most is top right in the back row (and also front left on page 73) with Cliff Roberts (of the Rockers) on right. Pete Best is on the right in front.

RIGHT: There was tremendous fun and camaraderie between the Liverpool groups. They occasionally got together for joint gigs under titles like "Operation Big Beat," with Bob Wooler as host. He was a brilliant MC who'd come out with the most outrageous puns. He usually never went onstage. He just sat in the corner with a microphone and gave a wonderful performance that was an integral part of the show. Sadly, there are no recordings of Bob in action but his introductions were a highlight of an evening at the Cavern. He's never received the true recognition he deserves for his contribution to the Liverpool beat scene.

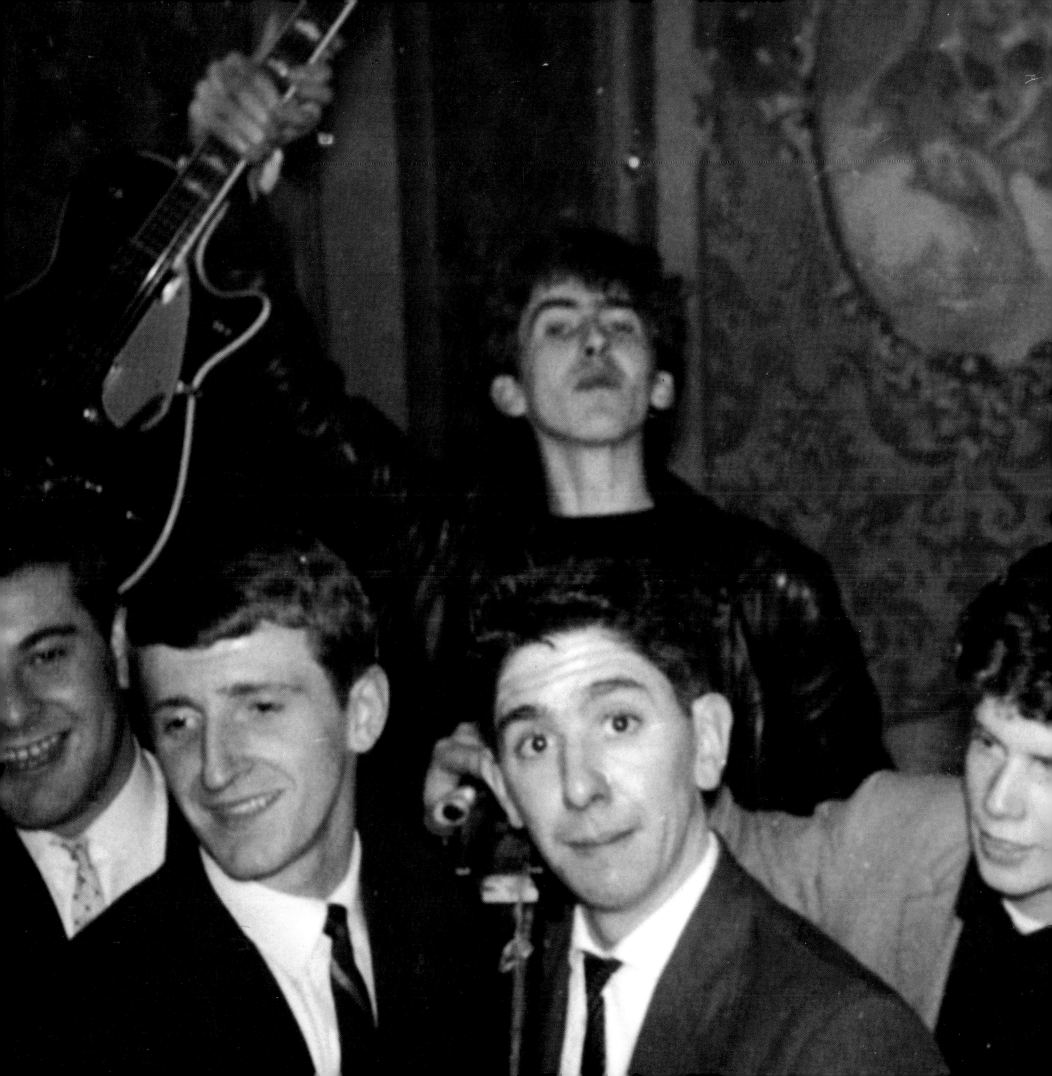

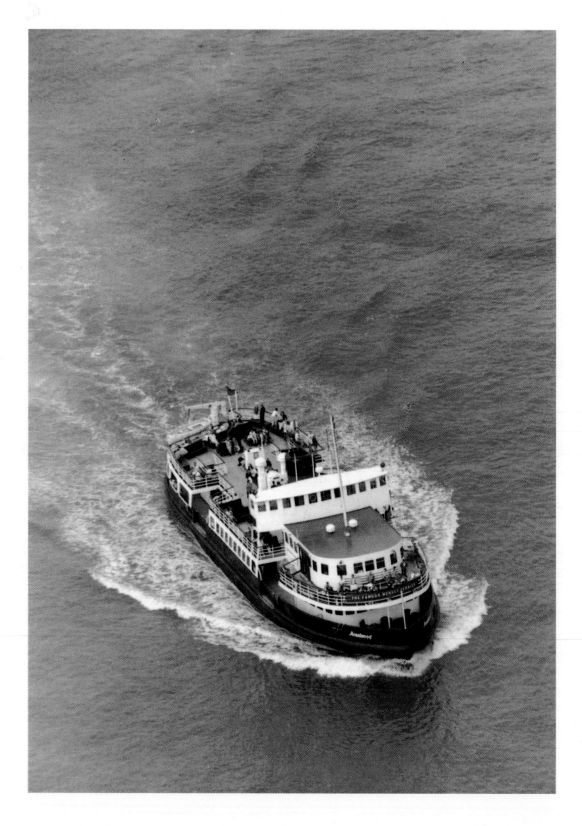

RIGHT: Another boat that plied the Mersey, *The Royal Iris*, which staged all-night shows called "Riverboat Shuffles." It cruised up and down the Mersey, packed with fans drinking and dancing. On this night, the star was Dixieland jazzman Acker Bilk. In between his sets, the Fabs worked up a sweat singing their repertoire, including "Love Me Do."

Although the *Royal Iris* hasn't been working for years, I recently found her in a backwater dock and am relieved to hear that someone is about to bring her back to life.

Ferry 'cross the Mersey—the *Mountwood* photographed from a plane for the National Museums and Galleries on Merseyside. All those years ago, Uncle Albert and Auntie Millie traveled by one of these ferries to cook our Monday dinners; the classy boats are still running today. (A tip if you take the ferry: ask for Ronny Fogg....)

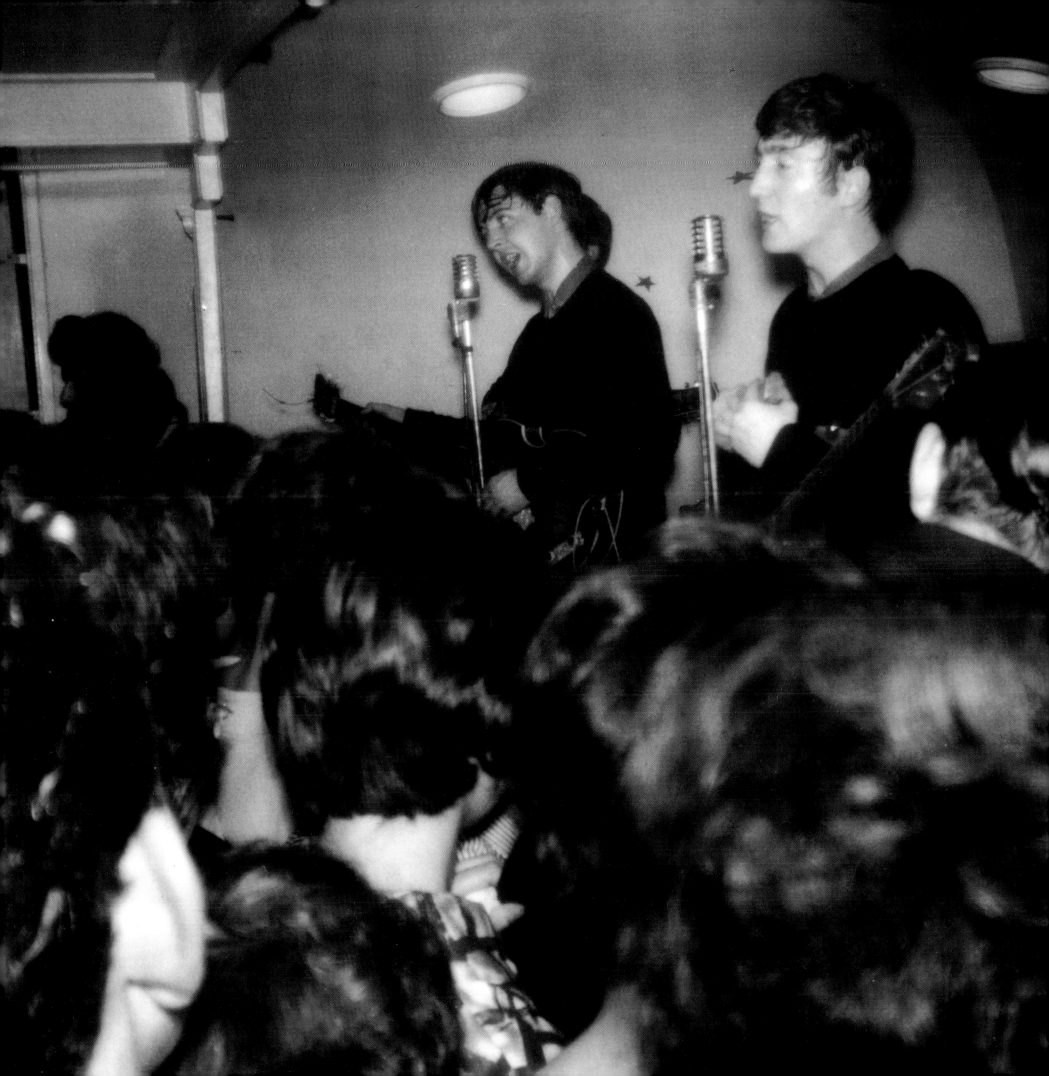

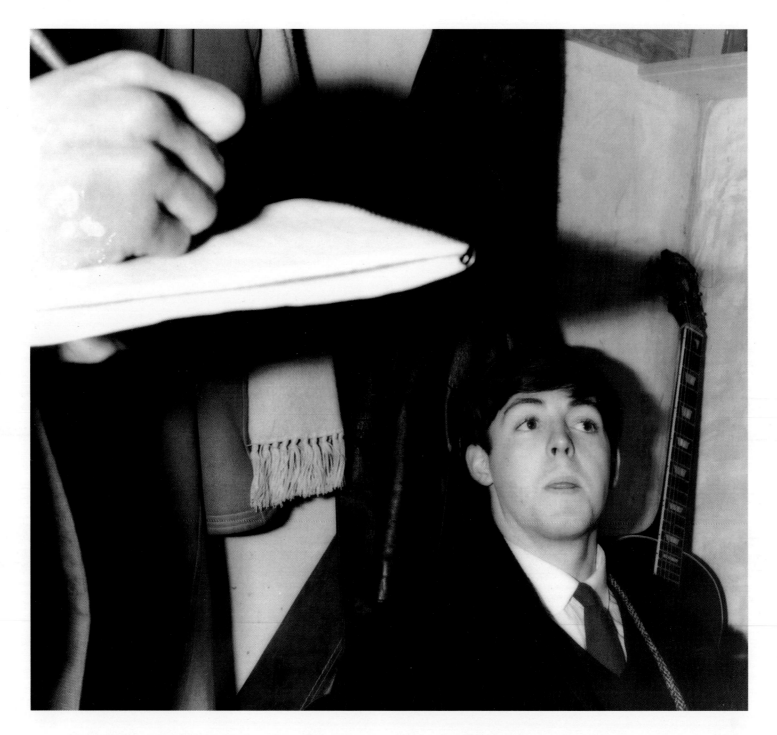

ABOVE: Paul doing his first press interview after a gig in North Wales, not long before "Love Me Do" was released. The hand and notebook belong to David Sandison of the *Wrexham Leader*.

RIGHT: Paul pretending to be famous, shortly before becoming very famous. He looks more like a bank clerk than a pop star.

PAGE 78: Elder brother getting ready for a gig in my "darkroom" in Forthlin Road. It became my darkroom only at night, when no light came through the curtains; during the day it was my bedroom.

PAGE 79: Paul helping Pete during rehearsals at the Cavern, showing the wall at the back of the tiny stage with the names of all the groups who played there.

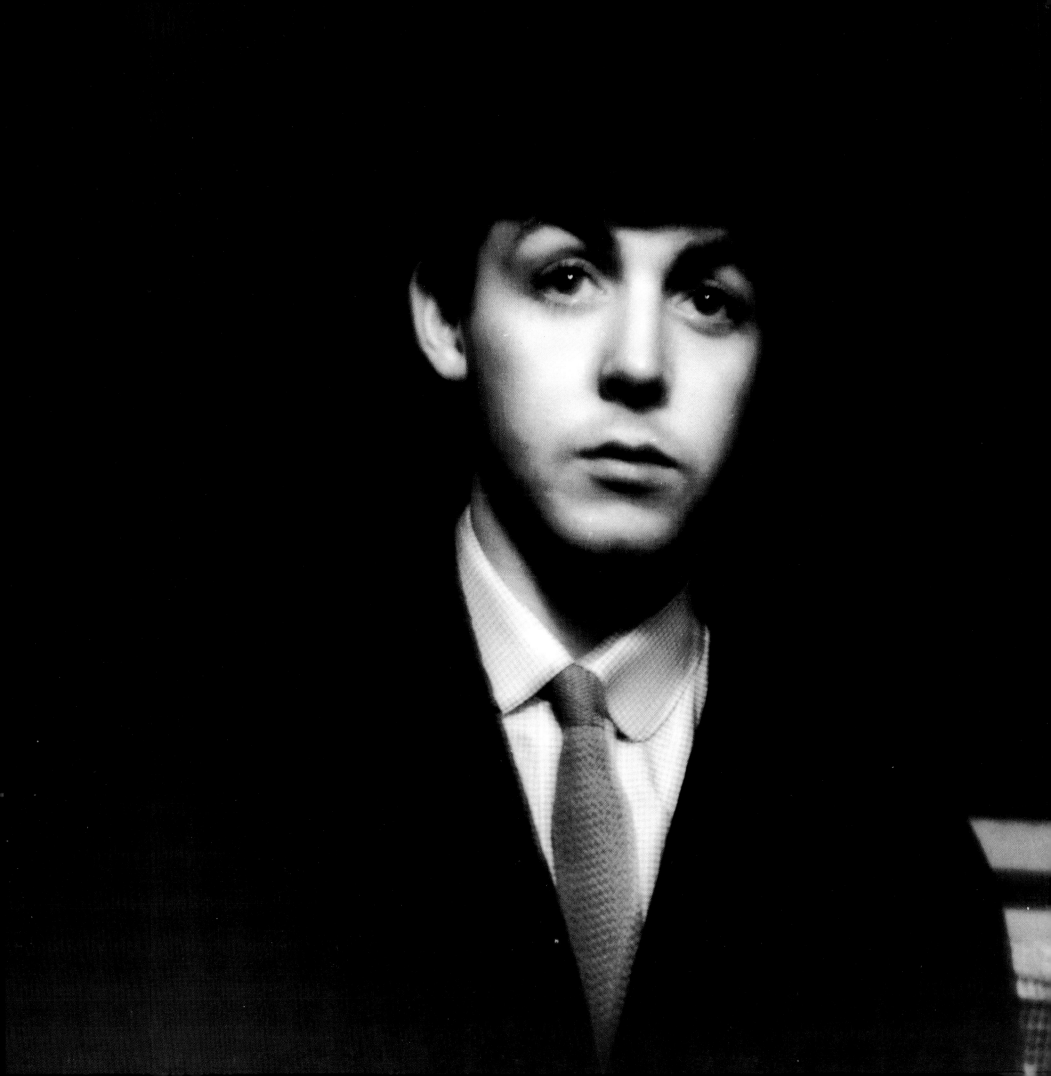

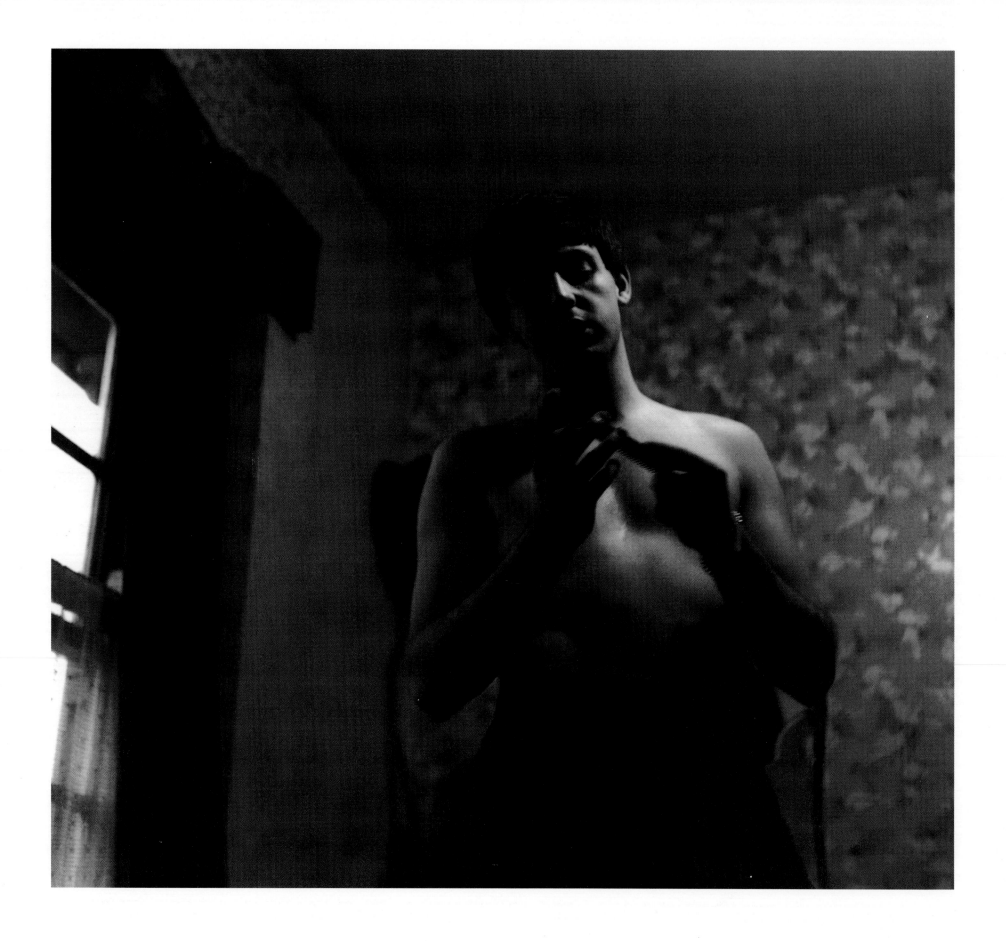

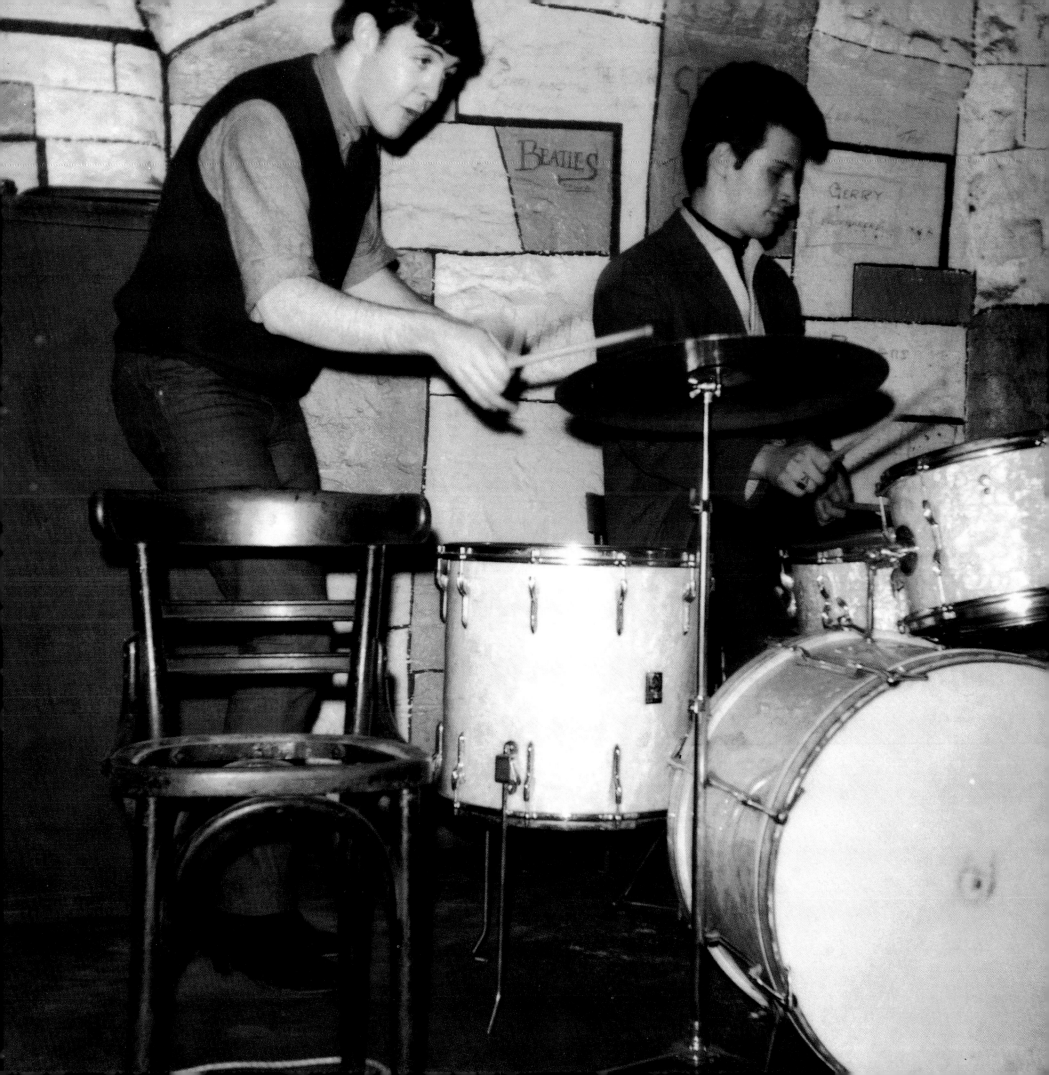

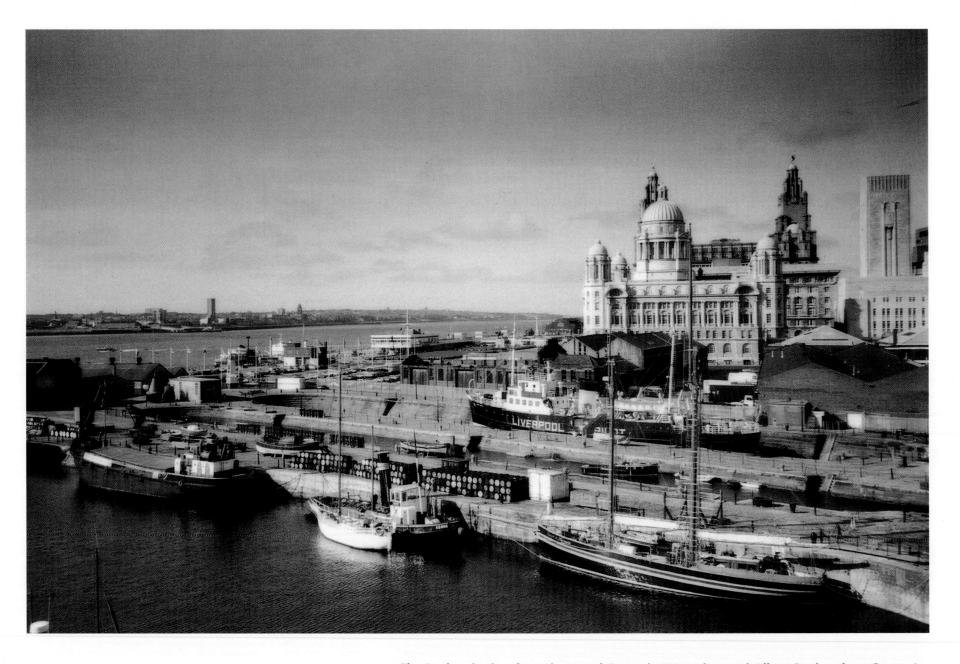

The Pierhead taken from the top of Granada TV studios and Albert Dock, where Cousin Ian works. The old dock fell into disrepair but was renovated and is now one of Britain's major tourist attractions. Thank good it didn't go the way of the Cavern, which was unbelievably demolished. However, a little bird informed me (but *don't* tell anyone else), that it's actually still there!

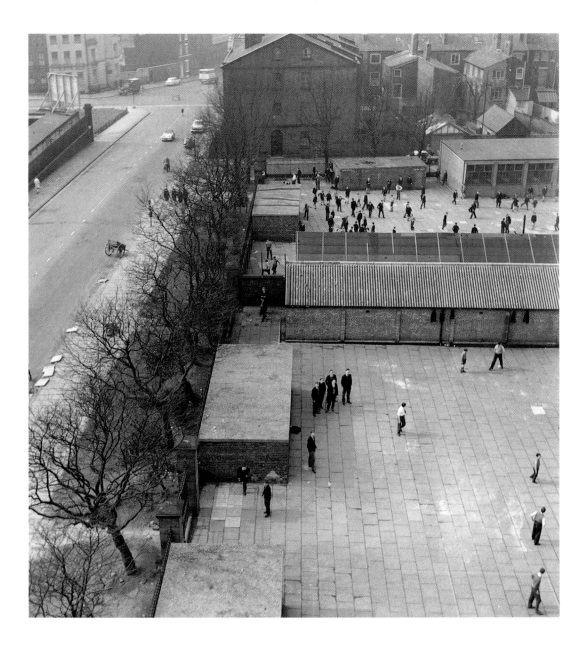

The upper and lower playgrounds of the Liverpool Institute High School for Boys, which George, Paul, and I attended. Before the houses in the background were demolished, two of them were the homes of Peter Brown, a close colleague of Brian Epstein's, and John Gorman, who was a member of Scaffold.

One day I lobbed a water bomb—a paper bag full of water —from the top yard and scored a direct hit on the prefect. Splat! Unfortunately, he caught me and I got a caning from our headmaster, "the Baz." I still see the prefect—on TV! He became one of Britain's best-known television newsreaders, Peter Sissons.

"The Inny," as we knew it, was closed by the Trotsky militants, but Paul is trying to reopen it as the Liverpool Institute School of Performing Arts, a sort of "Fame" school.

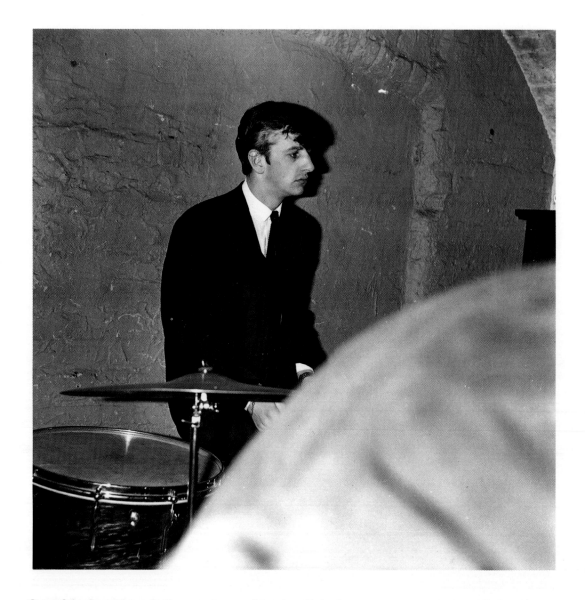

One of the first, if not *the* first gig Ringo played with the Beatles. Pete Best was sacked in August 1962, shortly after a show at the Tower Ballroom (page 5); by the next week Richie, as we still call him, had taken his place in the very same venue wearing a matching mohair suit.

There were lots of protests at Pete's sacking. He was very popular with the girls, mainly because of his good looks. Richie was not necessarily a technically better drummer than Pete, but he was more inventive (ask Jack de Johné). Pete was very good at the solid, old-fashioned rock-and-roll beat, but Ringo's drumming jelled better with Lennon, McCartney, and Harrison's music.

Pete's fans kicked up a stink—quite rightly—but events proved Richie was the right man for the job; he had a dry sense of humor, whereas Pete was a very straight, very shy person. A sense of humor was very important in that group. If Pete had been able to bite back at the others with humor, who knows? They might have told Epstein to sod off when he suggested sacking him.

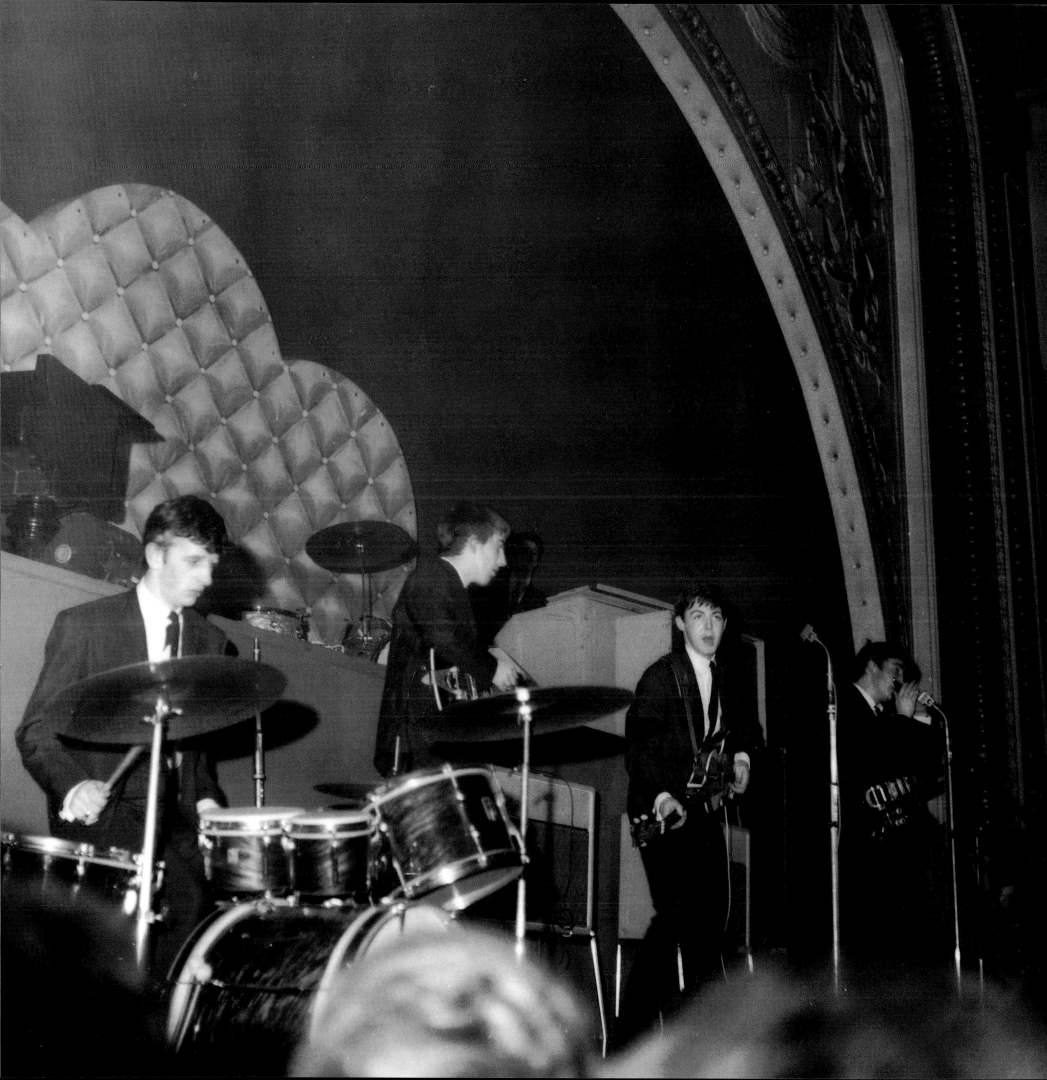

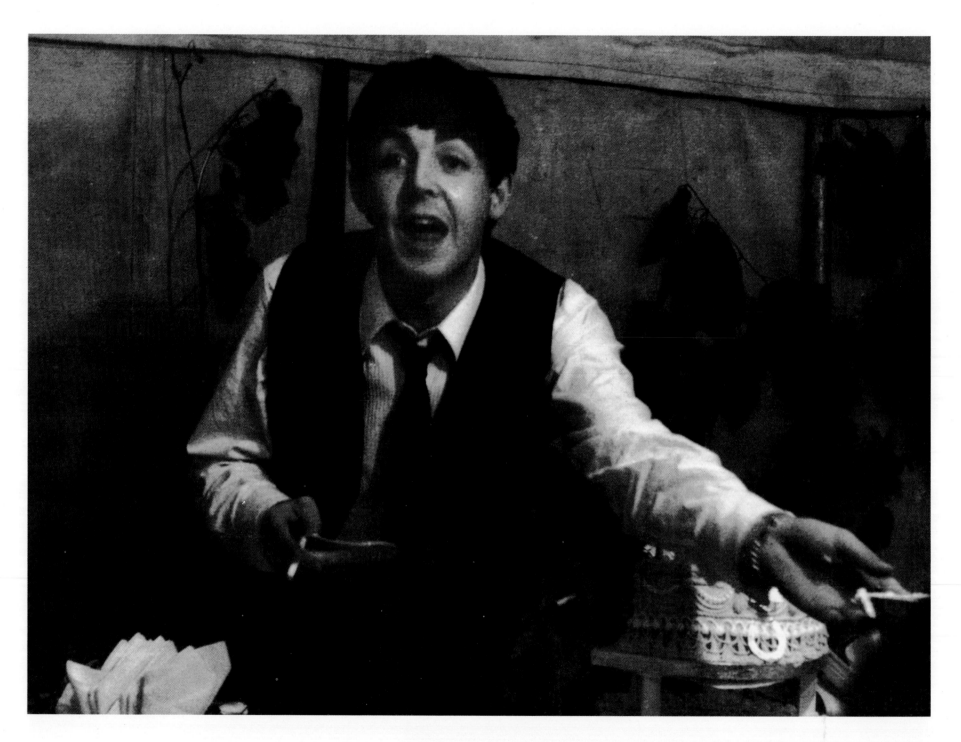

Inside the marquee, Paul giving out pieces of birthday cake at his twenty-first birthday party in June 1963. One of the guests was Sue Johnston, a big fan of Scaffold who later became a star of the television soap opera "Brookside."

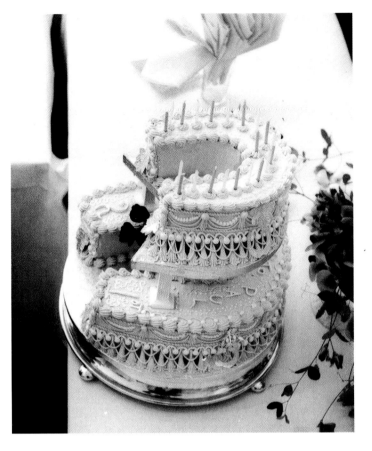

LEFT: The birthday cake. Although it looks more like a wedding cake, we thought it was really classy, and it cost a lot of money. It was the sort of cake that you only got when you'd reached the top.

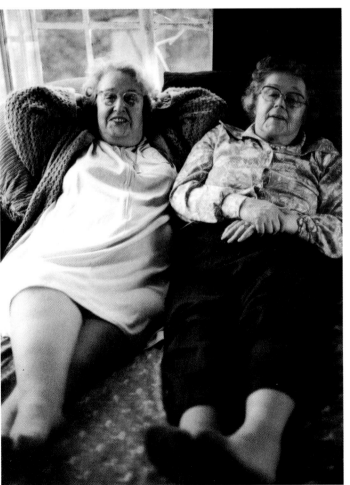

BOTTOM LEFT: "The Gin-Mill": On the Left is Aunty Gin, who was given the job of McCartney Matriarch by her mum and my Grandmum, Florrie, even though Gin was the youngest girl, and on the right, elder sister (Aunty) Mill, both lounging contentedly on a bed at "Sunset."

FOLLOWING PAGE: The party was at Auntie Gin's house in Huyton. By now, Paul could afford a marquee in the garden.

This is inside the house, where my comedy group, Scaffold, are performing for the guests. John Gorman and Roger McGough are onstage, and I'm photographing reactions to the act. The jokes are going well with Paul, his girlfriend Jane Asher, and an old school chum, Ivan Vaughan, but John Lennon was so pissed he kept shouting, "That's not funny" (until Paul told him to "Shhh!," which he did). Ivan Vaughan is a very important man; he was the member of the Quarrymen, who introduced John to Paul; without him there would be no Beatles. The rest, as they say....

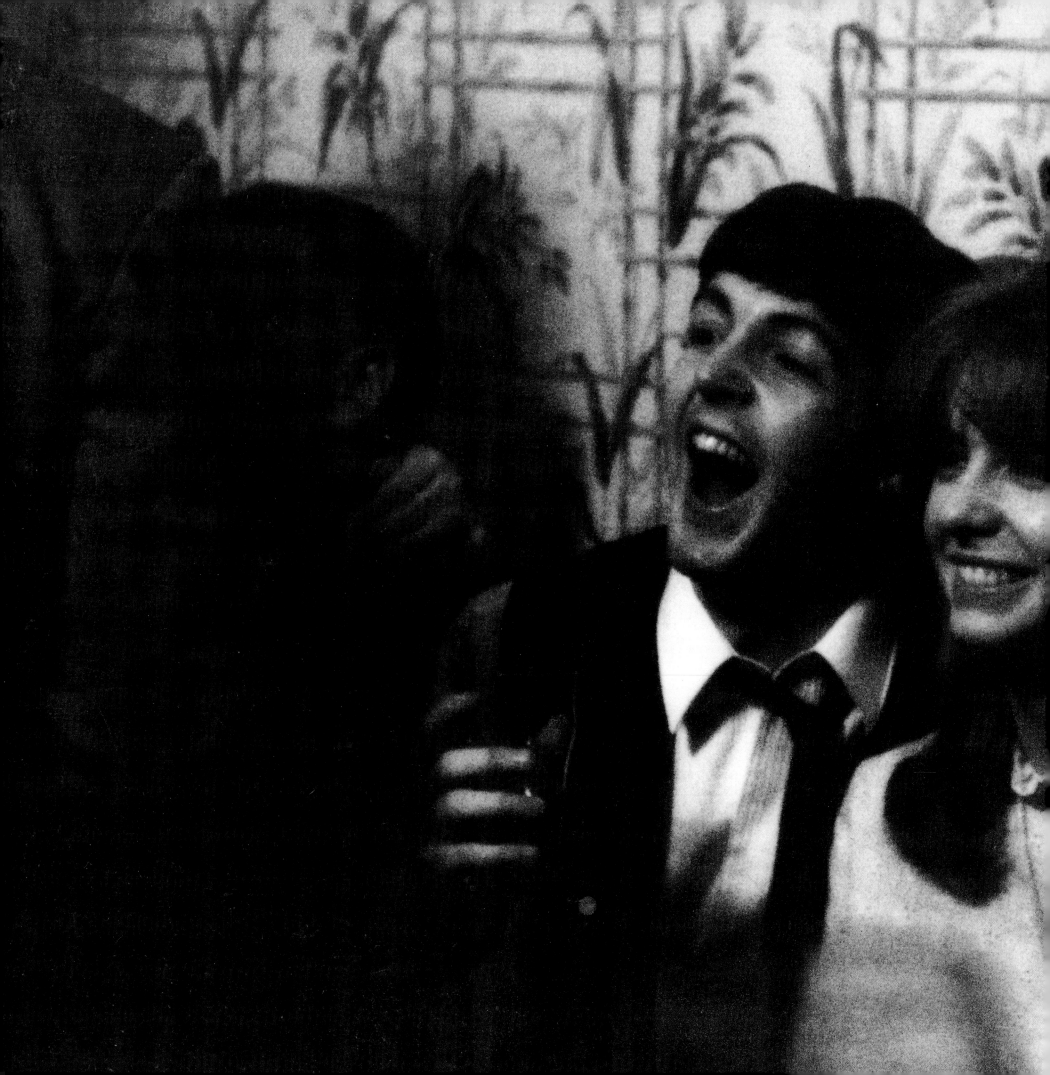

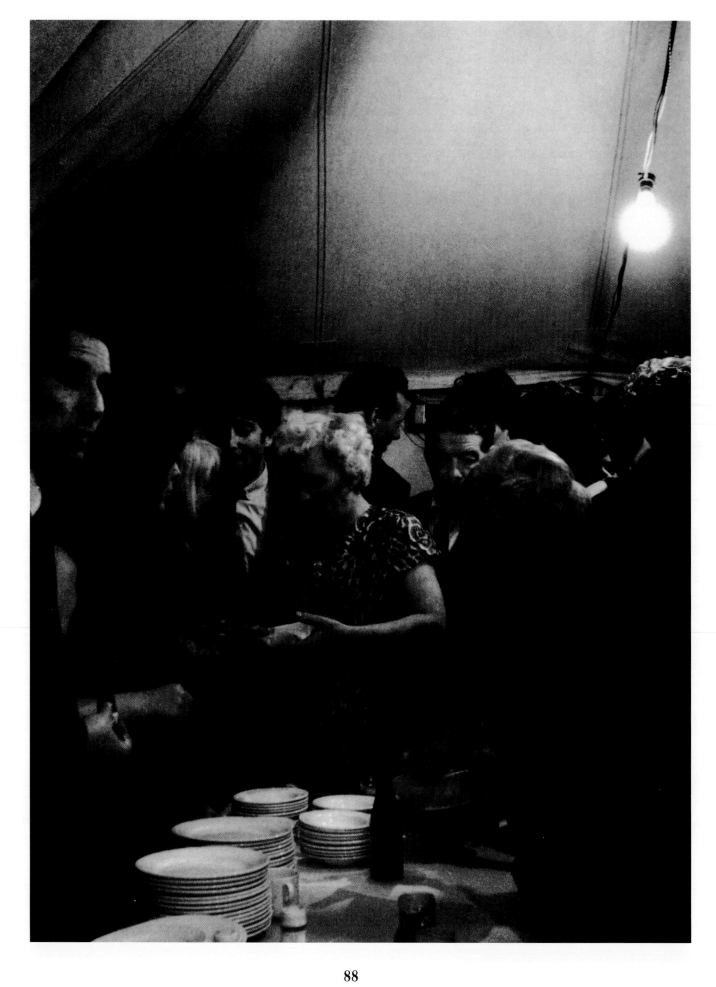

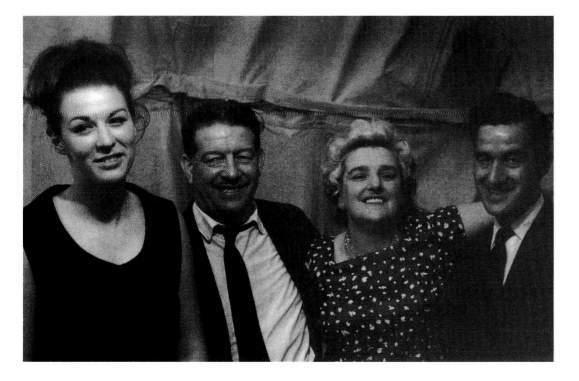

TOP LEFT: Trying to look as though they were frequently at parties in grand marquees are, from left to right, my first girlfriend, Celia Mortimer, Harry and Elsie Graves (Richie's mother and stepfather), and Harry Harrison, George's dad.

BOTTOM LEFT: Only a year earlier Paul had been begging me to make him look famous. Now one of the most famous pop people in Britain was at his party. In between Cousin Di and Dad is Hank B. Marvin, lead guitarist of Cliff Richard's group, the Shadows. Yes, right there in Auntie Gin's front room!

Ironically, the Beatles had never been big fans of Cliff and the Shads. They'd watch them on TV and say, ''You wouldn't catch us in those crappy mohair suits.''

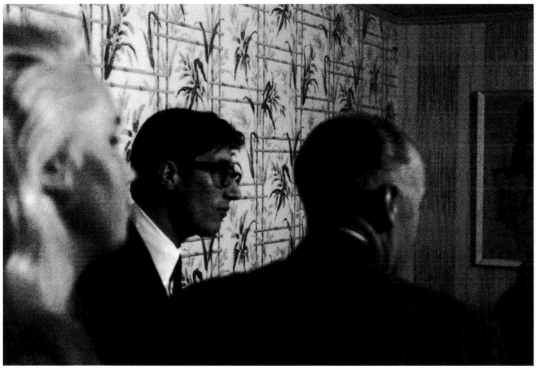

LEFT: Despite the fact that Paul was earning more money than we'd ever dreamed about, you can tell it's a working-class party from the sauce bottles on the table. No pretensions here. Standing with John is Cynthia, trying to keep him in order, but he was so drunk that he even beat up Bob Wooler (a friend!), breaking his ribs. In those days John's marriage was kept strictly secret from the fans, and it was rare to see him with Cynthia in a photograph.

The lady in the middle is George's mum, next to her is Harry Graves, Richie's stepfather, and Pete Shotten is peeping around the post on the right.

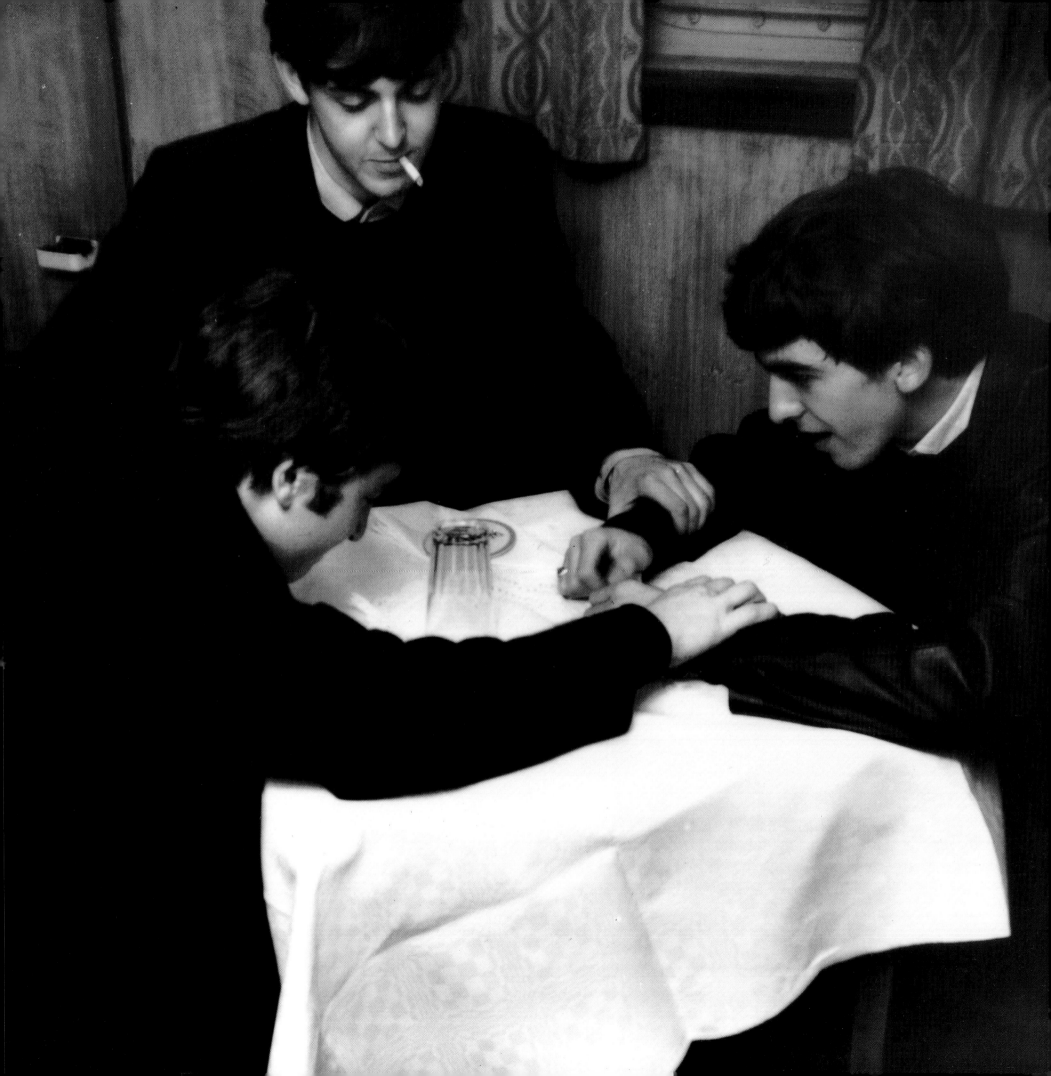

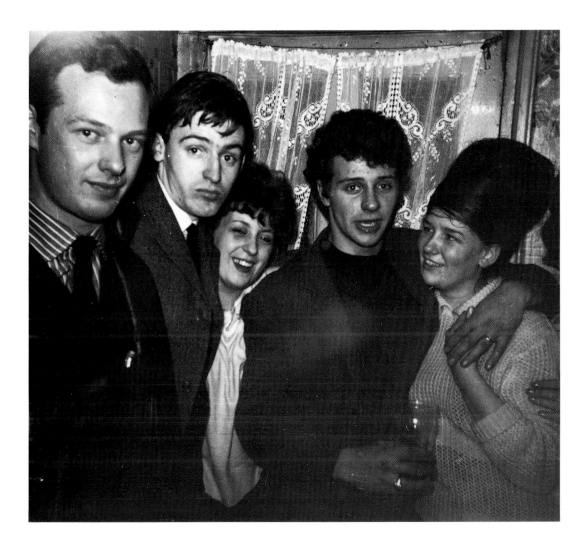

LEFT: The strange apparition standing next to Eppy is me, smashed out of my head. And Pete Best, with his beehived companion, isn't in much better condition. Brian is his usual cool self, sober, wearing his gloves, "David Frost" shirt, knitted tie, and leather jacket, not a hair out of place. He's slumming with the lads—he came from the posh part of town but loved a party in a working-class house.

We're in the back kitchen at a party in Liverpool. I think it was either Sam Leach (promoter) or Rory Storm's place; later his drummer joined the Beatles.

LEFT: On board the *Royal Iris* just before the boys performed on the all-night Riverboat Shuffle. They're in the second-best dressing room—Acker Bilk had the star's room—behind the captain's bridge.

We'd heard of something called a ouija board. We knew you turned a glass upside down on a table and somehow it would connect you to the supernatural. So the boys held each other's wrists to create a magic circle. The only thing we didn't know was that you had to put your hand on the glass!

An interesting question: Where's Pete Best? He'd probably wandered off somewhere because he never completely jelled with the others. Most likely he was with some beautiful girl below deck. Poor Pete!

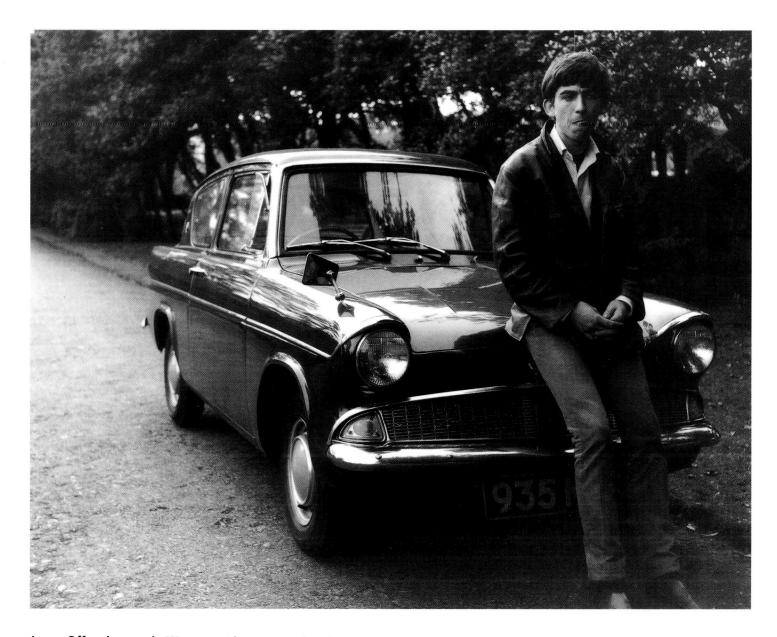

LEFT: Off to the match. We weren't huge soccer fans but tried to get to the major games if our local teams were involved. A few years ago we were driving to London for the Cup Final and felt the need to commune with nature. Among the light relief here are Ian McCulloch (former member of Echo and the Bunnymen, left) and on the right is Cousin Ted Robbins. Ian, being a mega pop star, was going to fly to London, but when he heard the McCartney mob was driving down in a van he canceled the flight to join in the fun.

ABOVE: George with the first car owned by any of the Beatles. A Ford Anglia, not very classy but it was all he could afford. I took this picture and the one on the next page to do him a favor. Years later I learned that he'd made a deal with the man who sold him the car. He apparently said, "You get some photos of the Beatles with the car, and we'll let you have it for a reduced price." Somehow George forgot to tell me, and so, I reckon, he still owes me a percentage of the discount. What's more, I think Paul bought his first car— a Ford Classic—from the same dealer, so I bet he got it cheap as well, but at least I got it later on as a hand-me-down.

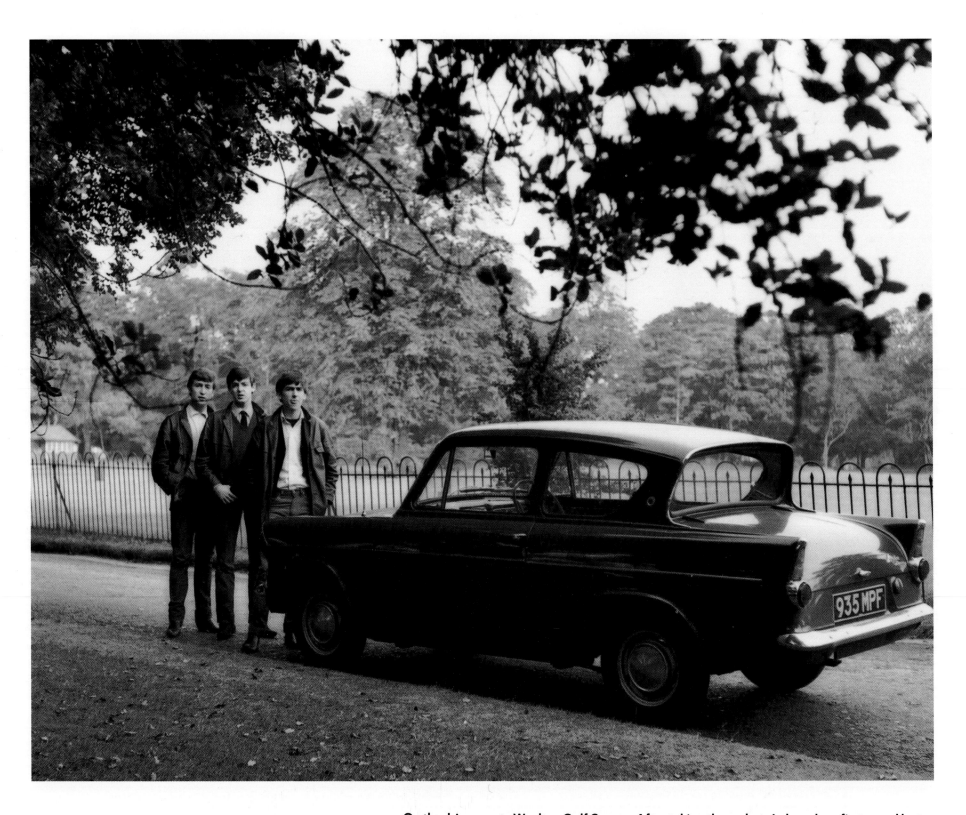

On the driveway to Woolton Golf Course. After taking these shots I played my first—and last—game of golf with the Beatles. The only person worse than me was John. At least he had the excuse of being blind as a bat.

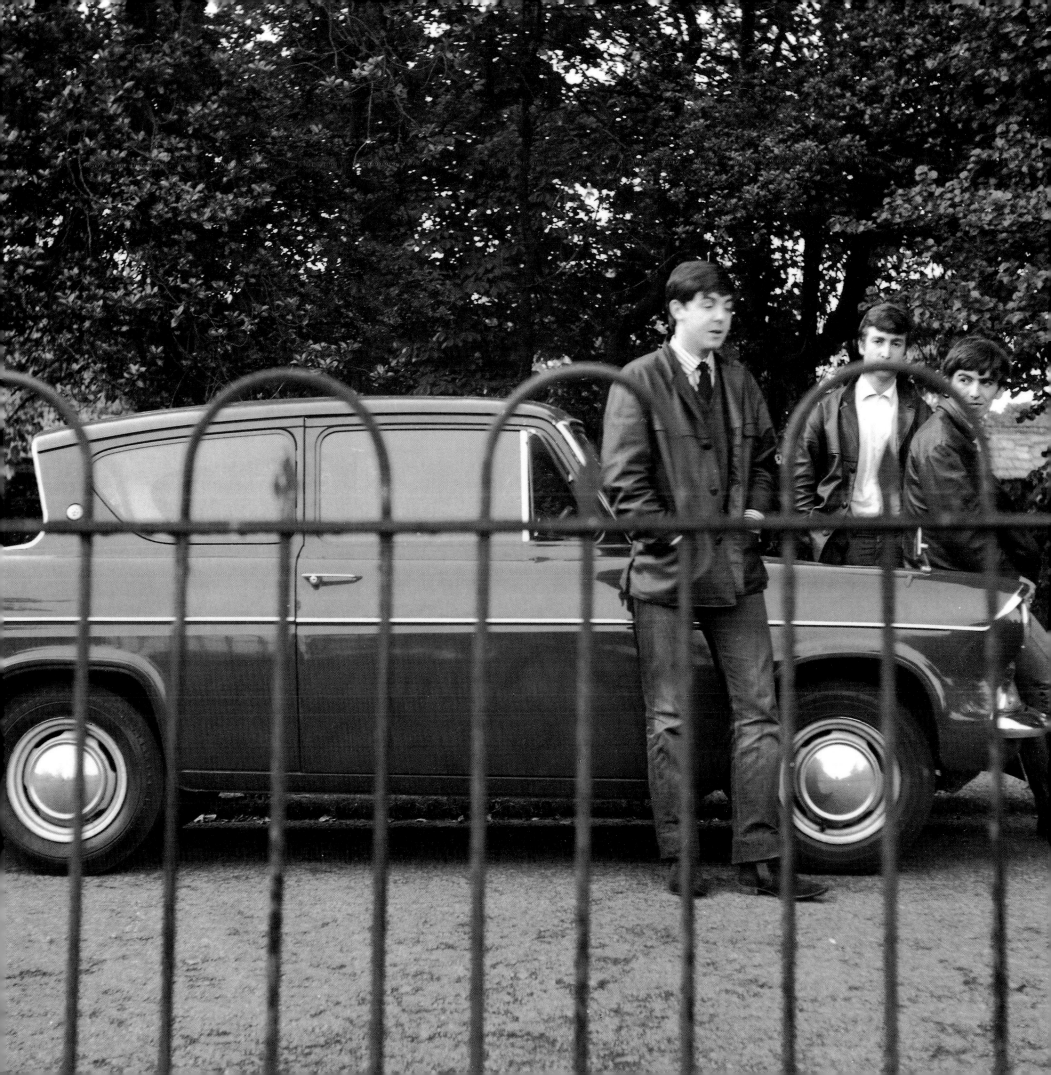

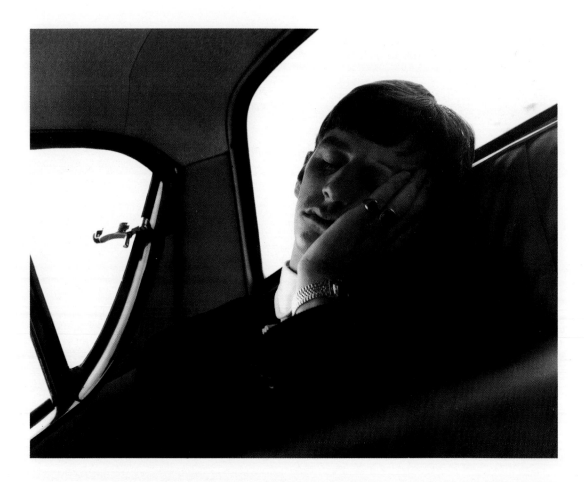

Richie resting in the back of Paul's first car, the green Ford Classic. You can see from what he's wearing on his hand how he got the nickname Ringo.

RIGHT: Not long after he bought the Ford, George could afford to trade it for a flash Jaguar. It was the first time I'd ever been in a car where you just pressed a button and the window wound up and down by magic. When he knocked on our Allerton front door demanding photos of his latest acquisition, I protested ''But, George, it's getting dark.''

''Bring your flash,'' came the reply.

''And it's raining!'' I added.

''Bring your umbrella,'' he finalized.

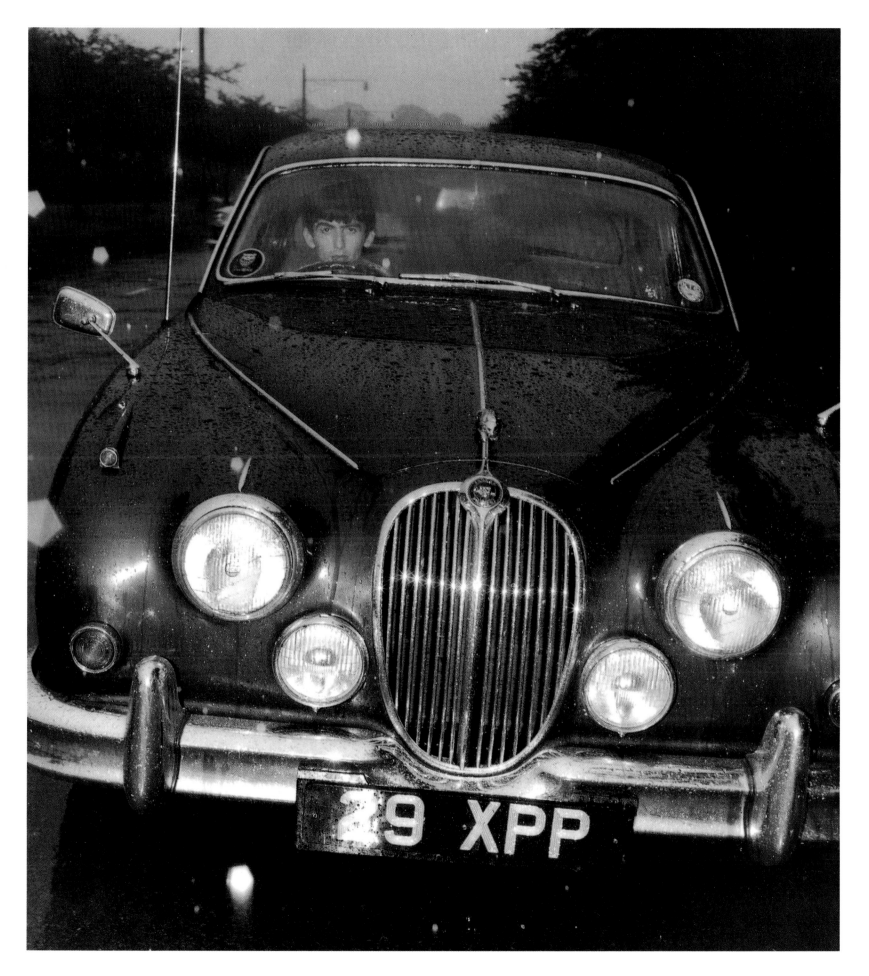

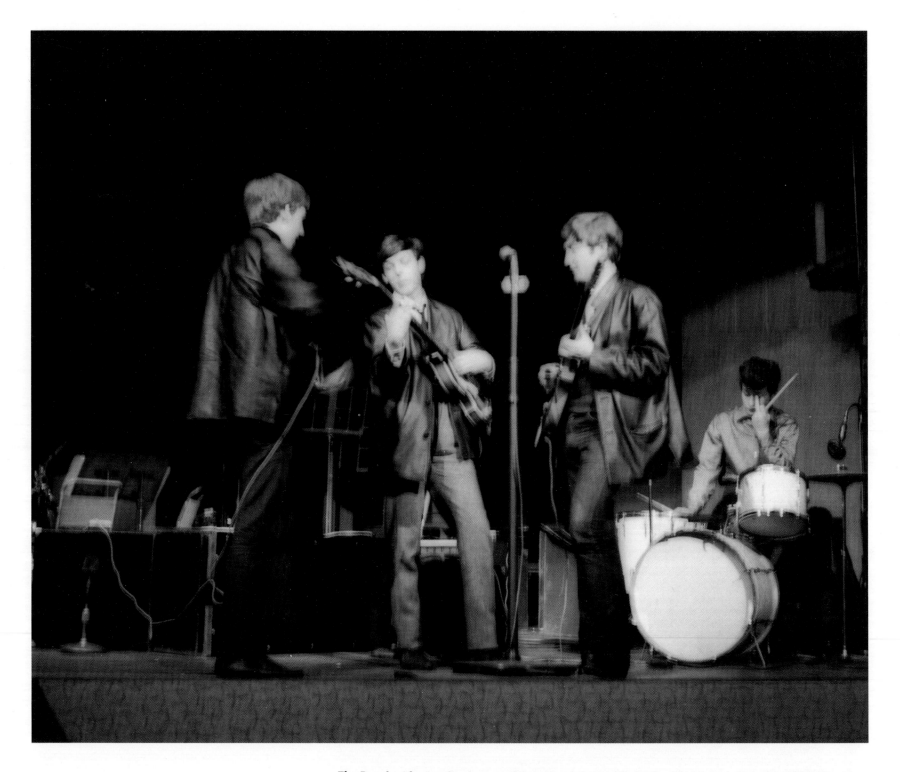

The Beatles' first radio show and Pete Best's last with the Beatles. It was June 11, 1962, five days after they had auditioned for George Martin at Parlophone, which resulted in the decision to sack Pete. Here (above) they're rehearsing in the afternoon, wearing jeans and leather jackets; when the live broadcast went out in the evening (right), Eppy insisted they wear their suits—on radio!

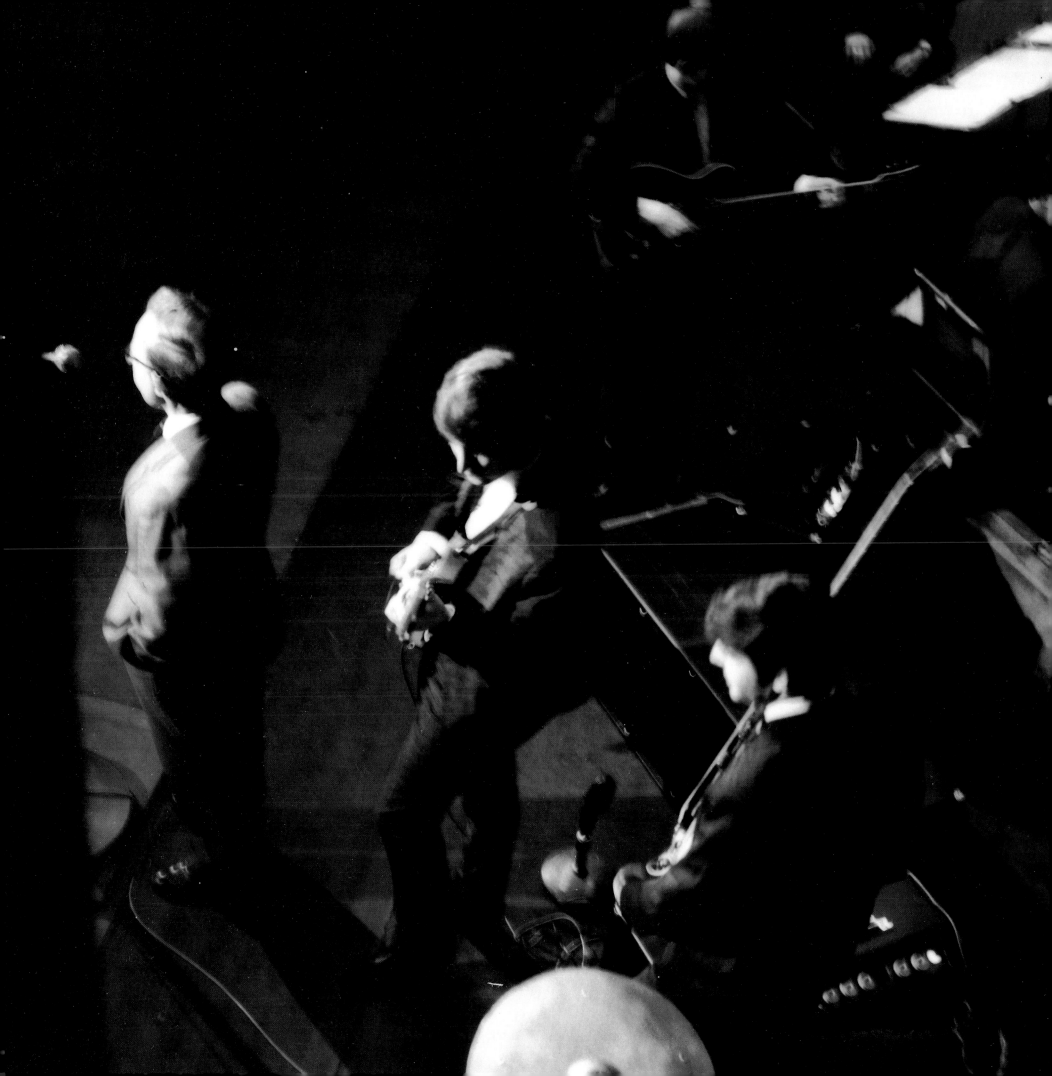

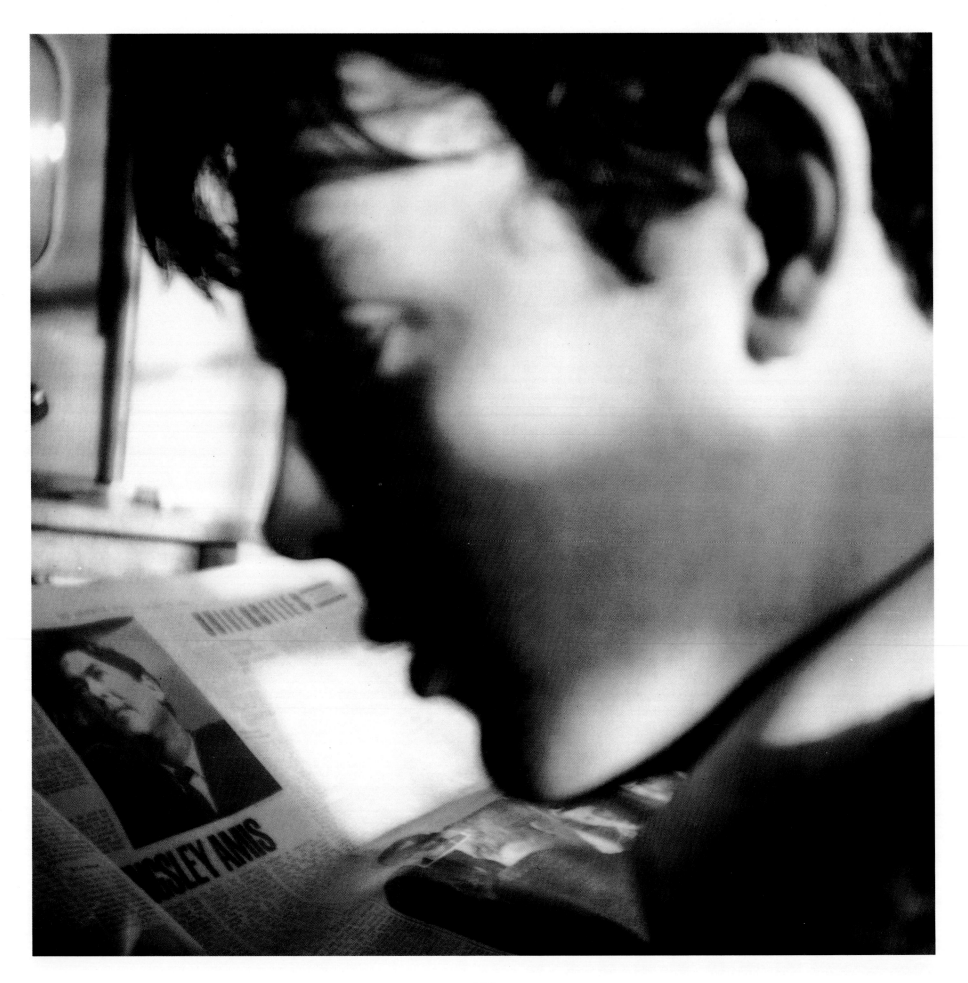

LEFT: Exposing the myth that we were ignorant yobboes—Paul reading an article in a heavyweight newspaper about the novelist Kingsley Amis. In those days, I suppose, we were quite a literate family; Our Kid got a prize for English literature and Mr. Durband, his teacher, wanted him to go to university.

He's in front of our black-and-white television. Under it is the gramophone from which we learned all our Everly Brothers and Little Richard songs.

PAGE 102: The Cavern dressing room; John and Paul are gooning with Ray McFall, the club's manager, and Cynthia.

As you entered the Cavern at night, the first things to hit you were the heat and the smell. It had been a fruit warehouse, so you got a smell comprised of rotten fruit, musty sweat, leaky toilets, and disinfectant. Someone should have bottled that smell. They'd have made a fortune selling it, like the more enterprising Liverpudlians who, when the Beatles left Liverpool, sold off bits of the stage and the bricks from the walls. Strangely, they flogged far more bricks and wood than were ever in the building. (I should know—Uncle Harry and Cousin Ian actually built the Cavern stage.)

As messenger to "get Cokes in" for the boys, I'd return through the dark archways, past the "Cavern Stomp" dancers and the fans, and bang on the solid iron door of the dressing room. By the time I got there, I'd be sweating like a pig.

But inside it was freezing, so the management generously installed a one-bar electric fire [see frontispiece].

PAGE 103: Long John Baldry, who later became a great blues solo star. He is the man Elton John named himself after when he played in the Hoochie Coochie Men. He and Paul on Lime Street Station, Liverpool, swapping records.

John would bring rare American blues records he'd obtained from friends in the merchant navy in London and exchange them for early Bo Diddley, Chuck Berry, Tamla, and Ray Charles records, which we'd get from friends who sailed into Liverpool docks.

A couple of years later these two couldn't have chatted in a public place without being torn apart by their fans, much the same as me in downtown Heswall Village now.

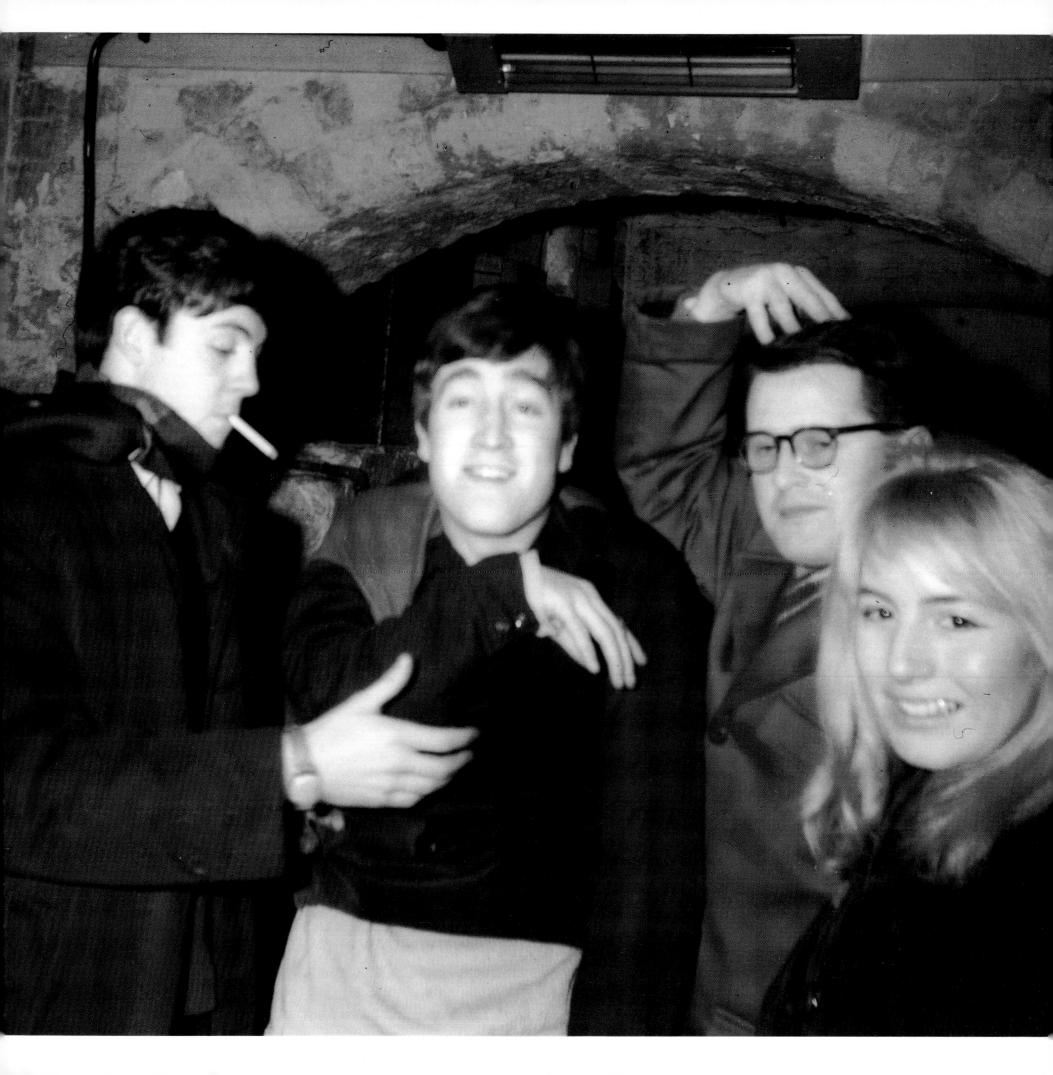

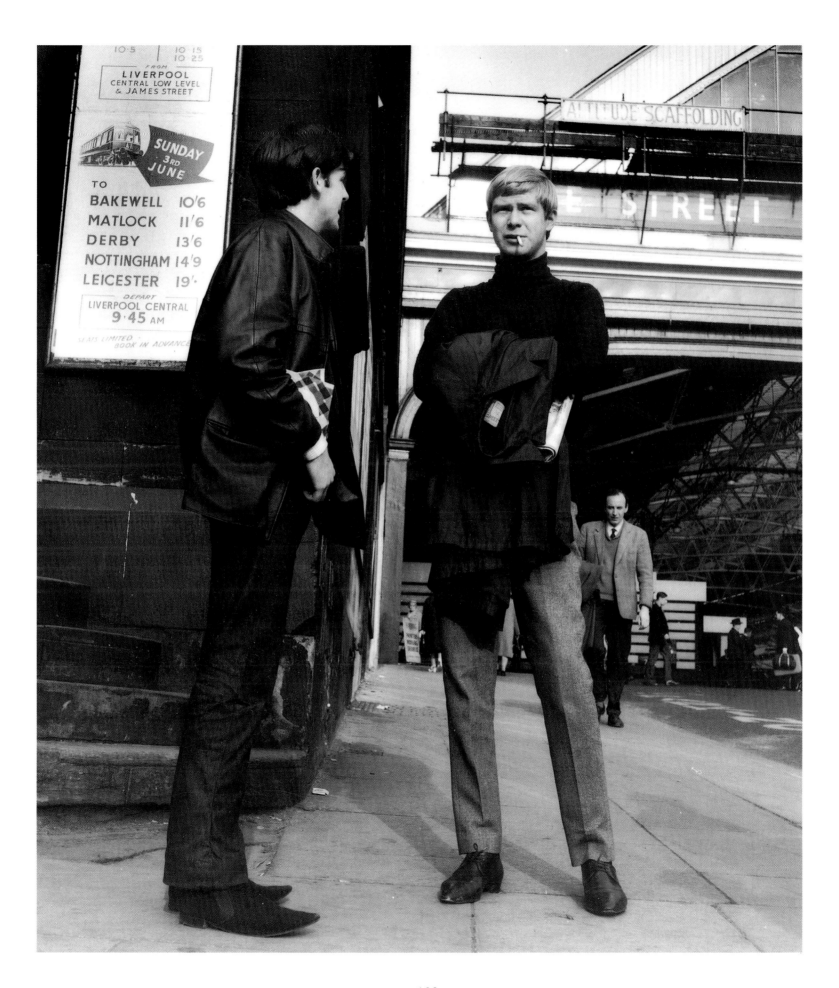

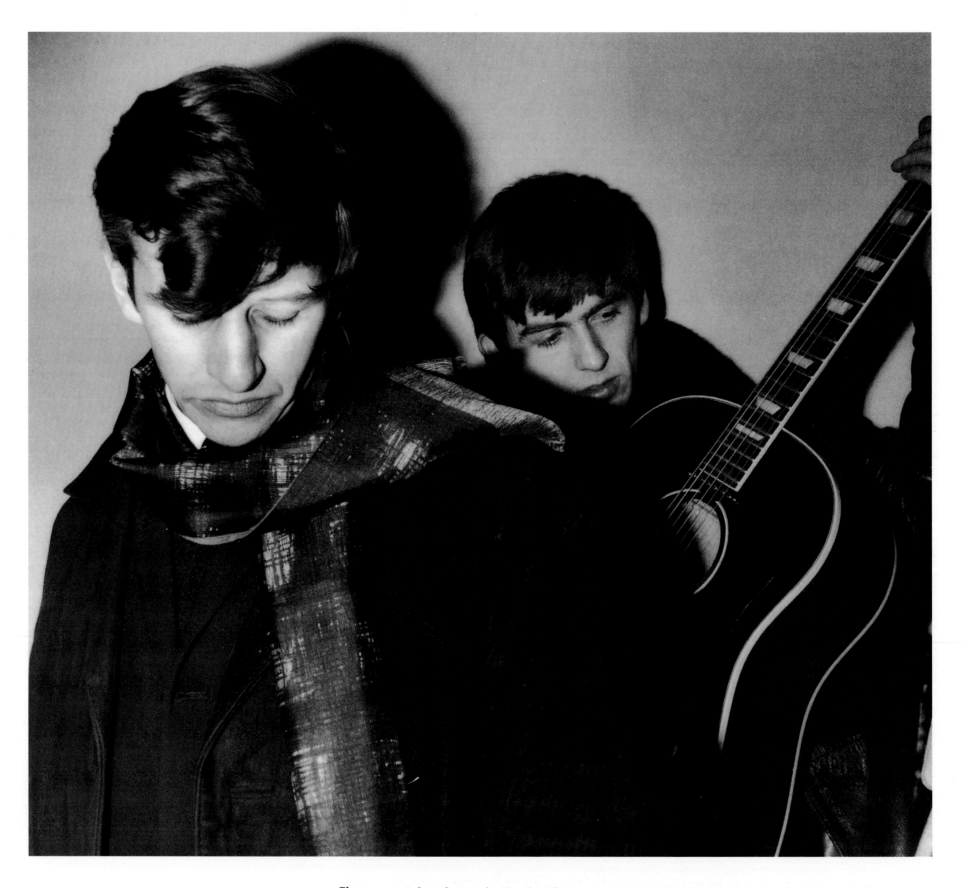

These were taken during the Beatles' first press interview for the *Wrexham Leader*. You can tell Richie hasn't been with the group long because he hasn't quite managed to train his hair into a mop-top.

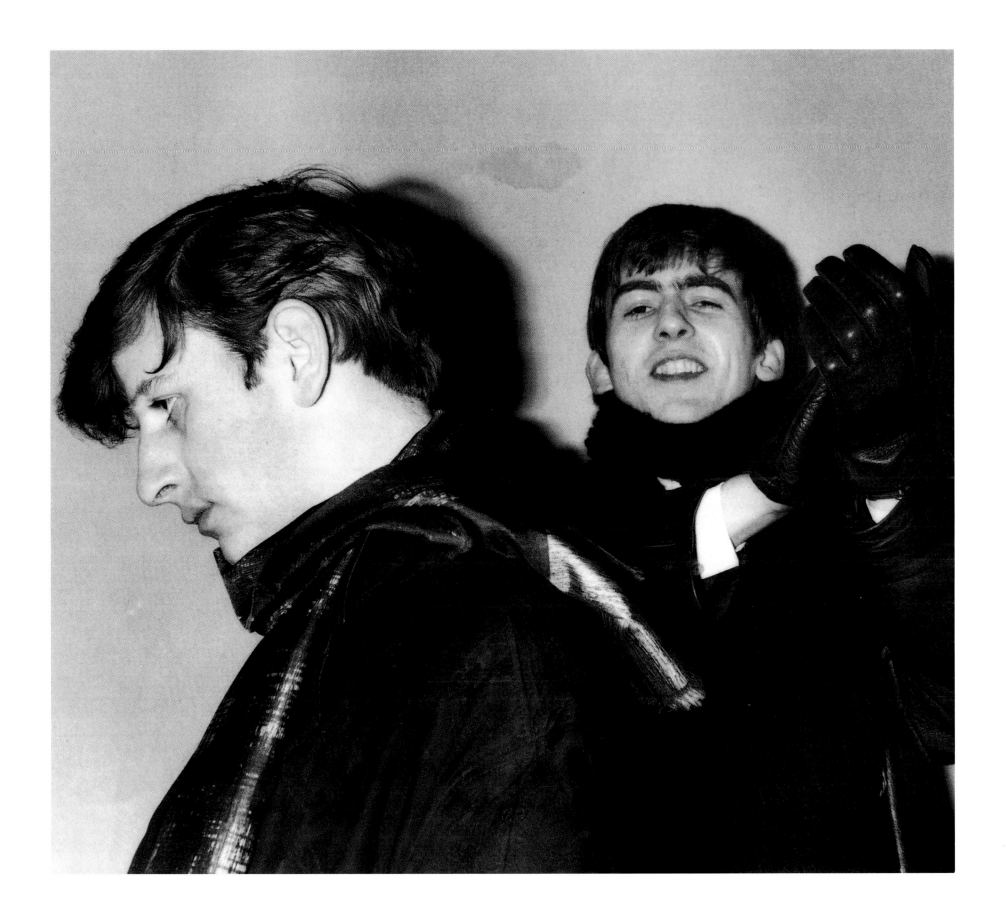

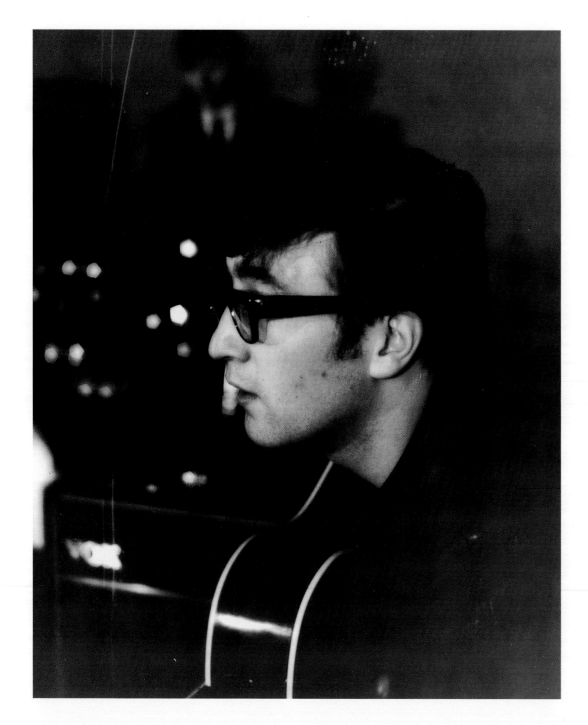

John rehearsing down the Cavern in his glasses. He'd walk to the art college, past our school, with his glasses off. I'd shout hello and he'd wave back to a lamppost or a postbox!

RIGHT: Paul, who never gave me credit for my photographic work, finally phoned me one year to say that this is a marvelous and important shot because it shows the truth. This is how it actually was, the Rodgers and Hammerstein of pop at work; John's musical hard edge merging with Paul's melodic feel, both creating genius... *together*. They're hard at work, their hands forming those strange chords that made their music so distinctive.

At their feet, scribbled in a school exercise book, are the words to "I Saw Her Standing There," which they're still working on.

Apart from its archival importance, this picture is particularly significant because it shows the *third* wallpaper in our front room.

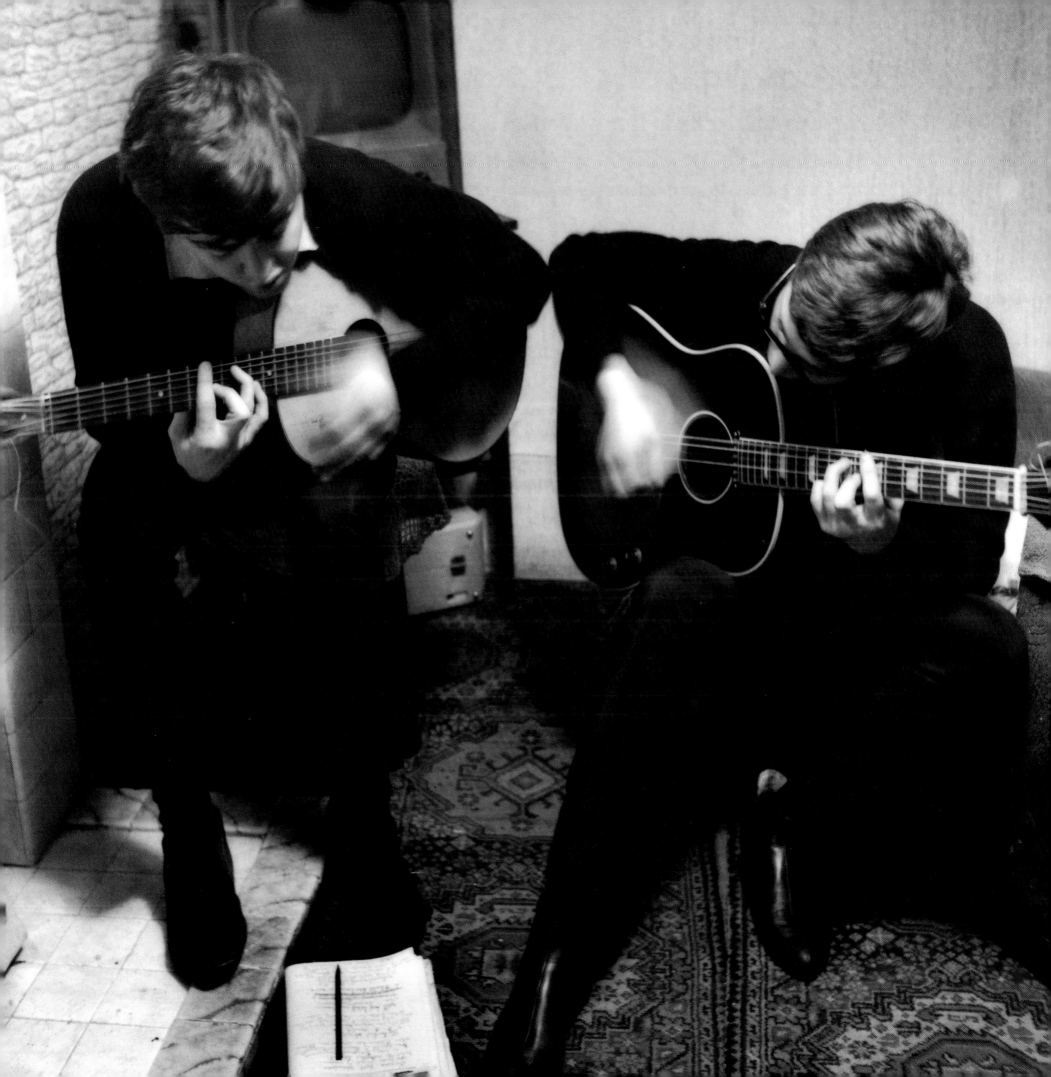

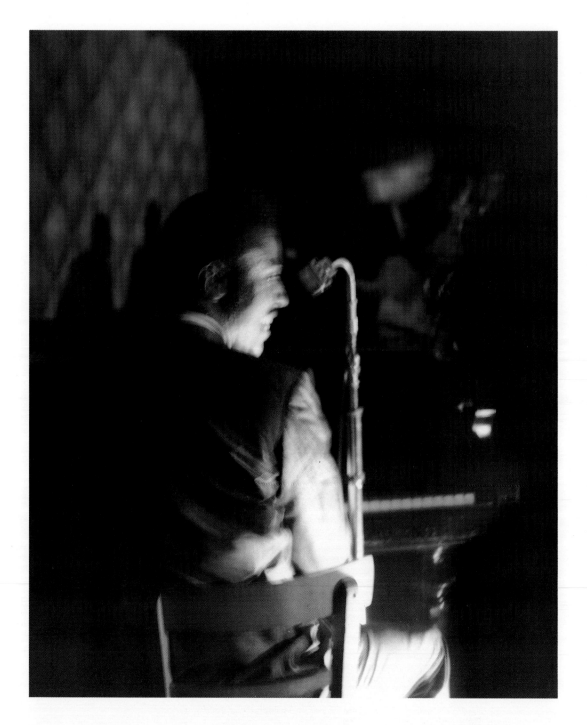

Shots taken during concerts at the Tower Ballroom at the mouth of the River Mersey.

ABOVE: One of our biggest heroes of all time, the epitome of rock and roll, Little Richard.

RIGHT: I shot this through a hole in the backdrop. Little Richard fancied Ringo and kept turning 'round to smile at him. I knew it would make a great photo but because of the technical limitations of my twin-lens-reflex camera, I couldn't shoot and watch Little Richard at the same time. So I handed Ringo the camera release cable and told him to click when I gave him the word. As Richard turned 'round with a huge grin I shouted to Ringo "Now!"

"Pardon?" said Ringo. By the time he'd clicked the shutter, all I got was a picture of the back of Little Richard's head.

PAGE 110: Little Richard giving his all. Look at his sound system—a little 'Alpha' box at the edge of the stage. Years later, I was launching a book in Los Angeles at the Beverly Hills home of my good friends, the Sputniks. I invited everybody I knew, including Richard (who didn't show) and Joan Collins (who actually turned up, just prior to her *Dynasty* superstardom). After the party and nearly dusk, I was driving from the house when a car drew alongside, Little Richard leaned out and asked directions to the party. Pretending not to recognize the King of Rock 'n' Roll, I said, "Why, who wants to know?" The man in the passenger seat with a Bible on his knee whispered "It's Little Richard."

"No way," I replied.

"It is," exclaimed the passenger. "Look, I'm Little Richard." Turning on the interior light, he gave me one of his huge grins!

PAGE 111: Jerry Lee Lewis. He's not singing "Great Balls of Fire," he's actually screaming at the bouncers, "If you don't get that f——g kid off the stage, I ain't going on."

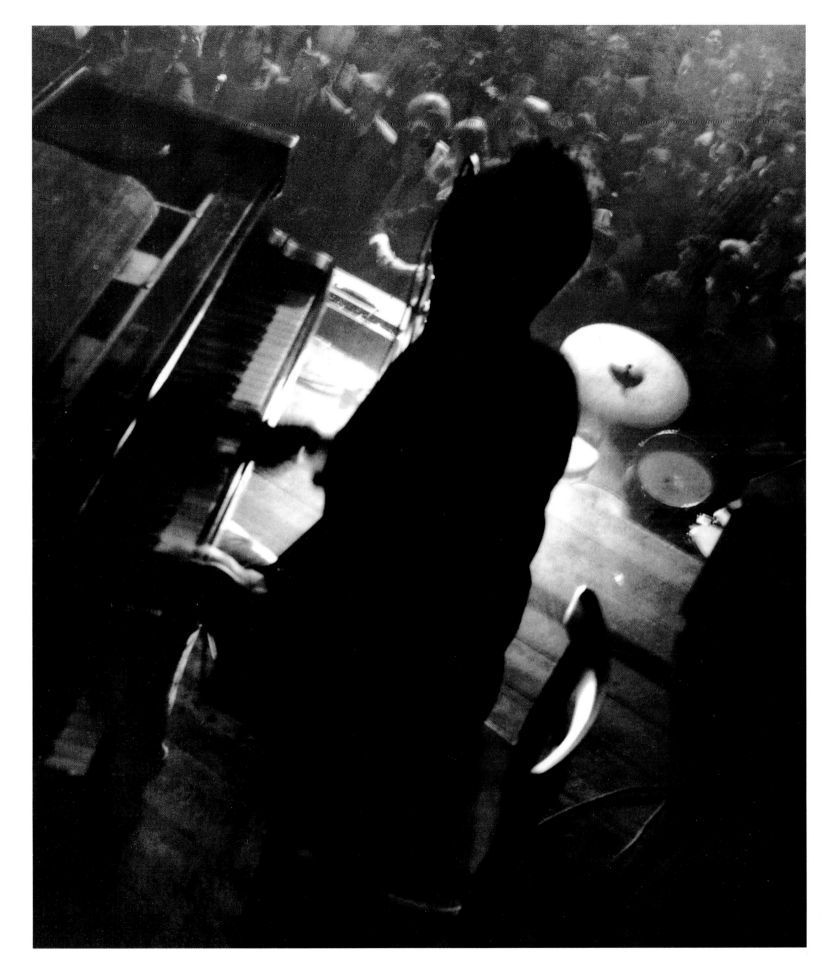

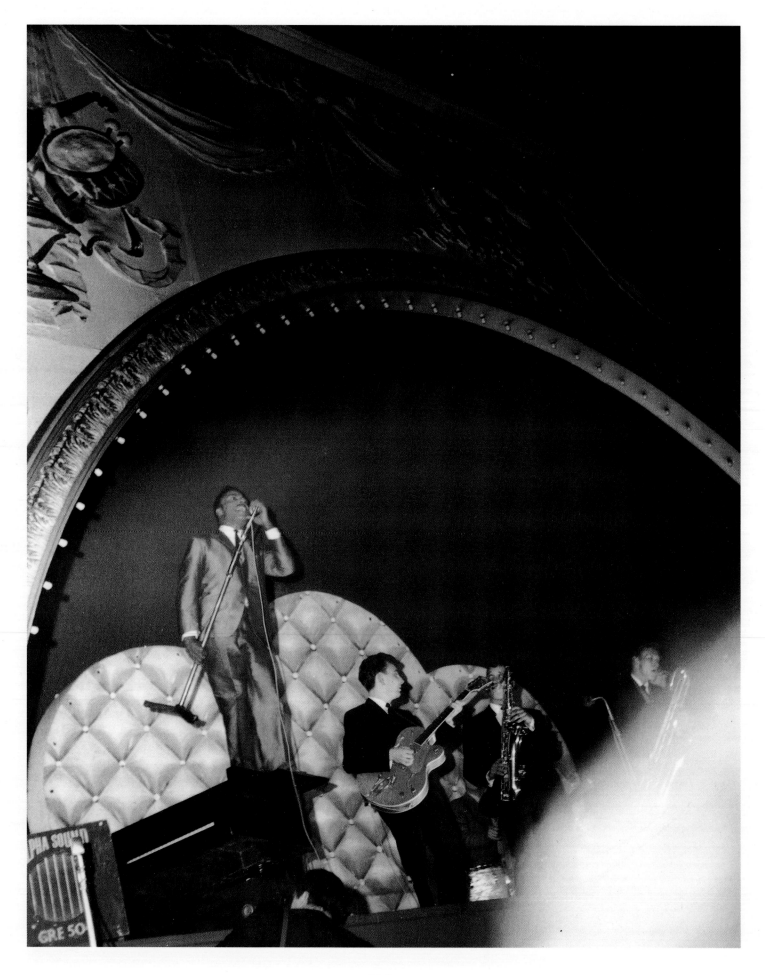

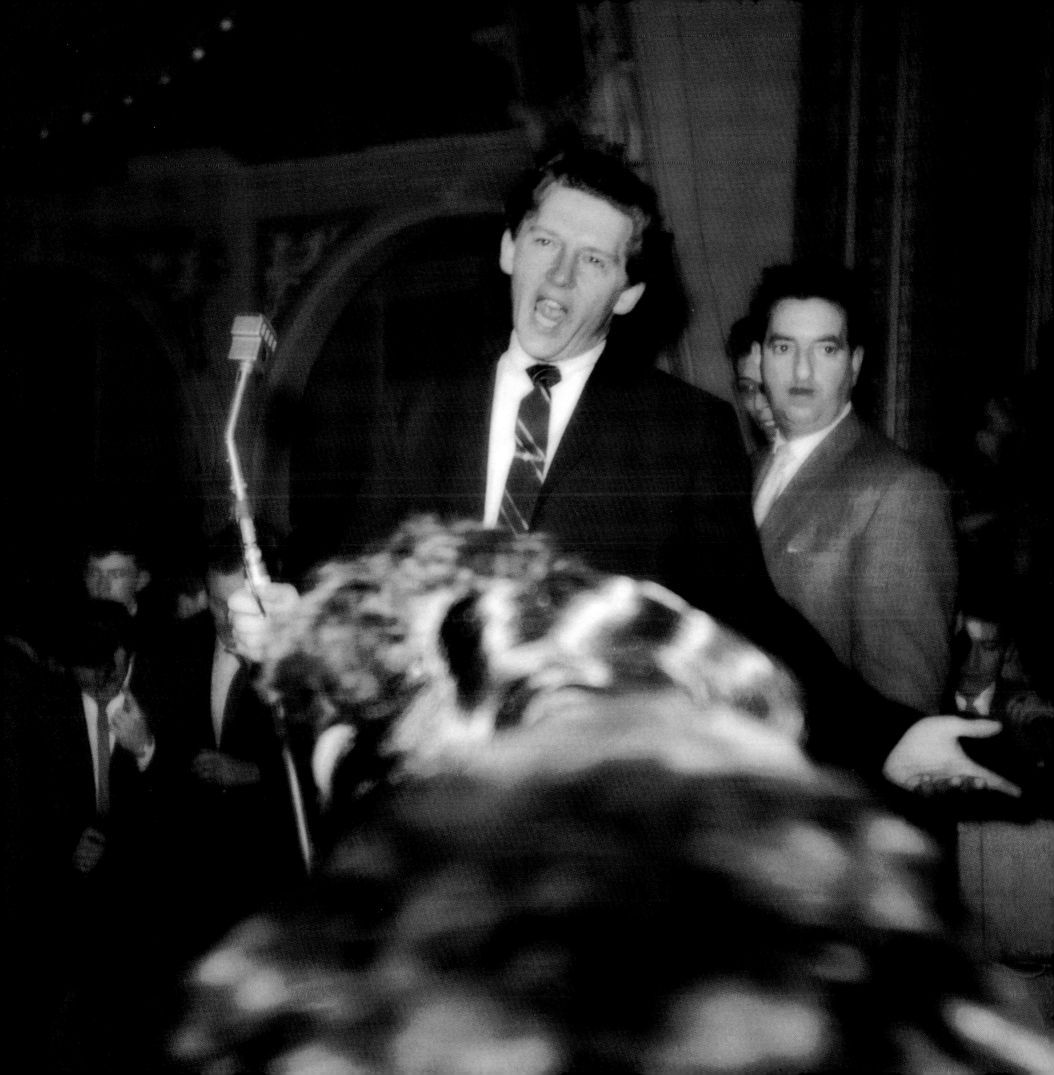

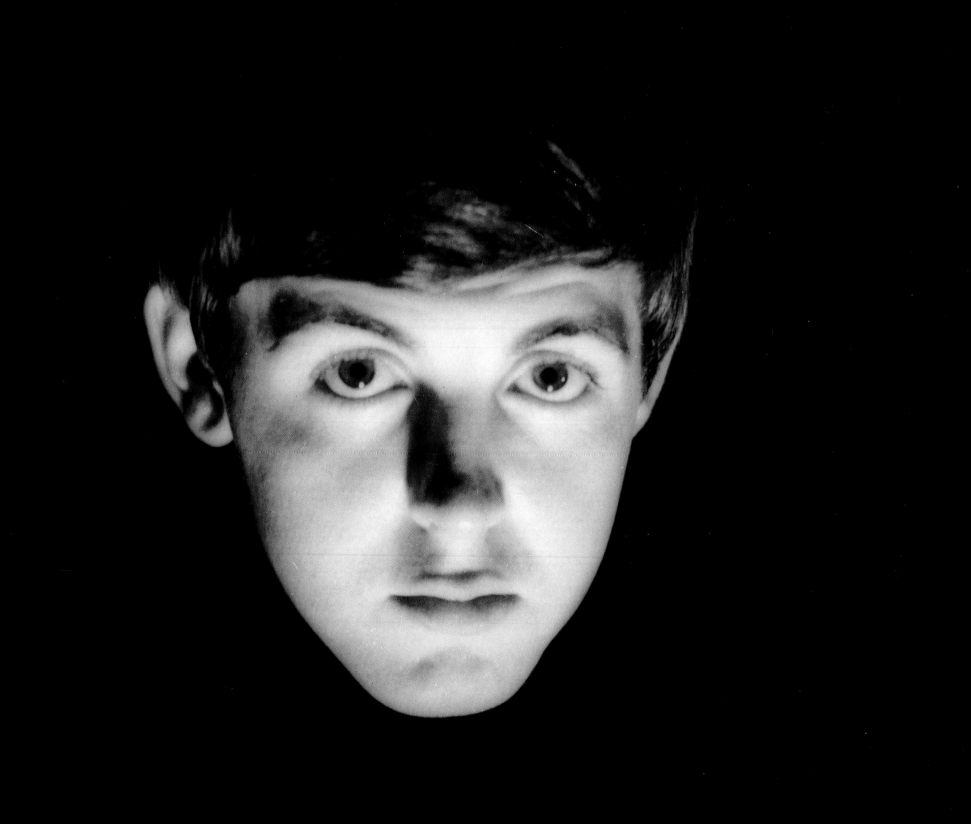

OPPOSITE PAGE: Experimenting by front-lighting Paul's head against a completely black background. He had to hold the pose for ages without blinking until I got the exposure just right. I took this in about 1962, but it's eerily similar to Robert Freeman's cover shot for *With the Beatles* a year later.

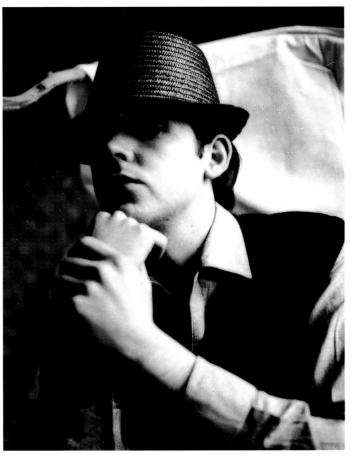

TOP LEFT: Paul in a straw trilby plus tree branch. I'd read about posing your subject in front of a backcloth, so I borrowed one of our bedsheets and hung it behind him. But, as you can see, I forgot to iron the creases out of it first.

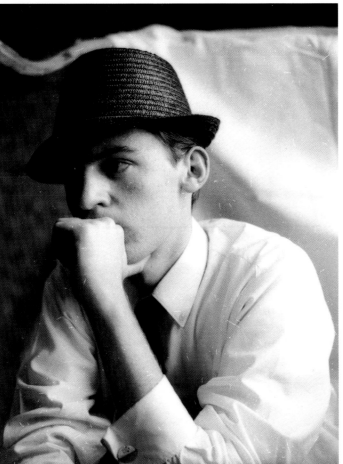

BOTTOM LEFT: "Brother Francis": Fed up with making *him* look good all the time, one day I must have told Paul "O.K. it's my turn. You make *me* look like Elvis for a change." This fine portrait of Frank Sinatra McCartney was the result.

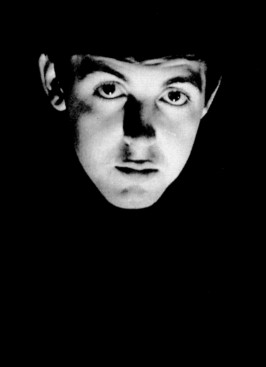

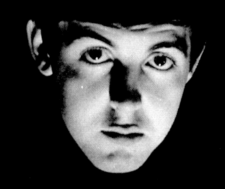
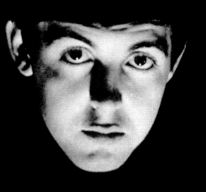
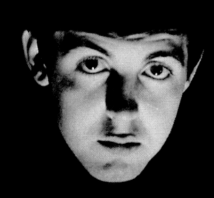

A silk-screen print of the photograph on page 112. I could have used any colors in the rainbow for this but I couldn't see it in anything but black and white. I simply imagined it as wallpaper, with these ghostly heads floating through the night.

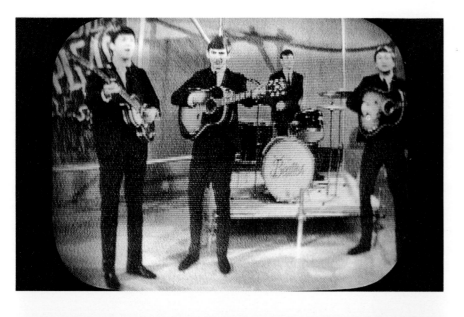
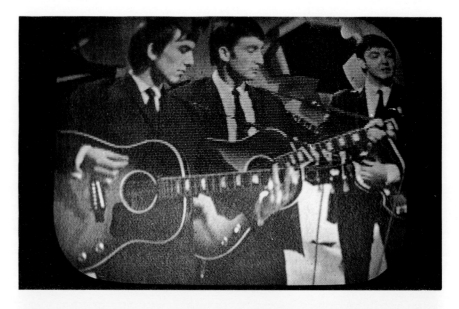
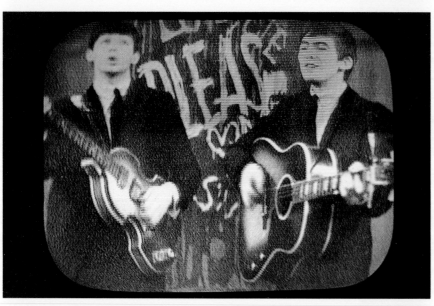
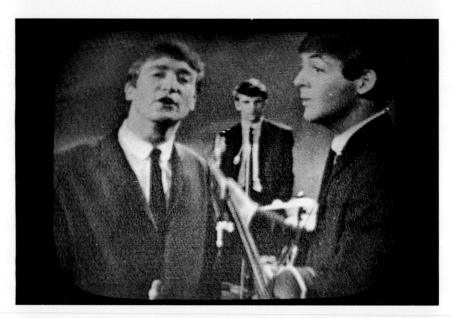
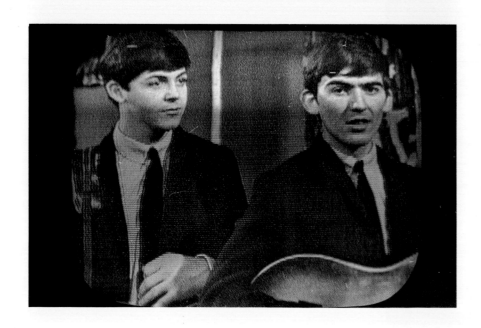
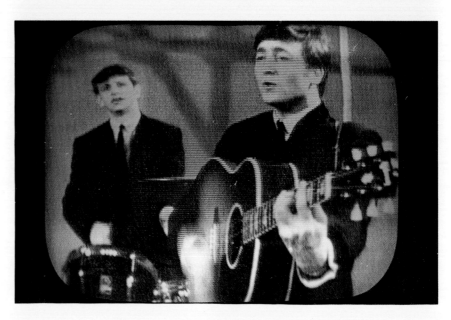

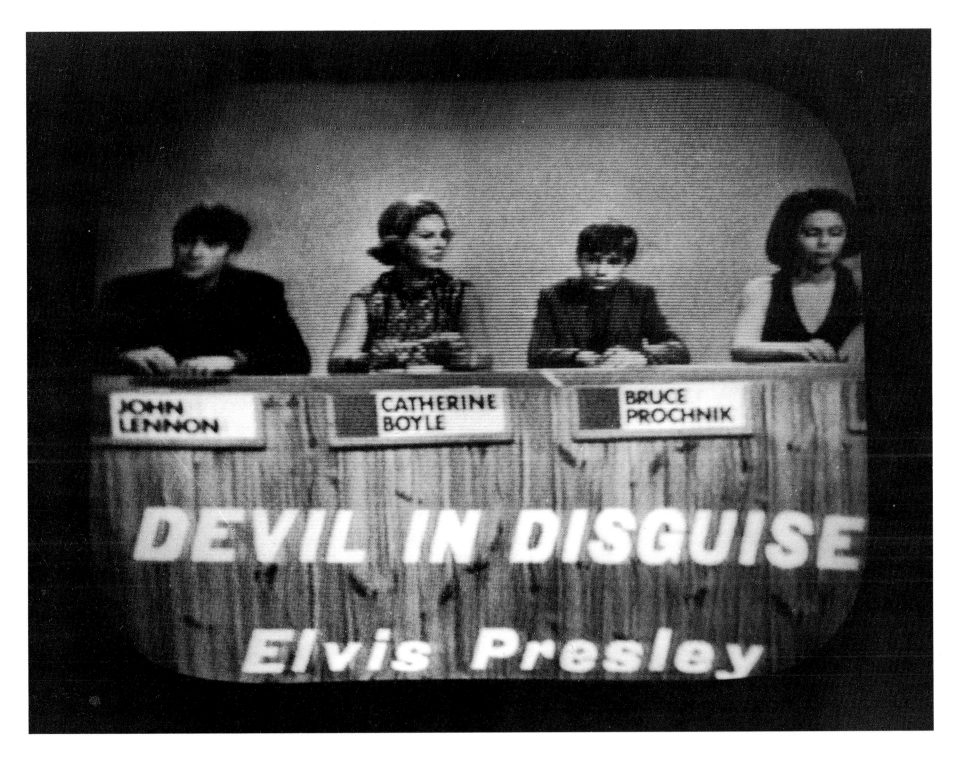

LEFT: More experimental exercises by a lunatic whose brother was on the telly. There was nothing in the books about taking photographs off a TV screen, so I stood my camera on a tripod in front of it and snapped as quickly as I could, hoping for the best.

ABOVE: We watched "Juke Box Jury" religiously, especially when Jane Asher was on, with Paul and I dreaming that maybe, one day....

The first time the Beatles were on the show they all appeared, which I think was the first time the panel was devoted to members of the same group.

John appeared again in 1963; I'm so pleased I caught him listening to a record by one of his great heroes. I wish I could remember if he voted it a hit or a miss (the little devil). And I wish I could remember who the hell Bruce Prochnik was and what happened to him.

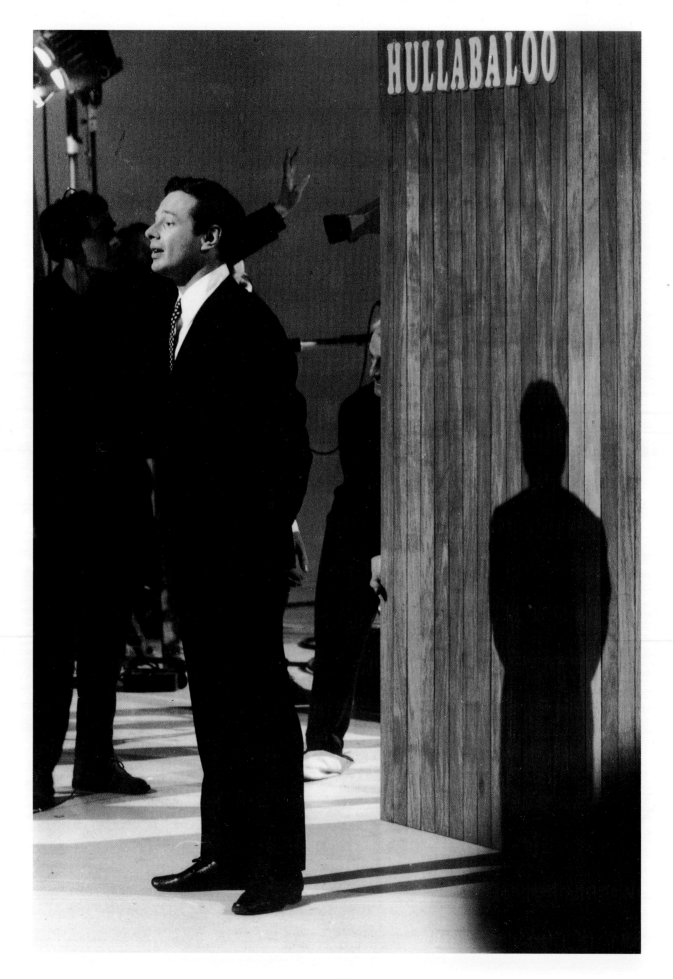

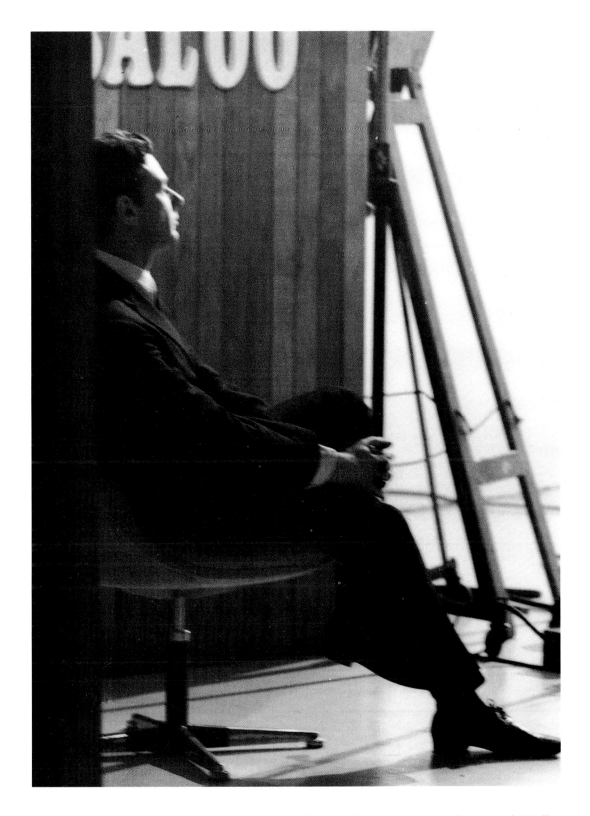

Very typical of Brian [Epstein]; he's standing and sitting down at the side of the set of "Hulla-
baloo," watching "his" boys and checking that everything meets his high standards. "Hulla-
baloo" was an American TV pop show that was never shown in Britain, although this series
was recorded in London. My satirical comedy group, Scaffold, which Brian managed for a
while, appeared on the show, doing sketches.

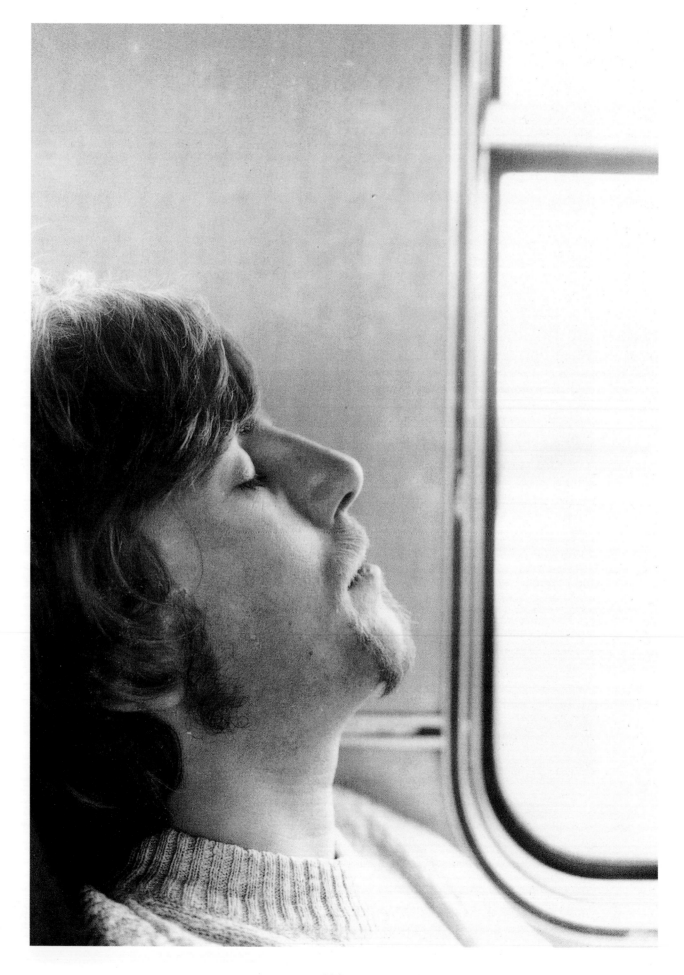

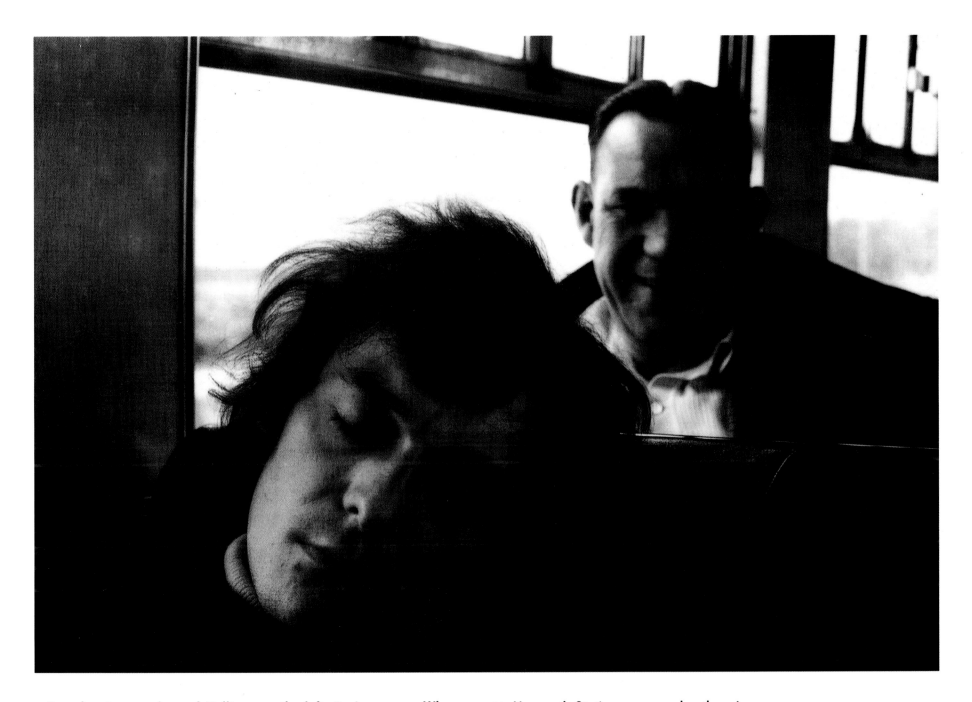

Two sleeping members of Hollies—on the left, Graham Nash, above, Allan Clarke—on tour with Scaffold.

One day in Scotland someone suggested we leave the tour coach, get on a train, and travel down the coast to Newcastle, where there was a legendary beer called Newcastle Brown Ale. So the three Scaffold and two Hollies caught the train. Graham and Allan fell asleep (much to the amusement of the passenger behind Allan); as a result they missed some marvelous East Coast scenery.

When we got to Newcastle Station, we saw a booth saying "Make Your Own Record." It was designed to take one person, but all five of us piled in and recorded "Tiptoe Through the Tulips" (Tiny Tim version...and this was *before* the ale!). I think John Gorman still has the copy of one of the rarest discs ever made. We then rushed into the nearest pub, downed a few pints of wonderful "Newey Brown," and caught a train to Manchester to do that night's concert.

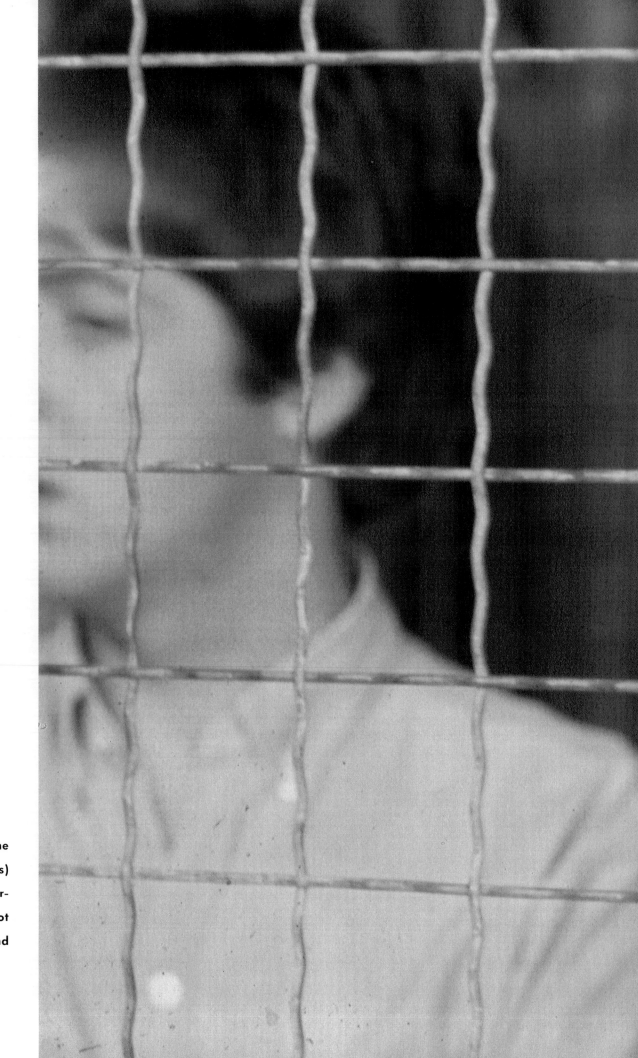

On the set of *Help!* This is a scene that was never used in the film. The Beatles were chased by an Indian sect (the Thugees) who wanted to recover a sacred ring that Richie was wearing. Whoever is wearing it will be sacrificed (Pete nearly got his job back here!). The villains have captured the Fabs and locked them in a cage.

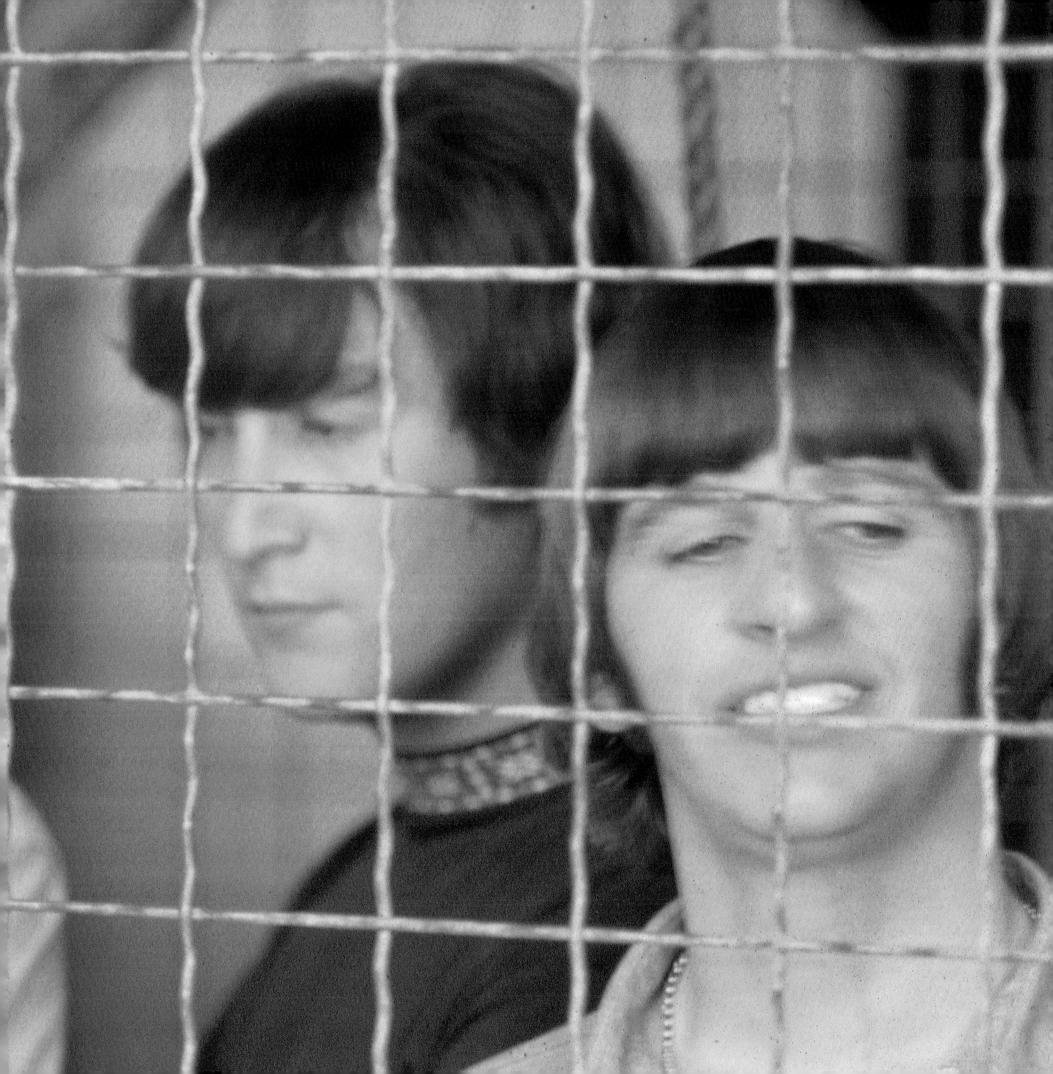

RIGHT: *Help!* It's Ringo again. Richie's showing off the ring around which the plot revolves.

FAR RIGHT: John Lennon being lynched by the Thugs. The Thug baddies have caught his feet in a noose and strung him up in the cage. As a result, he is nearly parted from his trousers.

124

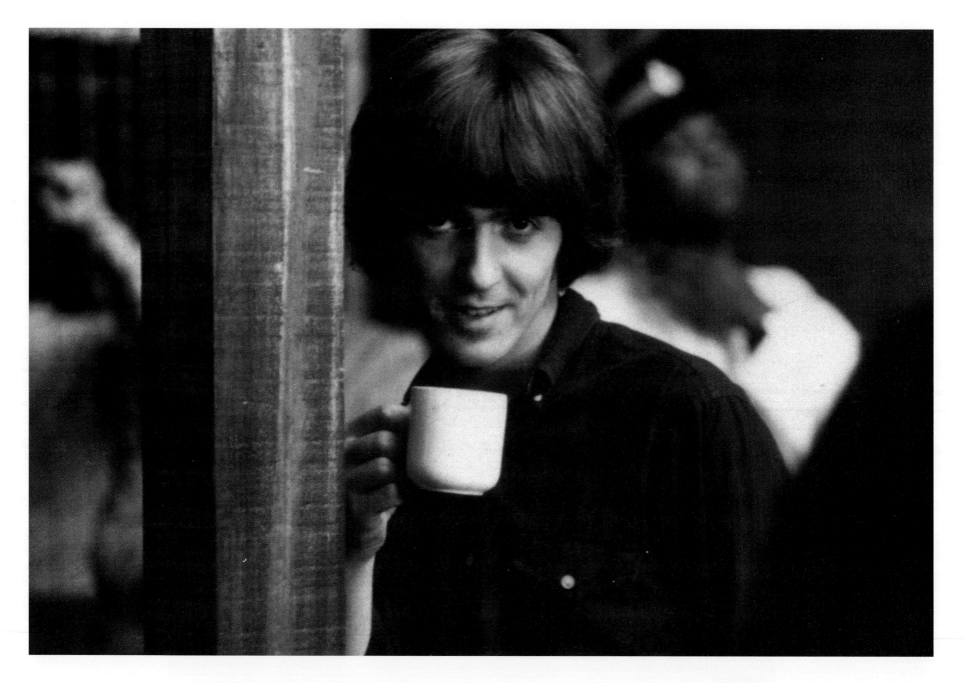

ABOVE: ''A cup of Rosie Lee, George?'' With a Bahamian cop in the background, holding his cup of tea between takes on the *Help!* set, George gives me a ''Here you are again, cheeky monkey'' look. He was essentially a shy, private young man, but when you got a smile out of George, it lit up the page.

RIGHT: On the set of *Help!* George is looking over the shoulder of Dick Lester, who directed both the Beatles' movies. Filmmaking can be an incredibly boring process; we'd hang around for hours waiting for something to happen. To pass the time we used to watch blue movies in one of the boys' dressing rooms, but even these were boring...unless you ran them backwards! They were supposed to be hugely erotic but we were on the floor, rolling around laughing at all the naughty bits they were doing...back to front!

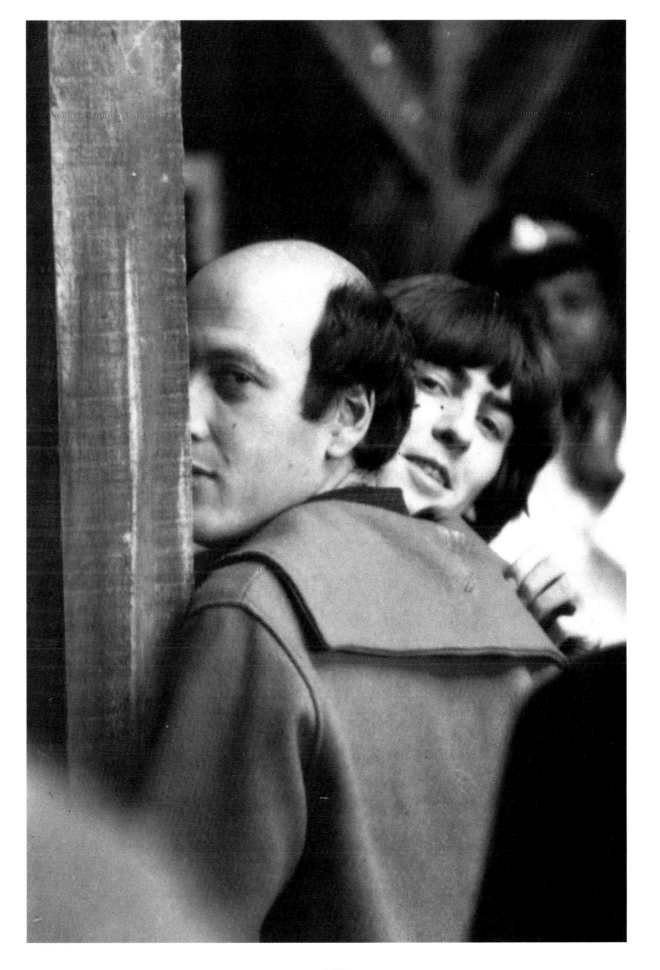

FAR RIGHT: Paul in his dressing room on the set of *Help!*, wiping off his Marcel Marceau makeup after a take. (We could have used that wallpaper on the fourth wall in Forthlin Road!)

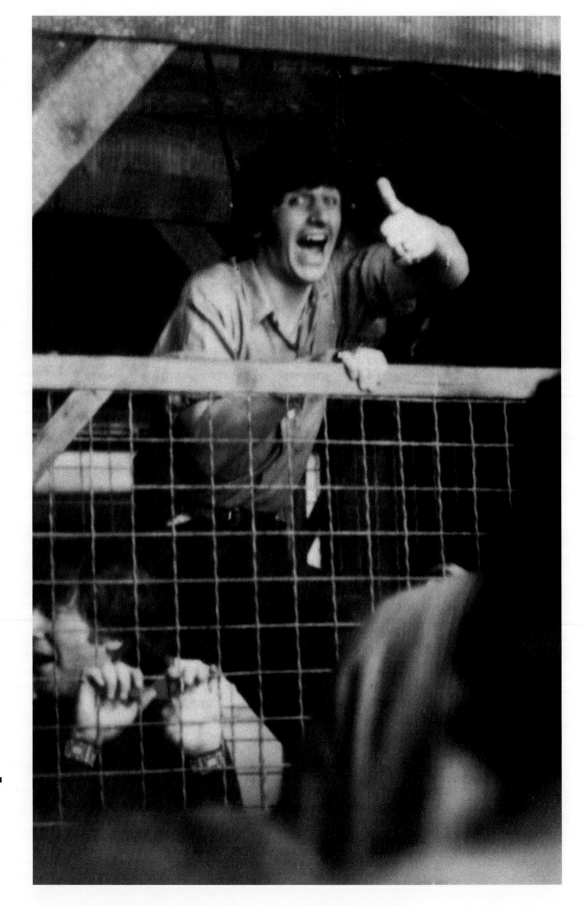

The same scene from *Help!*, with Ringo giving a "Fab Macca Thumbs Aloft."

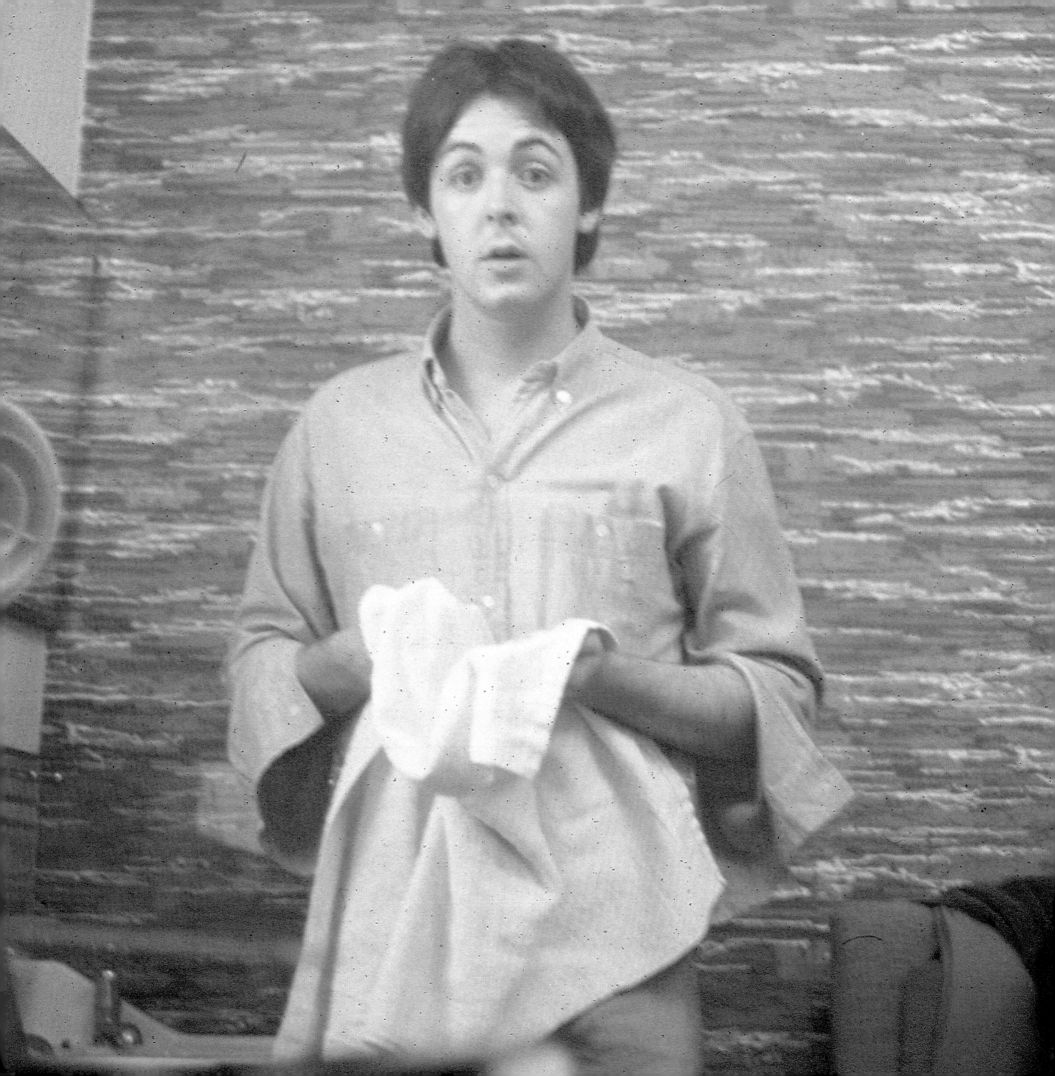

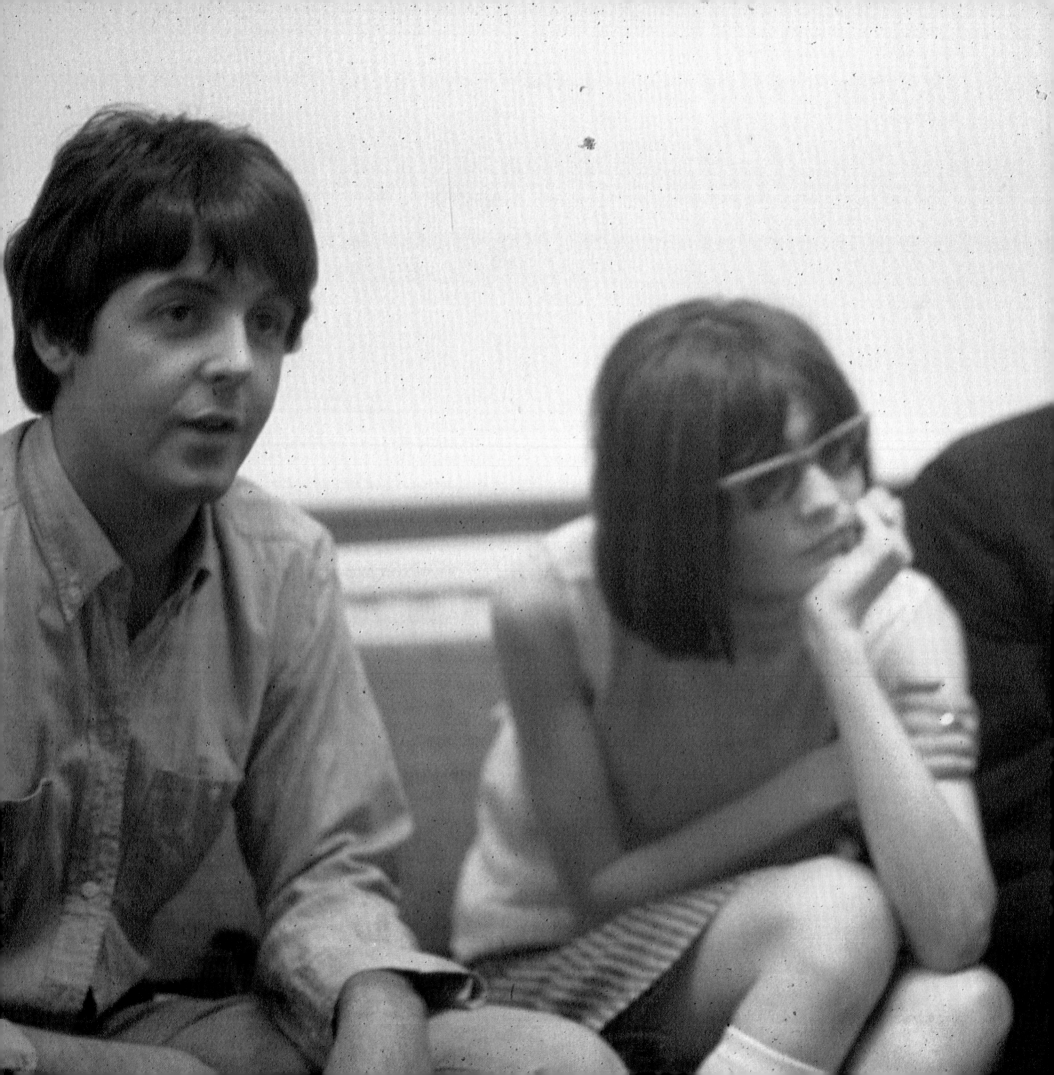

Paul with another pop icon, Sandie Shaw, with whom I stepped out for a short time. I was introduced to her by the gentleman on the right, Patrick Kerr. He and his wife, Teresa, were the more-than-able dancers on the TV pop show ''Ready Steady Go!'' and I used to stay with them when I was in London.

Sandie had the same magnetism as John Lennon, and for the same reason—without her glasses she couldn't see her hand in front of her face. Their myopia gives them an intense look that is very attractive and intriguing. Because they can barely see, they looked as though they are above everything going on around them, and dismissing it all.

131

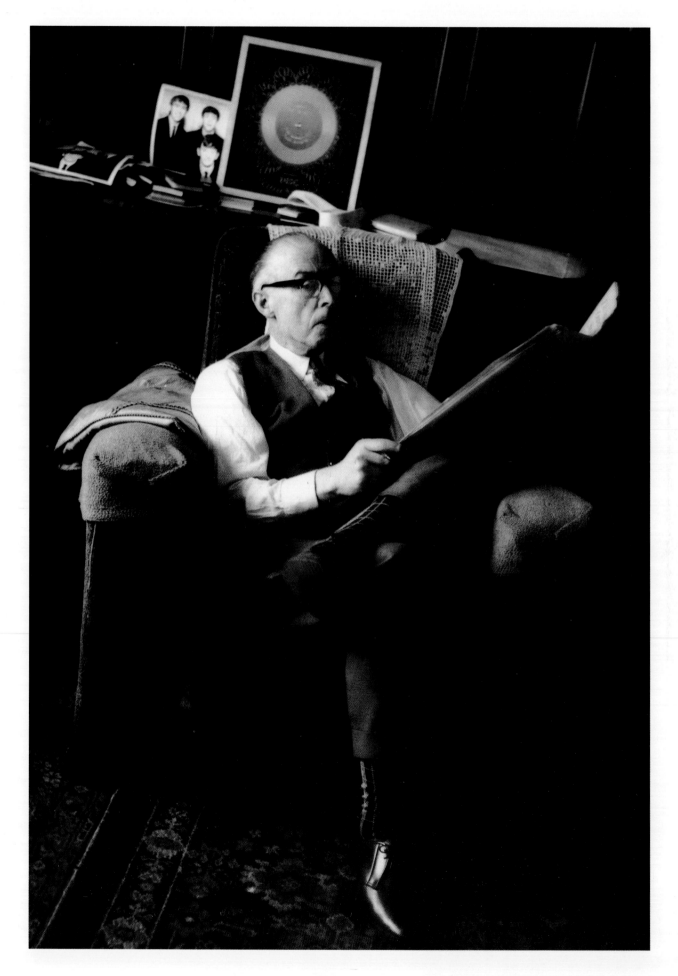

LEFT: Dad doing the crossword in front of his son's first gold disc and first publicity photo. Dad's love of crosswords runs in the family—Cousin Bert Danher is now a crossword compiler for many of Britain's top upmarket papers. The whole family was recruited to ''help'' with the Beatles' autographs on photos because they couldn't keep up with the demand. Cousin Bett did the best ''Paul'' of all.

Although Jim Mac is surrounded by the trappings of super-stardom, he's still earning only £10 a week selling cotton. This is the man who could tell exactly where in the world a skein of cotton came from, its strength and quality, just by rubbing it between his fingers. Later Paul bought him a posh Heswall house ''over the water'' on the Wirral. But here he's still in the armchair with the covers made by our aunties to disguise the holes worn in the upholstery by the springs poking through.

The floor's covered in off-cuts of carpet because we couldn't afford the real thing.

FOLLOWING PAGES: The garden of Rembrandt. The lawn was bigger than our whole house in Forthlin Road. Back then, it was a really posh place, with proper carpets—no off-cuts on the floor here—and *two* inside toilets!

We moved into this quiet suburb, but originally had intended to buy another house. The owner found out he was selling it to a Beatle and said, ''I'm sorry but I couldn't possibly leave my neighbors to have fans trampling all over their gardens.'' So he refused to sell it to us.

Paul and Jane Asher are having trouble here flying a kite with our stepsister, Ruth (Williams). Dad married Ruth's mother, Angela, who was introduced to him by Cousin Bett. Ruth has since adopted the name McCartney and is trying hard to make it in show business as a singer. She's now based in Munich and recently sent me a CD of her first album.

PAGE 136: Paul in cross shadow at Rembrandt, the house he bought for Dad, enabling him to take an early retirement.

Don't know how the house got such an arty name but it was the first posh place the McCartneys ever lived. By this time I didn't have to make Our Kid look famous because his looks are famous, but I still used him as my model.

PAGE 137: Jane Asher taken at Rembrandt, the house Paul bought for Dad and me in Heswall. She was a big star and I had a shock when I met her for the first time because I'd only seen her on our black-and-white TV. I didn't realize she had bright red hair!

Paul and Jane met in 1963, backstage at a concert at the Royal Albert Hall, London, shortly after he returned from a holiday in the Canary Islands. They hit it off immediately, and not long after he brought her up to Liverpool to meet us. Dad and I had gone to bed. When they finally arrived, Paul crept into my room and introduced me to my goddess—while I was still in my pajamas.

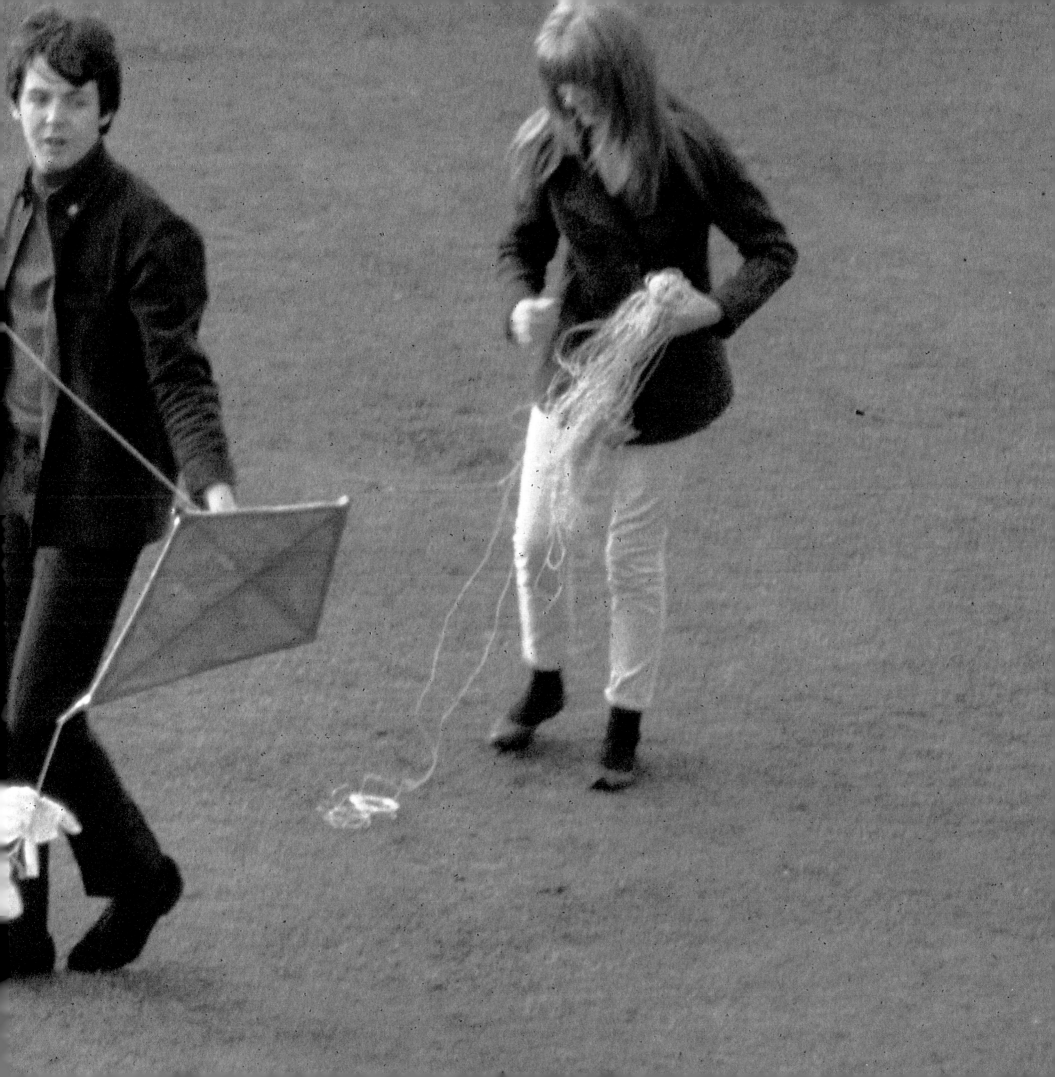

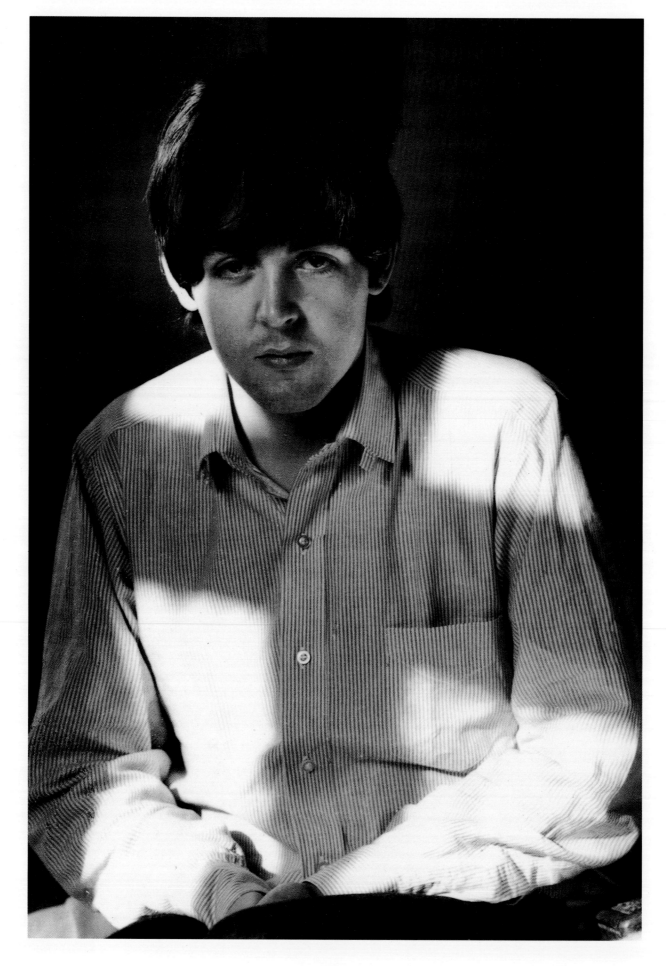

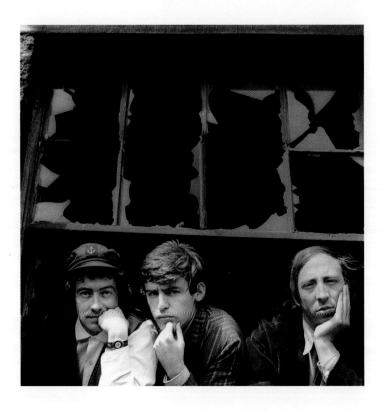

LEFT: Scaffold in Broken Window. Originally called the "Liverpool One Fat Lady All Electric Show." No one could remember all that, so we had to change it to "Scaffold." Here are the three members of the pop-humour group posing in a derelict building on the way back from a Peter Stringfellow gig in Sheffield. Roger (poet) McGough, left, Mike (straight man/singer) McGear (my stage name), center, and John (comedian) Gorman, right.

RIGHT: The best pic in the book, Scaffold, with John Gorman seated on the left — that's his real nose—Roger McGough in the center, and me on the right.

John was a post office engineer, Roger a schoolteacher, and I was a ladies' barber until we got together to form Scaffold as a satirical comedy group playing universities and theaters. For a time we were managed by Brian Epstein but he didn't really know what to do with us because we didn't make pop records. So we cut a couple of discs that died, EMI sacked us, and we left Eppy for another manager.

In 1967 I wrote a song to close our performances by thanking the audience for coming to the show. It was called "Thank U Very Much," and we'd recorded it at an EMI/Abbey Road session that Paul attended. After EMI dropped us, our new manager (coincidentally, David Frost's manager) suggested they listen to it. They changed their minds, put us back on contract (at a much better percentage), and released the song, which got to number four in the British charts.

Suddenly we were pop stars, and we had three more hit songs including "Lily the Pink"—based on an American elixir called Lydia E. Pinkham's Medicinal Compound, which went to number one. So both McCartney brothers have been top of the charts! We had a very good lineup on that record: Graham Nash (of the Hollies and Crosby, Stills, Nash, and Young) did lead vocals on the "Jennifer Eccles" verse, Tim Rice was the studio gofer, and Jack Bruce (of Cream) played bass.

Years later, in 1974, when we were recording the *McGear* album (recently re-released on Rykodisc in the U.S. and SeeFor Miles in the U.K.), Paul suggested an old Scouse song for Scaffold called "Liverpool Lou." He played on it with Wings, and it reached number seven.

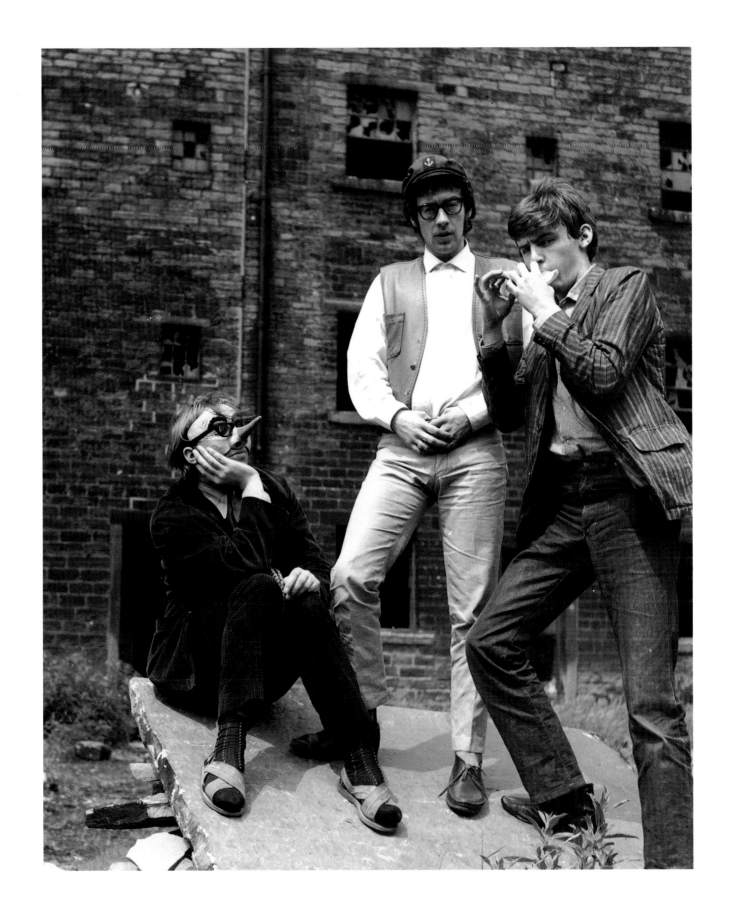

OPPOSITE PAGE: The silhouette of Gordon Waller, one-half of Peter and Gordon, in Paul's St. John's Wood house. His partner was Jane Asher's brother, Peter. Their first hit was the Lennon and McCartney song, "World Without Love." On either side of the Sgt. Pepper drumskin are two paintings by René Magritte. The first real Magritte paintings I'd ever seen were in the house of Lady Oranmore and Browne in Ireland. She was the mother of Tara Browne, the man who "blew his mind out in a car" in "A Day in the Life," on the Sgt. Pepper album and who was an early good friend.

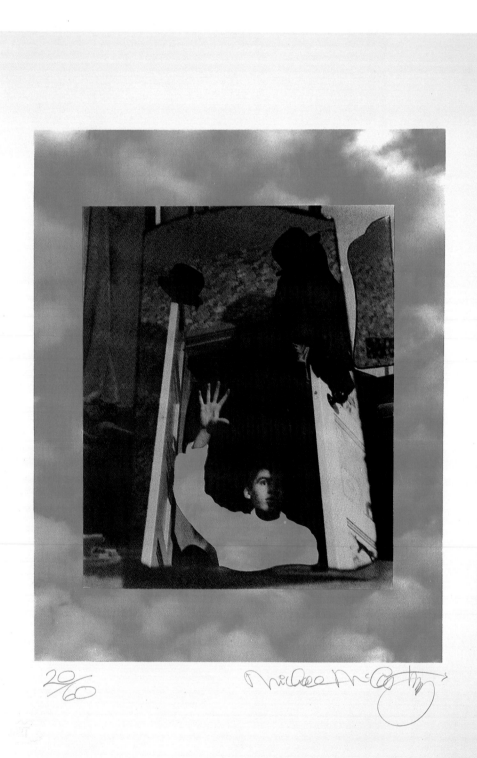

RIGHT: Slightly influenced by René Magritte back in the late 1950's. This self-portrait contains my photographic drying machine (a piece of string) and was taken in my darkroom (aka my bedroom, which could only be used as a darkroom when it got dark outside).

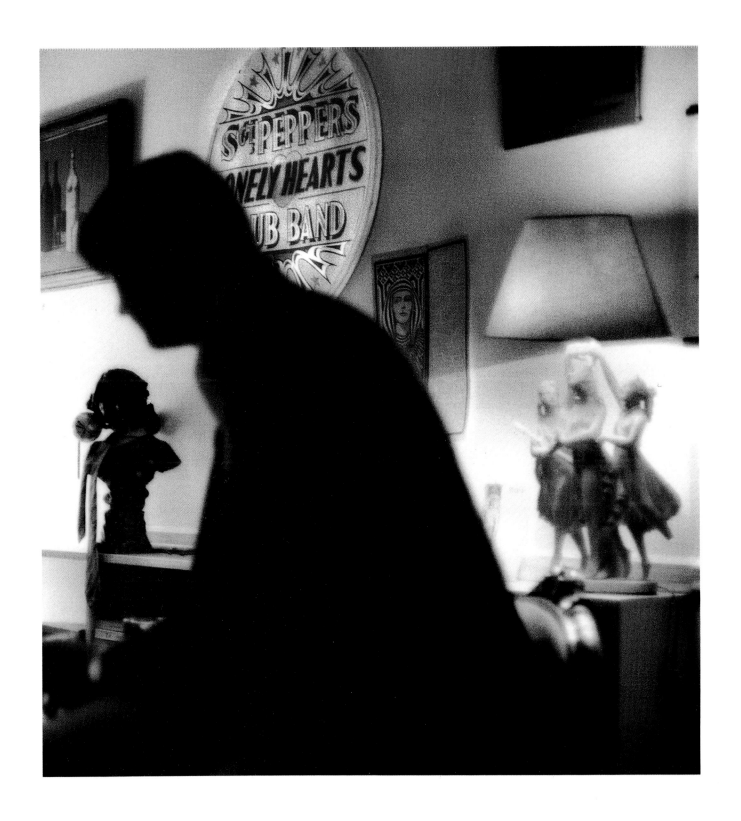

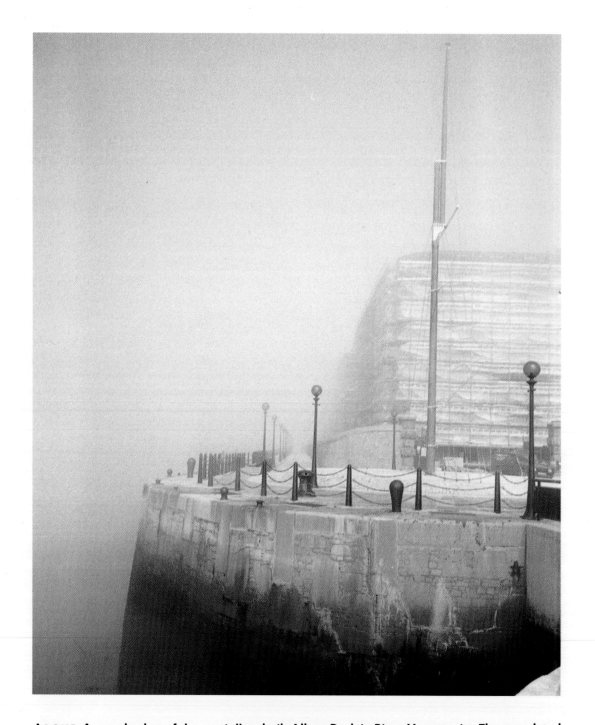

ABOVE: A moody shot of the partially rebuilt Albert Dock in River Mersey mist. The completed redevelopment now houses the Tate Gallery (North) and the Maritime Museum, where my *Liverpool Now* photographs were displayed during the Tall Ships Grand Regatta Columbus of 1992.

RIGHT: Me as a seventeen-year-old schoolboy on the roof of the new extension to Liverpool Art College, where John, Cynthia, and Stu were students. I'm looking down on the playgrounds of the Liverpool Institute; I took the picture on page 81 from here. Behind me is the Anglican cathedral where nearly the whole McCartney mafia gathered for the premiere of Paul's *Liverpool Oratorio* in 1991 and where new family rules were established.

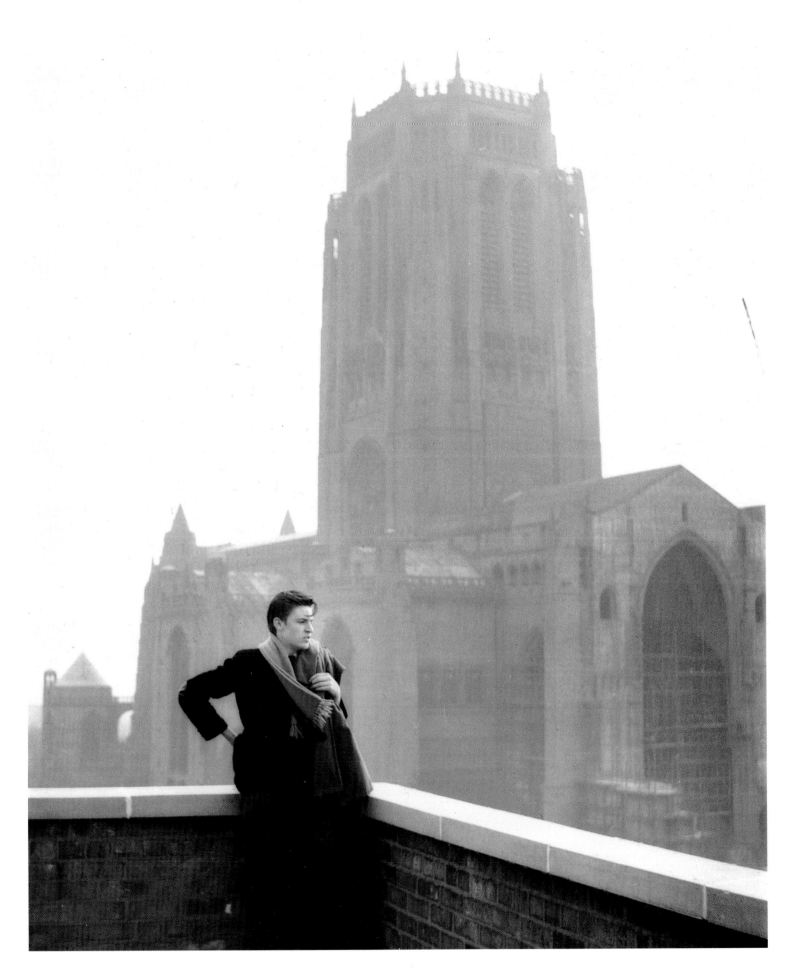

INDEX

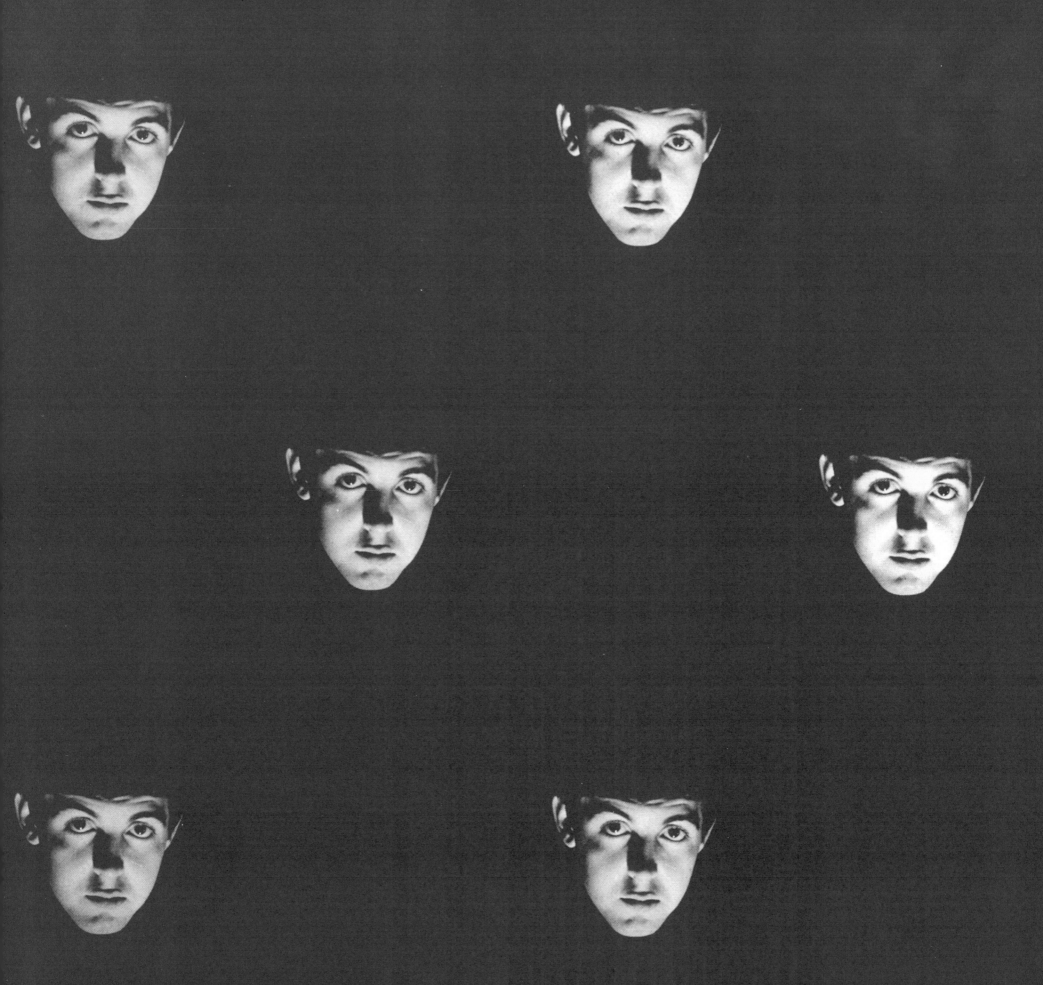